COLLECTOR'S GUIDE TO
EARLY
PHOTOGRAPHS

Wallace-Homestead Collector's Guide™ Series
Harry L. Rinker, Series Editor

Collector's Guide to Autographs, by Helen Sanders, George Sanders, Ralph Roberts
Collector's Guide to Baseball Cards, by Troy Kirk
Collector's Guide to Comic Books, by John Hegenberger
Collector's Guide to Early Photographs, by O. Henry Mace
Collector's Guide to Quilts, by Suzy McLennan Anderson
Collector's Guide to Toy Trains, by Al and Susan Bagdade

COLLECTOR'S GUIDE TO
EARLY
PHOTOGRAPHS

O. HENRY MACE

Wallace-Homestead Collector's Guide™ Series

Wallace-Homestead Book Company
Radnor, Pennsylvania

In respectful memory
of the thousands of
nineteenth-century
photographers whose
wonderful images
grace the pages
of so many books
accompanied by the
simple notation
"Maker Unknown."

Copyright © 1990 by O. Henry Mace
All Rights Reserved
Published in Radnor, Pennsylvania 19089, by Wallace-Homestead Book Company

Designed by Anthony Jacobson
Manufactured in the United States of America

Library of Congress Cataloging in Publication Data

Mace, O. Henry.
 Collector's guide to early photographs / O. Henry Mace.
 p. cm.—(Wallace-Homestead collector's guide series)
 Includes bibliographical references.
 ISBN 0-87069-547-9
 1. Photography—History—19th century. 2. Photographs—Collectors
and collecting. I. Title. II. Series.
 TR15.M24 1989 89-51557
 779'.075—dc20 CIP

1 2 3 4 5 6 7 8 9 0 8 7 6 5 4 3 2 1 0

Contents

Part 1 Cased Images, 1839–1869
Daguerreotypes, Ambrotypes, and Tintypes

CONTENTS

Part 2 Photography on Paper, 1839–1900

Preface

According to the old adage, a picture is worth a thousand words. Today, that picture could also be worth a thousand dollars, if it meets the proper criteria. In the case of early photographic images, "worth" is often a matter of opinion. The people who collect nineteenth-century photographs are as diverse as the images themselves, and what is valuable to one collector may be worthless to another. This results in inconsistent and conflicting pricing, which can be quite confusing, especially to new collectors. The purpose of this book is to help both new and established collectors to better understand factors which affect the value and collectability of these early images.

It is important to note that nineteenth-century photographs are sold both as antiques and as art. It is no surprise that rare and premium examples almost always fit into the latter category while common images are in the former. It is important to understand that early photographs have intrinsic or emotional value which can often affect their monetary worth. The personal appeal of an image to the collector is often a greater factor in the purchase decision than the image's rarity or price.

People who are interested in nineteenth-century photography are usually also interested in history. Often they view these early images as sort of a "time machine," giving them the ability to see the people, places, and events of another era, almost as if seeing them in person. To such people, to own an original image is to hold history in their hands.

Other collectors look at early photography with an artistic eye. They praise the use of light, composition, and posing in portraits, and the angles, depth, and shadow play in views. They extol the works of allegorical photographers and hold in reverence the members of the "Linked Ring" and the Photo-Secession group (see Glossary).

Still others see photography as a commodity, an investment whose value rises and falls with supply and demand. Such investors may or may not have any emotional attachment to an image, and it is probably best if they do not, for eventually it must be sold in order for the investor to realize a profit.

Regardless of why you collect early photographs, you will do well at it only if you are well-informed on the subject. The history and methodology of photographic processes have an important bearing on the collectability and value of images. This book has been designed so that each major type of photography used during the nineteenth-century has an individual chapter which includes a section concerning the history of the particular process, a section giving details of the process itself, and a section dealing with pricing trends and collectability. The first read-through will provide you with a concise overview of nineteenth-century photography and current collecting trends. The guide can then be used as a convenient reference for identifying and evaluating acquisitions to your collection.

If you are a beginning collector, the information in this book will help you to choose a specialty. Such a specialty might be a par-

ticular type of image, such as daguerreotypes, or a certain subject, such as landscapes. Your choice will be based mostly on personal emotional appeal, but careful consideration should be given to price and availability. For example, a collector who specializes in daguerreotype nude studies would have to be very diligent, patient, and wealthy.

The prices given in this book are based on documented recent sales and on a survey of current market trends. They are provided as the best method for collectors to compare relative values for particular types of images. The reader is regularly cautioned that value, like beauty, is in the eye of the beholder. Once you have ruled out that an image is a fake or a copy (to the best of your knowledge), then, using the information here as a guide, you should pay what the image is worth to you. Sometimes you will overpay, and sometimes you will get a bargain. If the image provides you with a degree of pleasure and satisfaction, it is worth the price *you* determine to be reasonable.

Investors, of course, should also base their decisions on comparisons to recent sales of similar pieces by well-known dealers and auc-

tion houses. Some examples are cited herein; however, sale catalogs are the best source of this information.

The time span of nineteenth-century photography coincided almost exactly with an era named for Britain's Queen Victoria, who inspired a romantic style and an admiration for the finer things of life. Although the Victorians were staid and somewhat prudish, they developed a great appreciation for design, art, and architecture. Although their tastes were sometimes somewhat garish, their homes were filled with the best of everything: silver, fine woods, leather, lace, and velvet. And, on nearly every table or shelf were the photographs—portraits of family and friends, albums filled with images of celebrities, travel scenes or art, and stereographs that could take the viewer to far-off lands or tell a funny story.

The Victorians were the first, and the best, photograph collectors, and for this we owe them our thanks. They have bequeathed to us the history of their era and the history of photography in its purest form. It is now up to us to protect and preserve that legacy.

Acknowledgments

This book would never have been written without the encouragement and help of my wife Kathryn. In addition, my sincere thanks go to the following people who provided assistance in various forms: Denise Bethal, Swann Galleries; Beth Gates-Warren, Sotheby's; India Dhargalkar, Christie's London; Ann M. Shumard, National Portrait Gallery; Roy McJunkin, California Museum of Photography; Grant Romer, George Eastman House; David White, artwork; Tina Lee, proofreading.

Thanks also go to the following dealers and collectors: Tony Ventimiglia, Gordon L. Bennett, and Chuck Reincke.

PART 1

CASED IMAGES 1839–1869

Daguerreotypes, Ambrotypes, and Tintypes

Daguerreotypes

da 'guerre o type: Image produced on a silver-coated copper plate. Sensitizing agent: iodine; developing agent: mercury. Invented by Frenchman Louis-Jacques-Mandé Daguerre.

Introduced	1839
Peak years	1852–1854
Waned	1858–1860
Last made	1865*

* Daguerreotypes are still produced today as an art form by a limited number of practitioners.

The History of the Daguerreotype

It is interesting to note that although 1839 is generally considered the birth date of photography, cameras were used as early as 1544 to view the solar eclipse, and an instrument called the *camera obscura,* which projected an image onto paper for tracing, had been used by artists since the seventeenth century.

In 1827, Frenchman Joseph-Nicéphore Niépce used a camera obscura to produce the first permanent photographic image, a view taken from the window of his home in Gras (the image, produced on a pewter plate, still exists in the Gernsheim Collection, Austin, Texas). Two years later, Niépce formed a partnership with Parisian artist Louis-Jacques-Mandé Daguerre who, after Niépce's untimely death in 1833, succeeded in perfecting the world's first practical photographic process, called the *daguerreotype.*

The French government awarded Daguerre a yearly pension in exchange for the details of his process, which the government wished to reveal to the world as a gift of France. A manual, published in August of 1839, quickly made its way into the hands of scientists and artists around the world.

In Daguerre's home country of France, excitement over the new invention spread quickly. Early in 1840, publisher N. P. Lerebours commissioned a number of daguerreotypists to take views of important scenic and architectural attractions around the world. These beautiful daguerreotypes were then reproduced by engraving, in a book called *Excursions Daguerriennes.* A number of expeditions of this type were mounted throughout the 1840s and 1850s. Lerebours opened the first portrait studio in France in 1841 and also began production of photographic "art studies" (nudes).

Frenchman Antoine Claudet, residing and working in England, introduced an acceleration process which shortened exposure times enough to make portraiture by the daguerreotype practical. Claudet and the major daguerreotypists of France displayed the best of their work at the French Product Exposition in 1844. The daguerreotypes of nearly 1,000 artists were exhibited.

Daguerreotypy reached its zenith in France around 1847. As the 1850s approached, the French were becoming better known for their expertise in producing photographic images on paper.

In Germany, Berlin businessman Louis Sachse was waiting for a shipment of daguerreotype equipment from Daguerre when he learned that, across town, optician Theodore Dorffel was already building and selling daguerreotype apparatus. This was only weeks after Daguerre's manual was published. While German daguerreotypes are not commonly available to collectors outside that country today, thousands were produced, for reproduction by engraving and by portrait artists and amateurs. Some of the finest artistic portraits still in existence were taken by the Biow and Stelzner partnership of Hamburg (1842).

Perhaps the most important German contributions came in the form of improvements to daguerreotype apparatus. A superior portrait lens, developed by Josef Petzval and manufactured by Voigtländer, achieved immediate acclaim and was soon in demand by daguerreotypists around the world.

The Daguerre cameras, produced in France and distributed by Alphonse Giroux, made their way to Italy in November of 1839. There, op-

Fig. 1-1. A quality daguerreotype portrait.

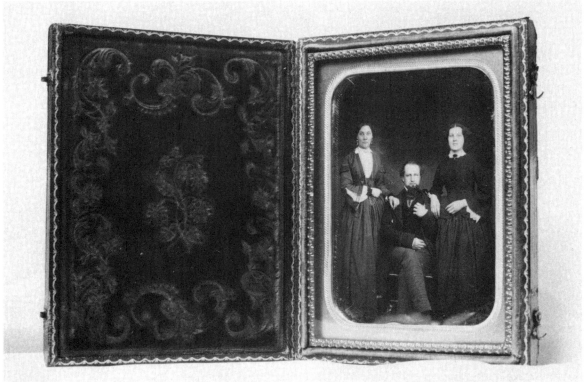

tician A. Duroni gave a public demonstration in the city of Milan. As in France and Germany, many Italian daguerreotypes were assembled for reproduction as engravings in books and travelogues. Some of the best of these were superb architectural and scenic views by Lorenzo Suscipj and Achille Morelli of Rome.

The daguerreotype was Daguerre's and France's gift to the world—with the exception of England. For reasons which invite speculation, Daguerre hired Miles Berry, as his agent, to apply for a British patent on the daguerreotype process. This made England the only country in the world which could not make use of the process free of charge. It is possible that Daguerre and France wanted to assert the precedence and superiority of this French invention over Talbot's calotype. Whatever the reason, the move severely hindered the growth of daguerreotypy in England.

Very few British amateurs were willing to pay the price of a license, and therefore British daguerreotypy was limited primarily to professional portraiture. The first two galleries to become well established were those of rivals Richard Beard and Antoine Claudet. Both Claudet and Beard were working on a bromide accelerator to shorten the necessary exposure times for portraiture. It was primarily through the efforts of Beard's associate, John Goddard, that this accelerator was perfected and Beard's studio was opened in March of 1841.

Portraits were taken in the Beard gallery using the *speculum camera,* invented by

Fig. 1-2.

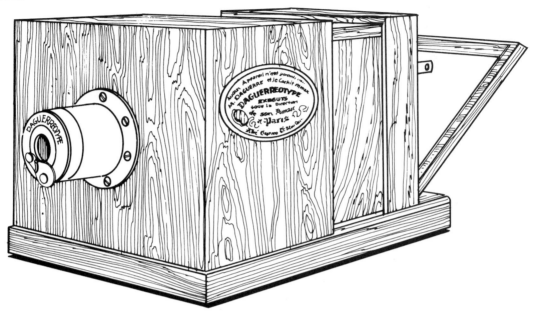

The Daguerre cameras, manufactured by Alphonse Giroux in Paris from 1839, were in great demand by scientists and others anxious to try the newly invented process. Early lenses were too slow for portraiture, prompting new designs from Voigtländer in Germany, among others. (*Art by David White.*)

Americans Alexander Wolcott and John Johnson. The design of this camera used a mirror instead of a lens, which afforded the increased speed required for portraiture. Wolcott and Johnson also helped to design an "operating room" setup which would become the pattern for a chain of Beard galleries throughout London. These galleries were the first to produce hand-colored daguerreotypes, many the work of the renowned Swiss painter J. B. Isenring. Early examples of these works, stamped "Beard patentee," today are rare and extremely valuable.

Despite the scale and success of Beard's establishments, his rival Antoine Claudet surpassed him in all areas. Claudet was instructed by Daguerre in 1839 and received the first English license in 1840. He provided daguerreotypes for the *Illustrated London News* and was

the daguerreotypist of choice for celebrities in both England and France.

During the 1840s, Regent Street became the center of daguerreotypy in London. One of the most famous galleries there was that of John Mayall, who specialized in oversized portraits, illustrative views, and the first vignetted portraits (see "The Daguerreotype Process"). Mayall would remain an active and influential proponent of photography throughout the nineteenth century. Also on Regent Street were William Kilburn, who used daguerreotypy to produce finely detailed miniature paintings, and William Telfer's Photographic Establishment, licensed in 1848. Operating in low-rent districts around London were a number of "black market" galleries that produced daguerreotypes without a license.

In England, as in France, the daguerreo-

Fig. 1-3. Portrait of an eighteenth-century ancestor; 1/6-plate daguerreotype, ca. 1845, L.B.B. & Co. plate.

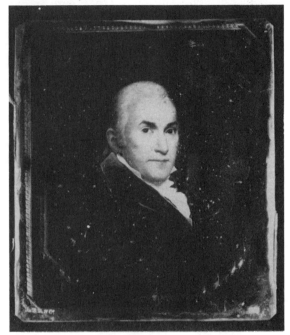

From the early years of the process, daguerreotype copies of paintings were requested by those who wished a more permanent and portable likeness.

type was quickly superseded by paper photography. Richard Beard was bankrupt in 1849 due to a court battle over patent rights, leaving Antoine Claudet as the last great daguerreotypist in England. Claudet remained active well into the 1850s specializing in stereo images.

While the English labored under stringent patent laws and the French basked in the exaltation of their ingenuity, Americans were quickly learning that daguerreotypy could mean prosperity. Inventor Samuel Morse had visited Daguerre early in 1839, and when details of the daguerreotype process arrived in America aboard the steamer Great Western in September of that year, Morse and his associate John Draper began experimenting with portraiture, and teaching the process to others. New Yorkers Alexander Wolcott and John Johnson developed the specialized portrait camera mentioned earlier and opened a portrait studio in March of 1840, just six months after details of the process had been published. By 1841, hundreds of Americans were involved in the daguerreotype "industry."

Back in November of 1839, a Frenchman named François Gouraud had arrived in America as Daguerre's agent and apparatus distributor. Although his methods and motives were suspect, there is no doubt that Gouraud's lectures and demonstrations were paramount to the rapid proliferation of new daguerreotypists. Early in 1840, a Gouraud lecture was attended by a 29-year-old Bostonian named Albert Sands Southworth who then immediately went to Professor Morse for instruction. Shortly thereafter, a partnership was formed between Southworth and Morse's assistant, Joseph Pennell. The two opened a studio in Cabotsville, Massachusetts, which was moved to Boston in 1841, at which time Pennell was replaced by J. J. Hawes. Inspired by Gouraud and taught by Morse, the team of Southworth and Hawes came to represent the best in early photographic documentation and portraiture. Today, hundreds of Southworth and Hawes daguerreotypes have found homes in museums nationwide, and still more await discovery and identification.

A less providential legacy was left by another famous American pioneer, John Plumbe. In 1838 he was employed by the U.S. government to investigate the possibility of a coast to coast, east–west railroad link. When funds ran out in 1841, he took up daguerreotypy, opening 14 studios nationwide in just four years. He became one of the largest suppliers of apparatus and materials and was the first to attempt a "famous portraits" collection. He also

Fig. 1-4. Gentleman with unruly hair, by John Plumbe Gallery; 1/6-plate daguerreotype, ca. 1847.

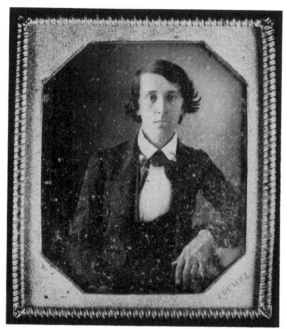

Images with the Plumbe imprint on the mat are valuable but were not necessarily taken by Plumbe himself. Plumbe maintained a large chain of galleries and traveled extensively. *Note:* Original seals on images with imprinted mats should not be broken, even to remove extensive dust (as seen on the image pictured here).

developed hand-engraved daguerreotype copies which he called ''plumbeotypes.'' Although a relatively large number of images bear John Plumbe's name, few of them were actually taken by him. Plumbe traveled extensively throughout the 1840s, still dedicated to the idea of a transcontinental railroad, and began selling off his galleries in 1847. When his railroad dream never materialized, he became deeply depressed and, in 1857, died by his own hand.

Plumbe had maintained a monopoly in Philadelphia until 1843 when German-born William and Frederick Langenheim appeared. As agents for Voigtländer cameras and Petzval lenses, their contribution to American daguerreotypy was solidly established. Later they would become major figures in the introduction of stereography, calotypy, and photography on glass.

By the mid-1840s, every major city in America had several daguerreotype galleries. But it was in New York that the industry was shaped and refined. By 1850 there were nearly 100 galleries in that city, most of which were located on or near Broadway. The most famous of these was owned by Mathew Brady. No name in the history of photography evokes such interest—or such controversy.

Fig. 1-5. A garden portrait; 1/6-plate daguerreotype, ca. 1855.

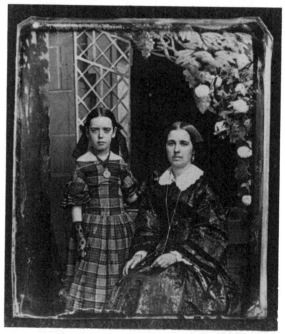

A wider view of this rare and elaborate setting can be seen in *The American Daguerreotype*, by Floyd and Marion Rinhart, p. 235. The original location of the setting and the name of the daguerreotypist has not yet been determined.

Brady received instruction from Samuel Morse in 1844 and opened a very successful gallery across from the P.T. Barnum museum. During the early years he received numerous awards, a trend which would continue throughout his long career. He recognized the publicity value of such awards, as well as the value of association with celebrities. It then became his ambition to make a photographic record of the famous and notable personages of his era, called the "Gallery of Illustrious Americans." Many photographs of important political figures of the nineteenth century would never have existed without the efforts of Mathew Brady.

Although many historical images bear the Brady name, it is unknown how many were actually taken by him. He employed many operators throughout his career, all of whom were trained to the Brady system. Perhaps as much

Fig. 1-6. Reverse of Plumbe Gallery image; ca. 1852.

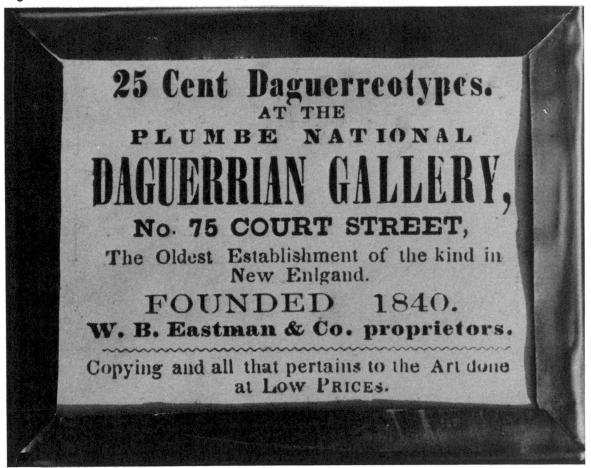

Before selling his chain of galleries in 1847, Plumbe introduced inexpensive daguerreotype portraits produced by the assembly line method. This advertising card was used by Plumbe's successor, Walter Eastman.

as 75 percent of the total volume of images bearing the name Brady were actually taken by these trained operators. However, this in no way lessens his importance as an innovator, teacher, and entrepreneur or his position as America's most valuable photohistorian. Mathew Brady's involvement in the photographic field was so immense that you will find reference to him in nearly every chapter of every book on the early history of photography.

While Brady was the most famous of the New York daguerreotypists, he was not without important competition. The Broadway galleries of Jeremiah Gurney and Martin Lawrence were equally as active, and both Gurney and Lawrence were recipients of numerous major awards for daguerreotype excellence.

Other well-known American daguerreotypists included Abraham Bogardus, Rufus Anson, Samuel Broadbent, C. D. Fredricks, and the Meade Brothers, all in New York City; Marcus Root in Philadelphia; John Whipple in Boston; John Fitzgibbon in St. Louis; and Robert Vance and the Shew brothers in California. During the early 1850s some galleries began using the production line concept to produce portraits for as little as 25 cents each (for 1/9-plate images). Brady and the other top galleries condemned these "cheap pictures" and lashed out at the operators who advertised them. Contemporary accounts, however, indicate that some of these daguerreotypes were as good or better than many taken by elaborate and expensive establishments.

Even as the rest of the world began to concentrate on paper photography, American daguerreotypy flourished. Major cities were overrun with galleries, while itinerants carried the process to small frontier towns and even to California. The first western routing expeditions and the gold rush were all documented by the daguerreotype. In 1853, daguerreotypists were basking in the overwhelming success of their chosen profession, unaware that in just a few short years the silver-coated plate would be replaced by collodion on glass (see Chapter 6) and the world's first practical form of photography would soon become obsolete.

The Daguerreotype Process

Daguerre had experimented with numerous other materials before finally arriving at the choice of a silver-coated copper plate as the base of his process. He used the recently invented electroplating system to "galvanize" silver onto the copper surface, and then the plate was given an acid wash to remove impurities. The plate was next placed in a closed box where it was subjected to iodine vapors. Now sensitized, it was exposed in a camera of Daguerre's design. In Daguerre's early experiments, exposures could take as long as 30 minutes and averaged no less than 5 minutes. After exposure the plate was placed in a second box where, by the fumes of heated mercury, the latent image was developed. A finishing bath in hyposulfate of soda ("hypo") made the image permanent.

The process sounded simple, but early practitioners discovered that great patience and attentiveness were required to obtain acceptable results. After Daguerre's manual *Historiqué et Description des Procédés du Daguerréotype et du Diorama* was published in 1839, experiments were soon undertaken to improve the process. England's John Goddard found that by including bromide in the sensitizing process the sensitivity could be greatly in-

Fig. 1-7. U.S. President James Buchanan; 1/4-plate daguerreotype, 1850s.

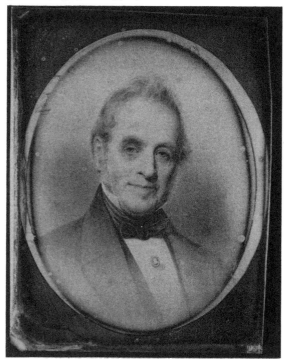

To meet the demand for portraits of celebrities and notable persons, daguerreotypists often copied paintings or lithographs, as for the image shown here.

creased. Eventually, individual operators would devise their own secret sensitivity-increasing formulas, called "quickstuff." These "quicks," along with other improvements, such as Wolcott and Johnson's speculum camera, made possible something which Daguerre had initially believed was unachievable: the daguerreotype portrait.

By the late 1840s, the process had been generally standardized. Plates were purchased from silversmiths who brazed silver sheets onto copper. Often the individual operators would then galvanize additional silver to the plate through electrolysis. A wet battery served as a source for the electroplating current. In 1851, the French platemaker Christofle began selling factory-galvanized plates, thus eliminating one of the time-consuming operations.

Before use, each plate had to be polished to a mirrorlike finish. It was attached to a holder, which sometimes required bending or gluing, then buffed, first with a leather-covered "buffing stick" and pumice and then with flannel cloth and jeweler's rouge. Since even the most thorough buffing left tiny scratches, the final strokes had to be performed so that these buff marks were parallel to the intended viewing light (lengthwise for horizontal format images and side to side for vertical format images). An 1849 manual suggested that buffing be done immediately before sensitizing, when the plate was still warm.

In large establishments, each part in the process was performed by a separate department with workers who specialized in a particular step or function. In such an establishment polishing was often done on a large steam-powered buffing machine. The plate was then taken to the "coating room," where it was sensitized, first in an iodine coating box and then with quickstuff, before being placed in a shield for delivery to the waiting camera operator. All of this took place as the customer was led from the lounge to the "operating room" and posed before the camera.

There have been numerous horror stories told about the discomforts involved in sitting for a daguerreotype portrait. It has become apparent that the degree of comfort experienced by the sitter was directly proportional to the degree of care and patience provided by the operator. The primary "evil" in these horror stories was the "head rest," a U-shaped device attached to the chair or a heavy metal stand, designed to keep the head motionless during exposure. When used properly, the head rest was just that—a rest on which to lean the head. In most cases, the pained looks and grim

Fig. 1-8. Baby in spindle-back chair; 1/6-plate daguerreotype, ca. 1852, H.B. plate.

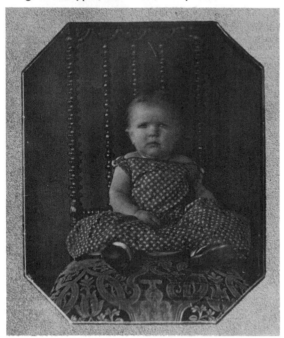

Due to lengthy exposure times, babies were very difficult to daguerreotype. This youngster was probably tied to the chair with the sash from her dress. The slight blurring caused by head movement was usually considered acceptable.

Fig. 1-9. "Rose," attributed to Samuel Broadbent; 1/6-plate daguerreotype, 1846 Scovills plate.

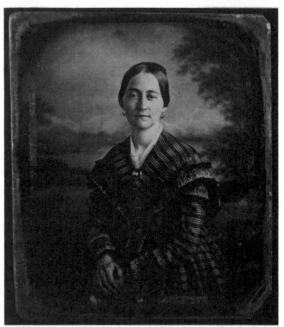

This beautiful painted backdrop (of which only a portion is visible here) was used by Broadbent for many years. The distance and/or angle was changed to give different effects. A large column, barely visible to the right here, can be seen in its entirety in other portraits.

expressions are not signs of discomfort, but signs of the time.

With the head rest in place and the sitter posed, the operator received a freshly sensitized, shielded plate which the operator slipped into the camera. The slide covering the plate was removed, the lens uncapped, and the exposure made. (Many operators would recite poems or sayings as a way of measuring the exposure times.) Then the cap and slide were replaced and the exposed plate removed to the developing room.

In semidarkness, the plate was taken from the shield to a mercury fuming box in which the latent image would be brought out. Careful control of time and temperature was necessary in this step. After development, the image was made permanent in a fixing solution of hyposulfate of soda. Next, the plate received a toning bath in gold chloride. This "gilding" process improved the tone of the image and also provided protective elements.

After the plate was washed and dried, several finishing steps could be performed. Most galleries employed artists who applied varying degrees of color in the form of powdered pigment. When elaborate coloring was required, stencils were cut to isolate the area receiving a particular color. In America, finished daguerreotypes were then taped to a cover glass

Fig. 1-10. Tiny daguerreotypes; 1850s.

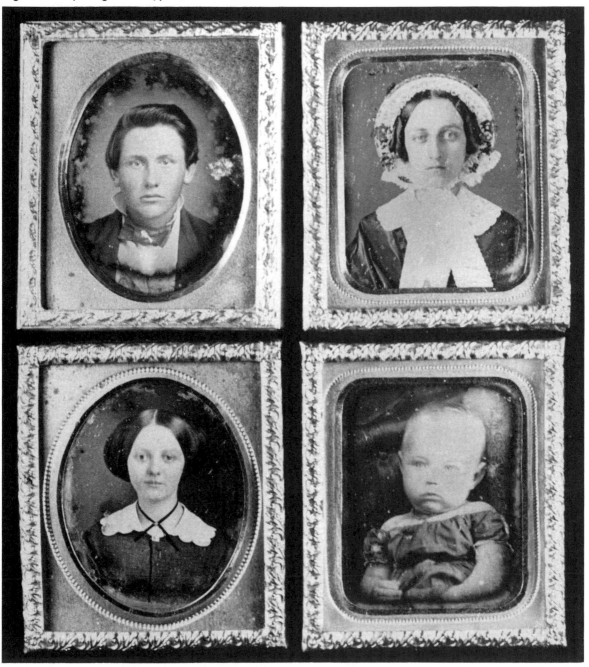

Small cased images were a convenient way to carry the likeness of a loved one in pocket or purse. Sixteenth-plate images such as these are becoming harder to find.

with a decorative (and protective) brass mat sandwiched between. The packet was then placed in a leather, papier-mâché, or plastic case (see Chapter 4). In France and other European countries the daguerreotype was often displayed behind painted glass and cardboard frames called *passe-partout* (detailed later in this chapter). The various elements which protect and adorn the daguerreotype add considerably to the enjoyment of collecting these images. By careful study of these various elements, collectors can often arrive at an approximate date for the image, as well as determine other interesting facts about its production.

The Daguerreotype Plate

Most plates were purchased from distributors, who purchased them from plate manufacturers. These manufacturers employed silversmiths who brazed a block of pure silver to a larger block of copper, rolling the combination out until the proper thickness was reached. On the finished sheet (only .02 inches thick) the silver layer was a mere 3 percent of the total weight. (When silver commanded its highest price during the 1970s, enterprising individuals who attempted to extract the silver by melting daguerreotype plates quickly found that it wasn't worth the effort.) This large sheet was cut into standard-sized plates which were then stamped with the manufacturer's hallmark.

Historians and writers seem to disagree as to the exact dimensions of these standard plates, probably because the two primary sources of this information (early catalogs and existing plates) are inconsistent. Measurement controls in factories were not always accurate, and more often than not the plates required additional trimming by the daguerreotypist. The list provided below is based on average measurements taken from this author's collection:

Full plate	$6\frac{1}{2}'' \times 8\frac{1}{2}''$
Half plate	$4\frac{1}{2}'' \times 5\frac{1}{2}''$
1/4 plate	$3\frac{1}{8}'' \times 4\frac{1}{8}''$
1/6 plate	$2\frac{5}{8}'' \times 3\frac{1}{4}''$
1/9 plate	$2'' \times 2\frac{1}{2}''$
1/16 plate	$1\frac{3}{8}'' \times 1\frac{5}{8}''$

These sizes carried over into all types of cased images. See illustration. I have also found references to a 1/8 plate ($2\frac{1}{8}'' \times 3\frac{3}{4}''$) and plates as large as $20'' \times 24''$.

Although American daguerreotypists were considered the best in the world, it was the French who produced the best daguerreotype plates. The most widely used French plates bore the initials H.B. or the initials J.P. in their hallmarks. The actual names of these manufacturers have not been determined.

Hallmark designs usually consisted of a star or initials, followed by a symbol (eagles, scales, horses, etc.) and a number which indicated the ratio of silver to copper. Commonly this number was 40, indicating 1 part silver to 39 parts copper. High-quality plates marked "20" and "30" and inferior quality plates marked "60" were rarely used. In England and America, the plate mark often consisted only of the manufacturer's name stamped on an edge or corner (see Appendix B).

These hallmarks are an important aid in dating a daguerreotype image, since manufacturers often changed the designs to indicate changes in process, quality, or ownership. Unfortunately for the collector, many operators bought full plates which they then cut into various sizes, as needed. The hallmark would then only appear on one of these "self-cut" plates.

The quality of the original plate played an important part in the overall results of the daguerreotype process. Only a well-polished plate, galvanized and properly sensitized, could produce a superior daguerreotype. One of the most difficult parts of the polishing operation

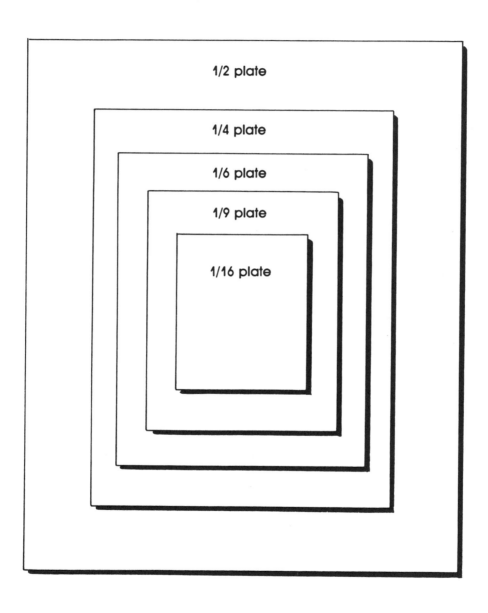

Fig. 1-11. Portrait of a gentleman; 1/6-plate daguerreotype, ca. 1842, Corduan plate.

This image bears the hallmark "Corduan & Co. N.Y.," indicating that it was made by the earliest American plate manufacturer. Daguerreotypes dating from the early years of the process are quite valuable. An ordinary image on a Corduan plate sold at auction in 1989 for $1,210.

was to keep the plate still during the aggressive buffing process. A number of devices were designed and patented during the late 1840s and early 1850s to hold the plate firmly in place. The various marks (bent corners or edges, indentations) left by these plate holders can be used as an aid in image dating. Plates with holder marks can be positively attributed to the period after 1848. However, not everyone used these devices, and therefore plates without marks are not necessarily pre-1849. During the mid-to-late 1840s, some daguerreotypists used a red waxlike glue to hold the plate to a wooden block.

Daguerreotypes in Color

Most daguerreotype portraits had some small amount of coloring added by artificial means. Usually this coloring was limited to "pinking" the cheeks and applying gilt to chains or jewelry; however, some operators employed professional artists who, through careful and expert application, could color an entire image with amazingly true-to-life results.

A number of coloring processes, both simple and elaborate, were patented. The most common method involved the creation of stencils to isolate the areas receiving a particular color. The artist would then breathe on the plate, forming condensation to which the pigmented dust would cling. Other artists applied the colors with a fine camel-hair brush.

One of the most fascinating stories of early photographic history involves the color daguerreotypes of Levi L. Hill, an American daguerreotypist residing in New York during the early 1850s. Hill produced a number of daguerreotypes in the "colors of nature," which were examined and attested to by contemporary experts. Existing examples have been thoroughly studied by modern methods which reveal no evidence of applied color. "Hillotypes," as Hill called them, were truly produced by the world's first color process, developed 85 years before the invention of Kodachrome. Unfortunately, Hillotypes were a fluke, that is, simply an accident of chemical experimentation. In 1865, after years of promising to divulge his secret, Hill died, still frustrated in his attempts to recreate the chemical combination. Modern daguerreotypists have also been attempting to duplicate the process, and as of this writing there have been rumors of some success.

Fig. 1-12. Little brother, big sister; 1/6-plate daguerreotype, ca. 1846, Edward White plate.

This image exhibits a clarity and tonal quality that is startlingly modern in appearance. The plate, marked "E. White, Maker, N.Y., Finest Quality," was considered one of the best.

Fig. 1-13. Ms. Hare of Harewood Manor, by Barratt & Stanley, Great Britain; 1/9-plate daguerreotype, ca. 1848.

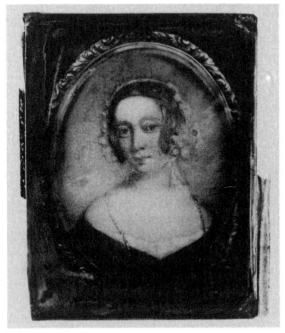

This copy-image is completely hand-tinted to match the original painting. The British were well-known for their full-color daguerreotypes with pigments applied by professional artists.

Fig. 1-14. Portrait of a lady; 1/6-plate crayon daguerreotype, ca. 1856, Norton plate.

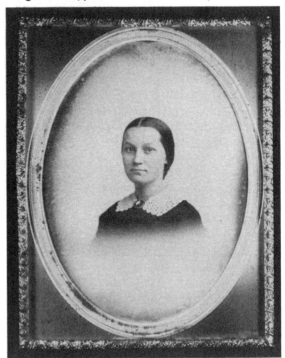

Whipple's patented process required a light-colored background and a paper cutout held in front of the camera. The result was a vignetted "bust" portrait which, due to decreased reflectance, was considerably easier to view than ordinary daguerreotypes.

Vignetted Daguerreotypes

In 1849, John Whipple patented the "crayon daguerreotype," a process which produced vignetted portraits with a light-colored background. By keeping the dark or shadow areas to a minimum, the crayon portrait greatly reduced the annoying reflections which had been the daguerreotype's greatest drawback.

During the 1850s a number of variations of vignetted daguerreotypes were introduced. The two most popular were the "magic background" and the "illuminated daguerreotype." In the magic background process a se-

ries of paper cutouts were placed over the center of the plate during the exposure to produce a halo around the subject. Illuminated daguerreotypes were similar to crayon portraits but were produced through manipulation of the mercurializing process, allowing the outer edges of the plate to receive less mercury and thus producing the effect of light coming from behind the subject.

Considering the simplicity of the process and the beauty of the resulting images (see Fig.

1-14), it is surprising that more crayon daguerreotypes were not produced. It may have been that the restrictions imposed by Whipple's patent or the licensing requirements of Whipple's agent Marcus Root kept the process from being used extensively.

Mats and Preservers

The purpose of the brass mat which lay between a daguerreotype plate and its cover-glass was twofold: first, to frame and enhance the image, and second, to provide a protective space between the image and the glass. Because the style and texture of these mats

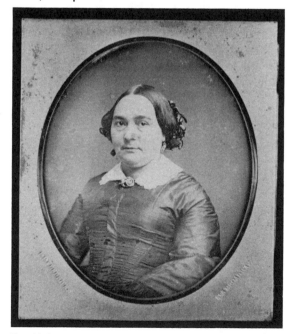

Fig. 1-15. Portrait of an unknown woman, by C. D. Fredricks; 1/6-plate daguerreotype, ca. 1856, J.W. plate.

Fredricks was a well-known and prolific daguerreotypist with galleries in New York and in Havana, Cuba. While this image bears the Broadway imprint, the sitter could well be Cuban.

changed over the years they provide today's collector with a quick reference indicating the approximate year an image was made (see Figs. 4-8 through 4-21).

Early mats were relatively thick and unadorned, becoming slightly more ornate around 1850 and then more lightweight and elaborate after 1855. Occasionally mats were embossed with the gallery name and address. When daguerreotypes were placed in jewelry, or in round or oval cases in which a mat was not feasible, a convex glass was sometimes used to provide the protective separation.

During the early years (1839 to 1845) a full sheet of paper was often glued to the back of the plate and wrapped over the edges of the cover-glass to hold all the elements together. Later a small strip of paper or thin tape, of the type used by goldbeaters in the production of gold-leaf, was employed for the purpose. Around 1849 a thin frame of malleable brass was introduced which slipped over the cover-glass and wrapped around the back of the plate. This frame, called a *preserver,* was at first straight and narrow, embossed with simple patterns. After 1855, preservers were much lighter in weight and more ornate (see Figs. 4-22 through 4-24).

On the continent, Europeans usually preferred to have their daguerreotypes mounted in frames of the type called *passe-partout.* For passe-partout frames a cardboard mat was cut and pressed to provide an oval or double-elliptical opening (see Fig. 4-14) edged in gold, black, or white. The plate and mat were then taped to a cover-glass, which may have been lacquered in black or painted to resemble tortoiseshell or marble (see Fig. 3-7).

The British also used both the passe-partout style frame or a leather case similar to those used in the United States, but with either a plain leather cover or embossed with the Royal Seal (see Fig. 3-8).

Understanding the many elaborate steps

19

Fig. 1-16. A family portrait; 1/4-plate daguerreotype, ca. 1856.

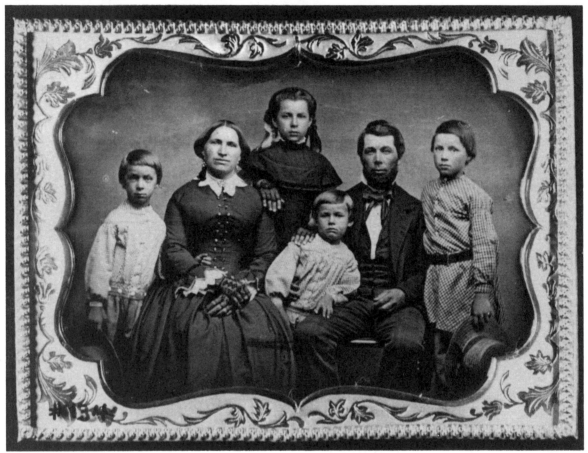

A group portrait (especially one including children) was quite a challenge for the daguerreotypist, even during later years. The unknown artist who created this masterpiece knew the business well.

involved in the making of a daguerreotype should give the collector a greater appreciation for the end product. Today, only a handful of people are capable of producing a quality example, yet during the period of the daguerreotype's popularity over 25 million were produced by amateurs and professionals around the world. And this was at no small risk to the maker, for the process involved poisonous chemicals,

sharp edges, and one of the most dangerous elements of the nineteenth century: fire.* Most remarkable were the itinerants who performed

* Hundreds of photographic establishments were destroyed by fire during the 19th century, often taking the entire town with them. Many important images were also lost when the buildings in which they were stored or displayed were lost to fire.

these functions in small wagons and tents on muddy backroads and snow-covered mountainsides.

The daguerreotype was the first, most permanent, and most difficult of photographic processes. For this reason alone, existing examples can only become more valuable in the years to come.

Collecting the Daguerreotype

Even though the reign of the daguerreotype was somewhat short (1839–1860), this area of photographic history today provides a wide range of appeal for both collectors and investors. Interesting portraits can be found at flea markets and antique shops for less than $35. At the same time, record prices in excess of $30,000 have been paid for individual examples at auction. At the November 1988 Sotheby's auction, a group of 11 daguerreotypes brought in excess of $50,000 (see Fig. 1-23).

Collectors are drawn to the historic and aesthetic appeal of the daguerreotype. As the first commercially marketable form of photography, its wide success assured generous stockpiles for future collectors. While unique examples are becoming harder to find, the stockpile is far from empty.

From a historic point of view, the daguerreotype is a "mirror of the past." Reflecting, in bold sharpness, the visage of America's pioneers, its recording quality is unrivaled. From an aesthetic point of view, this silver plate in a golden frame, housed in a rich leather case trimmed in velvet, is definitively Victorian. It is showy, yet classy. It is stylish and romantic. It is no surprise that organizations dedicated to this one unique nineteenth-century photographic process have been formed around the world.

Daguerreotypes in all price ranges have doubled in value during the past decade. Common examples that were found on flea market tables for $5 to $10 just a few years ago are now going for $30 and up. The fanfare accompanying the Sesquicentennial of Photography has educated the general public, and the "secret" of the daguerreotype has been revealed.

What to Look For

Daguerreotypes which in any way stand out from the thousands of common images on the market are collectible pieces, highly sub-

Fig. 1-17. Young black woman; 1/9-plate daguerreotype, ca. 1850s.

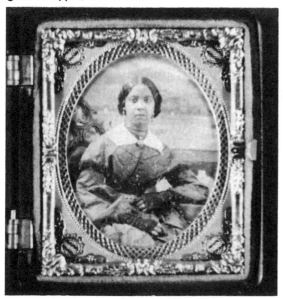

Early images of blacks and other minorities are rare and valuable. This image brought $523 at a 1989 auction. (*Courtesy of Swann Galleries, Inc.*)

Fig. 1-18. Smiling mother with barefoot boy; 1/6-plate daguerreotype, ca. 1855.

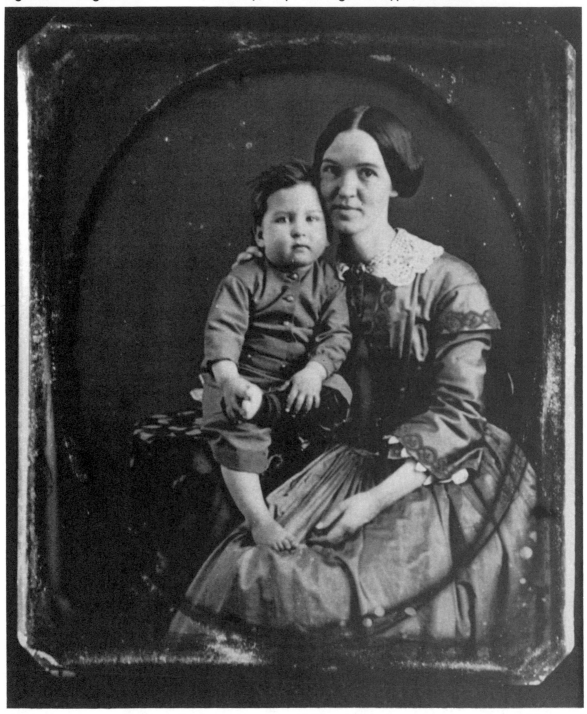

An unusually informal portrait, this image is representative of the advancements made in lighting and posing by the mid-1850s. Images of this type are highly prized by collectors.

ject to value appreciation. A seemingly common portrait can actually be uncommon when the sitter is identified as a famous statesman or author, or when the image is found to bear a rare plate hallmark (see Fig. 1-11). While most images purchased from secondary sources (dealers, auction houses) have been thoroughly studied, the well-educated collector can often discover a hidden treasure, especially when dealing with original and "first purchase" owners.

Whenever possible, try to ascertain the provenance of a piece (see Glossary). This is especially important when buying rare and premium examples, since a list of successive owners usually confirms the authenticity of the work and the legality of the sale.

When contemplating a daguerreotype purchase, ask yourself the following three questions:

1. *Is the image content unusual?* In portraits, look for unusual clothing or uniforms, animals (cat in lap, dog on floor), and/or unusual backdrops or lighting; in common images look for pipes, cigars, hats, canes, etc., which increase the collectibility of the image. Very early portraits often exhibit distortion, especially in the arms and fingers of the sitter and, if produced prior to 1843, are quite valuable. Some images stand out simply because of the artistic quality achieved through lighting and posing.

2. *What is the condition of the piece?* Never buy a daguerreotype which requires major restoration, unless it is a bargain. Restoration reduces the value of a piece and causes irreparable damage. The aesthetics of age-worn cases and stained mats are in the eye of the beholder. For the most part, the image is what the collector should be concerned with, and a single scratch on a daguerreotype can lessen its value. With each additional scratch, the value con-

Fig. 1-19. Seth Boyden, American inventor; 1/6-plate daguerreotype, ca. 1849, Scovills plate.

Boyden was an associate of Samuel Morse and was the inventor of the patent leather process. This image was purchased at a flea market for a minimal amount. A simple investigation of the name written on the back of the plate revealed the piece to be of significant historical importance.

tinues to drop. Examine dust and condensation carefully. Dust or condensation on the glass can be cleaned; if they are on the plate, they could be trouble. Also remember that images with the original seal intact are more valuable.

3. *Is the price right?* A collector who is well-versed in his or her subject can estimate the value of a piece after a basic examination. If the asking price is 10 to 20 percent below the value, it is often called a "buy"; if it is 30 to 40 percent lower, it is a "bargain." Never pass up a bargain! Under ideal circumstances, a

purchase should be based on the following factors:

Rarity	20%
Aesthetics	20%
Condition	20%
Price	30%
Emotional appeal	10%

Of course, the ideal is rarely the case. Emotional appeal is frequently the largest factor in a purchase, especially among collectors. If you are assembling a collection for your own appreciation, without particular investment concerns, this reliance on emotional appeal is not necessarily a problem.

Availability/Value Classifications

The Common Daguerreotype ($30 to $75)

About 75 percent of the daguerreotypes on the market can be considered *common*. These are the ordinary portraits, most often found at flea markets and in antique shops. An average 1/6-plate portrait usually sells for around $30. Slightly more valuable are those images containing children, flowers, hats, canes, spectacles, other cased images, and identified sitters ($35 to $60). Larger, 1/4-plate images will often bring $60 to $75, and tiny 1/16 plates bring $35 to $50. If an image is in a good, complete case, the value is increased slightly ($1 to $10 additional).

The Uncommon Daguerreotype ($75 to $200)

Uncommon images make up about 20 percent of the available daguerreotype base. They

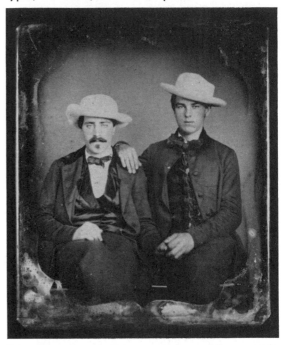

Fig. 1-20. The good guys; 1/6-plate daguerreotype, ca. 1855, J.F.S. "star" plate.

This unusual portrait is exemplary of the superb storytelling qualities of the daguerreotype.

can occasionally be found in antique stores, but they are most often made available through dealers. Many of the images now classified as *uncommon* will easily slip into the *rare* category in the next few years, making them excellent investments now. On the lower end, portraits by identified photographers, postmortems (death portraits), painted backdrops, vignetted portraits, and ordinary 1/2-plate images are *uncommon*. On the upper end, occupational portraits (including military portraits), works by well-known daguerreotypists, images containing musical instruments, portraits of "known" individuals, and copies of artwork may all soon be considered *rare*. Im-

Fig. 1-21. Uniformed man with sword; 1/4-plate daguerreotype, ca. 1858.

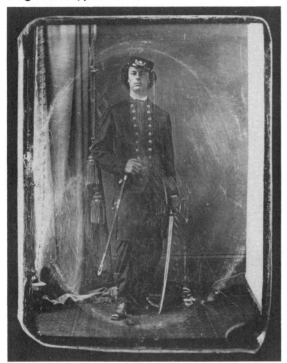

All military daguerreotypes are in the *rare* category. Of additional interest in this image is the large reflecting stand visible to the right.

ages contained in unbroken Union cases (see Glossary) are also uncommon.

The Rare Daguerreotype ($200 to $2,500)

Rare daguerreotypes comprise less than 5 percent of all existing images. Most of these are offered through dealers, and some occasionally come to auction. The April 1989 sale by Swann Galleries presented 19 daguerreotype lots with estimates from $200 to $10,000. One of these, an early portrait on a Corduan plate with an estimate of $200 to $300, brought $1,210. A half-plate view of a house and a 1/4-plate view of a horse and wagon brought $1,430 and $2,200 respectively. *Rare* daguerreotypes also include outdoor views; animal portraits; blacks and Indians; unusual half-plate, full-plate, and stereograph images; and certain works by well-known daguerreotypists. Collectors interested in this category should subscribe to dealer and auction catalogs and keep regular contact with those who deal in *rare* images.

The Premium Daguerreotype ($2,500 and Up)

In the average year, perhaps 10 individual *premium* daguerreotypes will come to auction. Generally, these are half-plate and full-plate images of scenic or architectural views. *Premium* daguerreotype portraits are usually of and/or by important historical figures, such as the image of Edgar Allan Poe which brought $9,250 at a 1973 auction or the daguerreotype of a daguerreotypist which brought $9,900 in 1977. As for scenic views, a full-plate view of Niagara Falls recently sold for $5,500 (Swann Galleries, April 1989), which was slightly less than expected. Daguerreotype series and collections often fetch in excess of $10,000, a significant example being the 1988 Sotheby's auction of 11 Acropolis views which realized $57,750 (Fig. 1-23).

The Future of Daguerreotype Collecting

The future of daguerreotype collecting is a two-sided coin. Prices will continue to climb, making existing collections more valuable, and at the same time, bargains will become nearly nonexistent as sellers realize the potential of these historical images. In short, now is the time to buy!

Fig. 1-22. Harriet Nash, aged 10, with accordion; 1/6-plate daguerreotype, Scovills plate.

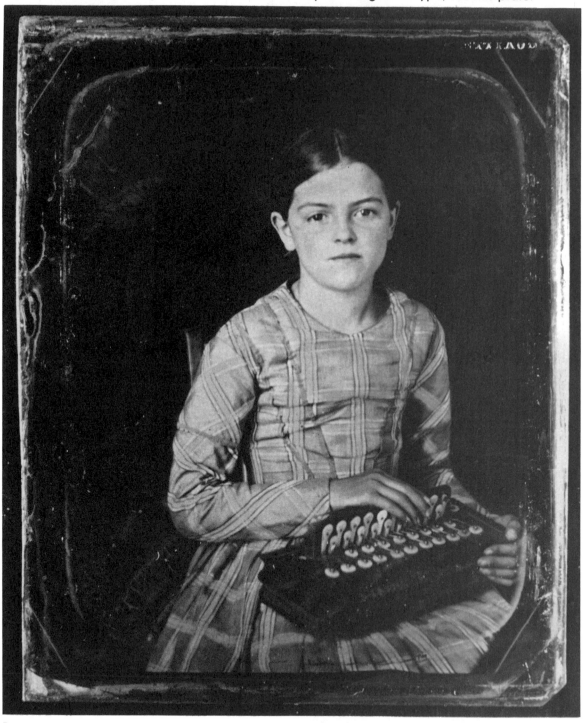

Daguerreotypes containing musical instruments are rare. This one is exceptional because of the age of the sitter and the overall quality of the image. The original plate is delicately hand-tinted.

Fig. 1-23. The Acropolis, by Phillippos Marga-
ritis or Philibert Perraud; 1/4-plate daguerreo-
type, late 1840s.

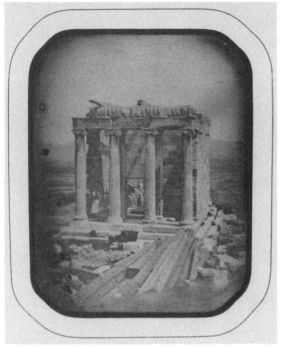

This premium image is one of a group of 11 which
sold at auction in 1988. All were contained in passe-
partout frames, some with the Perraud logo. The
lot realized a record $57,750. (*Courtesy of Soth-
eby's.*)

Fig. 1-24.

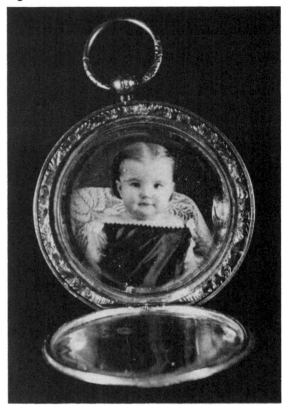

Photographic jewelry has been popular since the
beginning of the art of photography. This da-
guerreotype of a baby girl is contained in a beau-
tifully etched gold locket. Pieces of this type were
usually attached to a long velvet cord and tucked
into the mother's waistpocket. Items of this type
are valuable as both photographic and jewelry
collectibles.

Ambrotypes and Tintypes

'am bro type: Negative image produced on a glass plate, viewed as positive by the addition of a black backing. Sensitizing agent: silver nitrate; developing agent: pyrogallic acid. Invented by Frederick Scott Archer (Britain) and popularized by James Cutting (United States).

Introduced	1854
Peak years	1857–1859
Waned	1861
Last made	1865

'tin type (also called *melainotype* and *ferrotype*): Negative image produced on a thin iron plate, viewed as positive due to undercoating of black Japan varnish. Sensitizing agent: silver nitrate; developing agent: pyrogallic acid. Invented by Hamilton Smith. Patented by Peter Neff (United States).

Introduced	1856
Peak years	1860–1863
Waned	1865
Last made	1867*

* The last tintypes to be contained in cases were produced around 1867, marking the end of cased images. Tintypes were produced in various other forms until about 1930.

History of the Ambrotype and the Tintype

During the early years of paper photography, a thin sheet of paper was used as the negative (see Chapter 5). The lack of transparency and fibrous texture of these negatives led to research for an alternative material. While glass had been suggested for many years, it was not until 1851 that an English sculptor, Frederick Scott Archer, devised the best method for applying a sensitized coating to the plate. Archer suggested the use of collodion, a thick, sticky liquid which had previously been used by military physicians as a sort of liquid bandage. The collodion, when mixed with sensitizing chemicals, clung tightly to the glass and formed a light-sensitive surface. The only drawback was that the sensitivity quickly dwindled as the collodion began to dry. The plate, therefore, had to be exposed as quickly as possible after coating, suggesting the name "wet process" (see Chapter 6).

A number of photographers, including Archer, noticed that when a thin collodion negative was viewed with a black backing using reflected light, the image appeared positive. In July of 1854, Bostonian James Cutting took out three U.S. patents based on this concept. In Cutting's patented process, a thin negative was made by slightly underexposing the plate. Then a second sheet of clear glass was sealed to the image with balsa gum (this seal was supposed to protect the image from dust and scratches, but, as we will see, this process did more harm than good). After a coat of black varnish was applied to the back of the plate or to the back of the case, the finished image was placed under a mat and preserver, and then cased or framed. During the early years, daguerreotype cases were used. Then as the ambrotype become more popular, cases were made deeper to allow for the double thickness of glass.

The suggestion for the name *ambrotype* came from Cutting's associate Marcus Root, who based the name on the Greek word *ambrotos,* meaning "immortal." Since most existing ambrotypes are of persons who passed away many years ago, the name now seems very appropriate. In France and England the process was called "collodion positive," and ambrotypes were advertised as "daguerreotypes on glass," or by various trade names, such as Verrotype (used by Lanes Photographic Gallery, Brighton, England).

By 1856, ambrotypes were being made by almost every major gallery in America and by many in Europe. Cutting and his partner Isaac Rehn traveled extensively, selling licenses and promoting the process. Even though the finest examples never compared to the richness of the daguerreotype, ambrotypes were cheaper and easier to make, and, lacking the reflectivity of the daguerreotype, were easier to view.

During the peak years, 1856 and 1857, ambrotype production surpassed daguerreotype production and signaled the beginning of the end for the daguerreotype. At the same time, two other forms of photography were about to make their debut: the carte de visite (in France) and the tintype.

The major faults of the ambrotype were fragility and the necessity of using a black backing. Neither of these problems existed in the tintype process.

While experimenting with the ambrotype in 1854, Hamilton Smith, a chemistry professor at Kenyon College in Ohio, tried using blackened sheet iron instead of glass. He found the resulting images to be nearly equal in quality, more durable, and cheaper and easier to make. One of Smith's students, Peter Neff, Jr.,

Fig. 2-1. Lady in bonnet, 1/6-plate ambrotype, ca. 1858.

Not all ambrotypes were "poor-quality, cheap pictures," as was often the complaint. This beautiful dark vignette is a superb example of quality ambrotype portraiture.

Fig. 2-2. Grandmother and Mrs. Fischer; 1/2-plate ambrotype, ca. 1859.

This ambrotype on coral glass is contained in a bright white passe-partout frame and presentation box. The advertisement used as a backing indicates that the image was American-made, even though this framing style was seldom used in the United States.

struck a bargain to bankroll the invention in exchange for patent rights to the process, which they called the "melainotype". The patent was issued February 19, 1856. In the fall of that year, Neff exhibited a number of melainotypes at the Fair of the American Institute, where his work received a bronze medal. The resulting publicity aroused interest, but stringent licensing requirements hampered expansion.

As the tintype business began to grow, a competitive plate manufacturing firm was opened in Lancaster, Ohio, by Victor Griswold, a former Kenyon College student. Griswold called his product "ferrotype plates," a name which, despite early opposition, eventually won out over Neff's "melainotype."

Both Neff and Griswold were manufacturing their plates on a large scale when photography's greatest boon was created by the Civil War. Thousands of young soldiers visited the tintypist before heading into battle, and hundreds of itinerant tintypists headed their wagons for the battlegrounds. For many, the lowly tintype would provide a last cherished look at loved ones (see Chapter 11).

One of the most historic uses of the tintype took place during the 1860 presidential campaign. Some three hundred thousand campaign buttons were produced containing a tiny tintype of candidate Abraham Lincoln. The image was taken by Mathew Brady on the day of Lincoln's famous Cooper Union speech. President Lincoln would later state: "Brady and the Cooper Union made me President of the United States." Lincoln played an important part in the history of photography by being one the few (and most recognized) presidents to be photographed by every major process being used in America during his life span (daguerreotype, ambrotype, tintype, carte de visite, and albumen print).

While the carte de visite was the process of choice for big city galleries, tintypes were made on a large scale throughout the war years. Although production then waned, tintypes continued to be produced as beach and carnival novelties until after the turn of the century.

Even though a tintype process was demonstrated in France three years before the American patents were issued, it never really caught on in any European country and was always known as "the American process."

Fig. 2-3. The caballero; 1/9-plate tintype, ca. 1860.

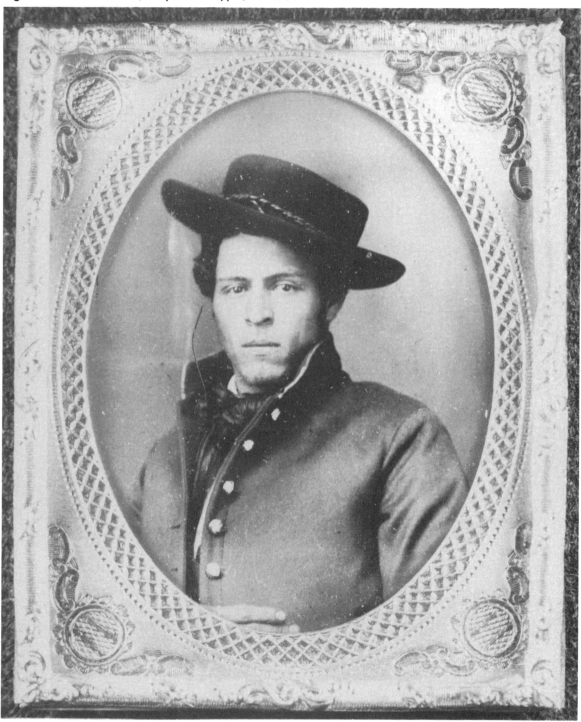

Rarely do tintype portraits exhibit the artistic qualities shown here. An early tintypist has captured the spirit of "Old Mexico" in the countenance of this bold vaquero.

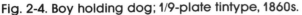
Fig. 2-4. Boy holding dog; 1/9-plate tintype, 1860s.

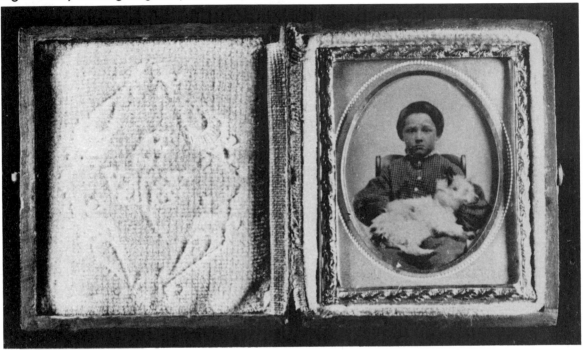

While it would not be out of line to assume that this tintype is an animal post mortem, one would rather hope that the expressions of both the boy and the dog are due to their displeasure with the process of being photographed.

The Ambrotype/Tintype Process

At the heart of both the ambrotype and the tintype processes was a substance called collodion. Some operators made their own by dissolving guncotton in alcohol and ether: others purchased their collodion, premixed, from suppliers such as a Edward Anthony in New York. Anthony advertised a variety of ambrotype supplies in 1856.

Making an ambrotype was a messy proposition, leaving sticky collodion residue to clean and silver nitrate–stained fingers. First, the glass plate had to be thoroughly cleaned to remove dirt and oils. Then the ambrotypist (or an assistant) poured a small amount of collodion onto the center of the glass and tilted the plate in all directions until the sticky liquid had spread to the edges. In a darkroom, working by the filtered light of a candle, the coated plate was immersed in a tray of silver nitrate for a few minutes and then quickly removed and placed in a shield. From this point, time was of the essence, for the plate would quickly lose its sensitivity as it began to dry. The shield was taken to the operating room and inserted into the waiting camera.

Because the ambrotype, being less sensitive than a daguerreotype, often required more than 30 seconds of exposure, the infamous head

rest was always used for indoor portraits. During pleasant weather, the ambrotypist often set up an outdoor operating room where exposure times could be reduced to as little as 5 seconds.

After exposure, the operator quickly returned the shield to the darkroom, where the still-tacky plate was set into a tray of pyrogallic acid. By candlelight, the image could be judged as correctly developed; then the plate was fixed, washed, and dried. Now the ambrotype was ready for application of color and placement in a case.

As previously mentioned, a black background was necessary to produce the appear-ance of a positive ambrotype image. During the early years, this was done by simply blackening the bottom of the case. Then it was noticed that the crispness of the blacks in the image were directly affected by the quality and smoothness of the backing. Ambrotypists experimented with a variety of backings, including metal plates coated with Japan varnish, dark velvet material, painted cardboard, and black varnish on the back of the plate. The latter method seemed to give the best results by minimizing the space between the surface emulsion (which made up the highlights) and the backing (which produced the shadows). The importance of this can easily be seen in extant

Fig. 2-5. Little girl holding bonnet; 1/6-plate ambrotype, ca. 1857.

This early ambrotype was taken outdoors, probably on an overcast day when the slow speed of this process made indoor shooting impossible. The table with books and the well-dressed little girl form a sharp contrast with the rough brick wall.

Fig. 2-6. Twin girls; 1/6-plate ambrotype, ca. 1860.

The placement of a white card behind half of this ambrotype gives the little girl on the right a "negative" twin sister, demonstrating a primary principle of the process.

ambrotypes with dirty or damaged backings (see also Chapter 4).

Two additional variations of the ambrotype were produced. The first type, produced on "coral glass" (a dark, violet-colored plate which required no backing) looked very much like its tintype cousin. The second, a "white ambrotype," was produced by carefully painting in only the shadow areas on the back of the plate. The background area of the emulsion was then scraped away, and a white backing was used, producing the effect of a photograph on milk glass (Fig. 2-7). Obviously involving a time-consuming process, white ambrotypes were rarely made.

Because ambrotypes were considerably thicker than daguerreotypes, manufacturers began producing thinner mats and deeper cases to accommodate the change. Since one of the primary attractions of the ambrotype was its low cost, case makers also began cutting back on quality standards to produce appropriately "cheap" cases.

The tintype (melainotype, ferrotype) process was identical to the ambrotype process except that tintypes used a thin iron plate painted with black Japan varnish. This plate was coated with collodion, sensitized, ex-

Fig. 2-7. Portrait of a young couple; 1/6-plate ambrotype, ca. 1858.

Fig. 2-8. Girl with dog, outdoor view; 1/9-plate tintype, ca. 1867.

One of the major complaints about the ambrotype was its lack of tonal quality. By scraping away the greyish background and using a white backing, this ambrotypist sought to improve contrast by creating a "white ambrotype."

An unusually expansive view for a small-format tintype, this image shows the difficulty of obtaining depth of field with early cameras. Only the trees near middle of the scene are in sharp focus.

During the Civil War period, tiny "gem" tintypes were produced for insertion in small albums (Fig. 2-9) or carte de visite–sized sleeves (Fig. 2-10).

posed, and developed as previously described for the ambrotype process. The image was then adorned with mat, cover-glass, preserver, and case. At the beginning of the Civil War, tintypes were sometimes placed in carte de visite–sized sleeves, which could be easily carried in a soldier's Bible and could be displayed in carte de visite albums at home.

Improvements in the wet-plate process reduced tintype exposures to under 5 seconds, and even less with the newly invented "fast" camera lenses. Multilens cameras with revolving backs produced tiny "gem" tintypes, sold

cheaply by the dozen. (The backs of tintypes in carte de visite sleeves occasionally contain the tintypist's price list. One such advertisement for Ohlwiler's in Erie, Pennsylvania, shows the price for gem tins as 6 for 50 cents or 16 for $1.) Tintype prices were lowered even more by simply giving the plate a coat of varnish and handing it to the customer without a case or sleeve.

After 1880, tintype dry plates were purchased presensitized from the manufacturer. The boardwalk tintypist would load all of the plates in the morning, then expose and develop them at his or her leisure.

Collecting Ambrotypes and Tintypes

Much of the information provided in the section in Chapter 1, "Collecting the Daguerreotype," applies to this collecting category as well, and will not be repeated here.

The collecting of ambrotypes and tintypes is primarily an offshoot of daguerreotype collecting. Because most ambrotypes and tintypes are priced considerably lower than equivalent daguerreotype images, they are an excellent choice for beginning collectors or those on a budget. (This is not to say that rare and expensive examples do not exist, as we shall see.)

What to Look For

As for daguerreotypes, when contemplating an ambrotype or tintype purchase, ask yourself the following three questions:

1. *Is the image content unusual?* By 1860, photography in its several forms was commonplace; therefore, the pool of ordinary images from this time period is large. As with the daguerreotype, anything which makes a particular ambrotype or tintype image stand out from the rest makes it more collectible.

2. *What is the condition of the piece?* The collector of ambrotypes quickly learns to tell the

Fig. 2-11. An artilleryman; 1/2-plate ambrotype, ca. 1859.

Images of American military personnel taken prior to the Civil War are quite valuable. This image is of exceptional quality and affords an excellent view of badges, buckles, and symbols necessary for identification.

Fig. 2-12. Man on horse; 1/6-plate tintype, 1860s.

While this image would be more valuable as an ambrotype, tintype views of this type are uncommon and are historically important.

difference between damage to the image emulsion and damage to the backing, which can be repaired (see Chapter 4). Both ambrotypes and tintypes are subject to cracking of the emulsion and oxidation, which sometimes forms a dark halo around the image. Damage of this type lessens the value of a piece and cannot easily be arrested or repaired.

3. *Is the price right?* Just as the consumer of the late 1850s was fooled by the advertisement for ''daguerreotypes on glass,'' many sellers

Fig. 2-13. A postmortem; 1/6-plate ambrotype, ca. 1860.

The use of a dark vignette in this image and the man's strange hair combine to create an eerie ''death portrait.'' Although it may seem macabre to us, such postmortem pictures were not uncommon during photography's early years. Postmortems are prized by collectors.

today still don't know the difference. Just because an ambrotype or tintype is contained in a brass frame and leather case, doesn't make it as valuable as a daguerreotype. Unfortunately, many of the more common images are overpriced as a direct result of this confusion. However, when purchasing better-quality pieces from knowledgeable dealers, this will not ordinarily be a problem.

Availability/Value Classifications

The Common Ambrotype or Tintype ($5 to $35)

Of the total number of ambrotype and tintype images available to the collector, approximately 90 percent are considered *common*. As

Fig. 2-14. G.L. Letts Blacksmithing; 1/4-plate ambrotype, ca. 1861.

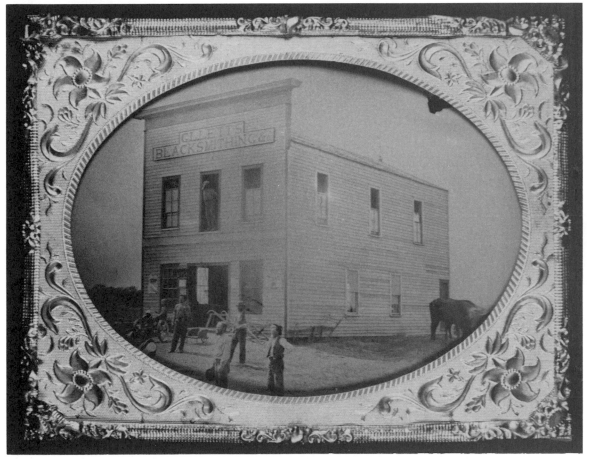

This unique ambrotype view contains two cows, seven tools or implements, and seven people looking at some unknown point of interest. Views of this type are historically valuable and are prized by collectors.

with the daguerreotype, *common* images are ordinary portraits of ordinary people. For the collector of faces, here is an endless supply: children, families, twins, the elderly, and so on. Those interested in fashion can find anything from working man's "duds" to high-society ball gowns. Plate sizes of 1/9 and 1/6 abound; 1/4 and 1/16 sizes are slightly more valuable. In all categories, ambrotypes are always more valuable than similar tintypes.

The Uncommon Ambrotype or Tintype ($50 to $100)

About 10 percent of the available base falls into the *uncommon* category, which is comprised largely of American Civil War images (see Chapter 11). Also included here are post-mortems, some occupational portraits, and tintype views.

The Rare Ambrotype/Tintype ($100 to $500)

Less than 1 percent of the available base can be considered *rare*. Most occupational portraits and images containing tools, weap-

ons, musical instruments, or animals are considered *rare* (especially ambrotypes). Ambrotype landscape views and some unusual tintype views are also *rare*. For example, a half-plate ambrotype view of a couple posed in front of Niagara Falls brought $413 at the Swann Galleries April 1989 auction.

The Premium Ambrotype or Tintype ($500 and Up)

Premium images of this type seldom become available and are usually unique views or rare portraits of notable persons.

The Future of Ambrotype Collecting

As is true for daguerreotypes, ambrotype images are now being recognized as being historically important, and prices are rapidly rising in all categories. By meeting the requirements for collectibility—rarity, aesthetics, and emotional attraction—the ambrotype and cased tintype provide wide-ranging possibilities for the collector and investor.

Image Cases

Cases were produced with a wood-frame base covered in paper, cloth, or leather, and were molded from plastic, made from a mixture of shellac and woody fibers.

Introduced	1839
Union case	1852
Peak years	1853–1860
Last made	1867

History of the Image Case

While the primary concern of this book is the collection and appreciation of photographic images, cases are discussed, too, because of the important part they played in the preservation of early images, as well as because of their historical, aesthetic, and monetary value. Even though the cased image is priced as a package, the value of the case itself is often a separate consideration in the value of the piece. This chapter provides information essential to understanding this concept.

The use of a leather case to enclose and protect photographic images was adopted in the United States and England almost immediately after the introduction of daguerreotypy in 1839. Similar cases had been previously used to hold both miniature paintings and various products of the jeweler's art. After 1840, the new daguerrean industry required more cases in one year than the *total* that manufacturers had produced since cases had first been introduced.

Early cases in both England and the United States were of a wood-frame construction, covered in plain moroccan leather, but by 1842, American cases were on their way to becoming elaborately embossed works of art. Many of these were designed by the daguerreotypists themselves. Mathew Brady, John Plumbe, and William Shew all produced cases during the early years.

By 1850, there were a number of successful case manufacturers throughout the eastern United States. It is unfortunate that most of these companies did not imprint their names on their work so that existing designs could be attributed. Because motifs were seldom patented, many popular designs were produced by more than one manufacturer. Cases were purchased, along with other supplies, from distributors like Scovills and Edward Anthony and Co.

Early wood-frame cases are recognizable by their low-relief embossing of simple designs. Both geometric and floral motifs were used beginning in 1845. In 1848, high-pressure stamping machines were introduced that produced deeply pressed patterns with a bold relief. During the 1850s, hundreds of new motifs were designed and manufactured. Geometric and floral patterns were still the most popular, with nature themes (birds, etc.) running a close second. Gilt trim, brightly colored velvet pads (early pads were covered in plain silk), and "superior quality" cases (as indicated by double clasps) were available to the customer at additional cost.

The introduction of the ambrotype and tintype in the late 1850s signaled a drastic change in case making. Cheap cases were required for these "cheap pictures," and price reduction was achieved through a reduction in quality. Those stalwarts who continued to prefer the "high-priced" daguerreotype, or those who just preferred a better case, opted for the plastic Union case.

Various patents were issued for the use of plastic in the production of daguerreotype cases: to Samuel Peck on October 3, 1854; H. Halverson on August 7, 1855; Mark Tomlinson on August 24, 1858; and others. Credit is usually given to Samuel Peck as having been the first to produce and market a perfected thermoplastic case, which he called the "union case." The substance used, primarily a compound of sawdust and shellac (varnish), had been patented (in form) by Nelson Goodyear in 1851 as an improvement in the production of India rubber. The word *union* was used by Peck as a synonym for the word *composition*

Fig. 3-1.

John Plumbe supplied large numbers of cases to daguerreotypists during the 1840s, many of which contain his imprint in the image compartment.

in his patent, and thereafter became his trade name for this type of case. Since the name was never registered, it was used freely by many other manufacturers.

While the Union case has been (and still is) often referred to as the "gutta-purcha" case, it is important to note that no gutta-purcha was ever used in the production of photographic cases. This plastic substance, made from the sap of certain Malaysian trees, was used to make small boxes, frames, buttons, and cane heads during the 1850s. However, items made from gutta-purcha quickly discolored and became brittle. For this reason, very few of these pieces have survived to the present day. Those who still use the term in reference to thermoplastic cases are uninformed.

Thousands of beautiful designs were conceived and manufactured in plastic from the late 1850s through the Civil War period. A

Fig. 3-2.

Cases produced during the mid-1840s usually had very flat embossings. The case shown here displays one of the most common designs of this period, called "The Delicate Roses." The design is attributed to David Pretlove.

Fig. 3-3.

During the early 1850s a number of case manufacturers were experimenting with plastic. The example pictured is a transitional case with a molded plastic motif attached to a standard wood-frame base. Transitional cases are rare and are prized by collectors.

number of improvements to the hinging system of the Union case were implemented as well. By the end of the war, cased images were quickly becoming supplanted by card photographs, and case manufacturers soon began producing new and different plastic products.

Throughout the period of the union case, production of the older style wood-frame case continued as well. Coverings during the late 1850s and early 1860s were usually cardboard or papier-mâché, and rarely leather. When demand for cases sharply decreased after the Civil War, case manufacturers turned their efforts to the production of jewelry cases and albums for the then-popular card photographs.

The Manufacture of Image Cases

In the production of the wood-frame case, names were given to the various parts of the housing. The individual pine boards which made up the basic frame were called "rails"; a thin strip of leather which acted as a hinge was called the "outside back" (a smaller piece on

Fig. 3-4.

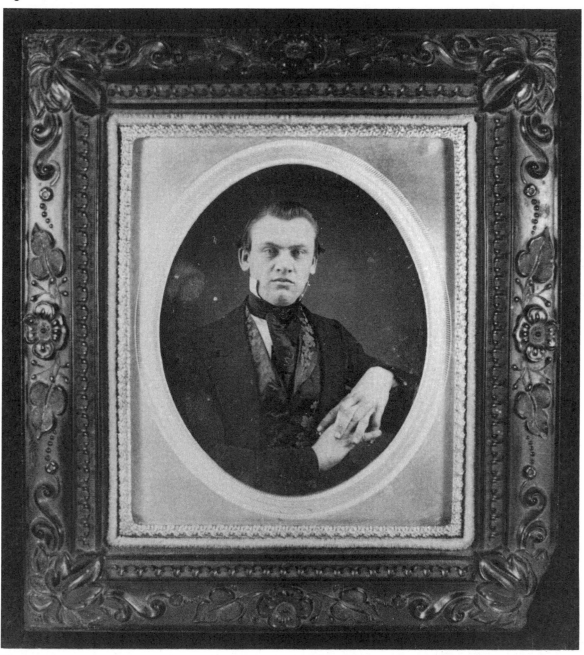

The same thermoplastic process used in the production of cases was also used to produce frames such as the one shown here. These early plastic frames are uncommon and are sought after by collectors.

the inside was called the "inside back"); the embossed leather, silk, or paper "toppings" were glued to thin sheets of wood called the "cover" and the "bottom"; a velvet pad placed inside the cover was called the "cover pad"; and the small strip of velvet lining the bottom rails (designed to hold the image in place) was called the "pinch pad." These last two items were also called "trimmings." Holding the case shut were either a hook and eye or a spring latch.

In the case factory, young boys and girls were hired to perform the various operations of construction: sawing, gluing, cutting, and pressing. Artists designed the various topping motifs, and engravers transferred the artwork

Fig. 3-5.

Some gallery operators paid to have their imprints embossed on the velvet cover pad, as did Samuel Van Loan and T. J. Ennis for their Philadelphia gallery.

Fig. 3-6.

Among the most prized wood-frame cases are those with mother-of-pearl inlays. A cardboard base was coated with black Japan varnish, inlaid with mother-of-pearl chips, and then painted with an appropriate pattern, as shown here. This type of case was first produced in the mid-1850s.

Figs. 3-7 and 3-8.

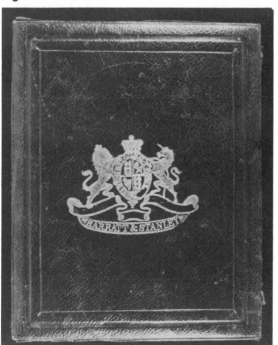

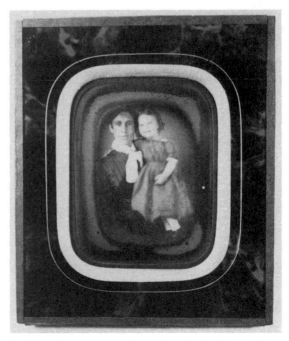

The British received their finished daguerreotypes in a plain leather case embossed with the Royal Seal (Fig. 3-7) or in the passe-partout frame (Fig. 3-8) preferred by most people in other European countries.

to dies for the press. These designers seldom received credit for their excellent work. Occasionally, one would incorporate his or her name into a tiny corner or edge of the engraving. The names of David Pretlove, A.C. Paquet, C. Loeke, and the firm of Gaskill and Copper can be found on selected cases. Ideas for motifs came from Greek, Roman, and Egyptian artwork, and from various paintings. Nature, religious, and patriotic themes were also used.

During the peak of case production in the 1850s, a number of particular case styles were created. Cases shaped to resemble tiny books were covered in paper and painted to simulate tortoiseshell, marble, woodgrain, etc. Some of the most beautiful book-style cases were coated with black Japan varnish and inlaid with chips

of mother-of-pearl, which were incorporated into paintings of flowers or scenes (Fig. 3-6). A few rare cases were covered entirely with sheets of tortoiseshell, mother-of-pearl, or, more commonly, velvet (see Fig. 3-15).

In England, the conservative Britons preferred a plain and elegant case of moroccan leather. Usually these were stamped with the Royal Seal and occasionally with the photographer's name (Fig. 3-7). Although a few more elaborate cases were purchased from American makers, this plain case would remain in use for daguerreotypes until the end of their production in England in the late 1850s.

Both the English and French also favored the passe-partout style of frame mentioned in Chapter 1. In the production of passe-partout frames an oval or double-elliptical opening was

Figs. 3-9 and 3-10.

The Union case was produced entirely from molded plastic, with metal hinges and clasps. Even common geometric deisgns (Fig. 3-9) are very collectible. Octagonal and oval cases (Fig. 3-10) are prized by collectors.

Figs. 3-11 and 3-12.

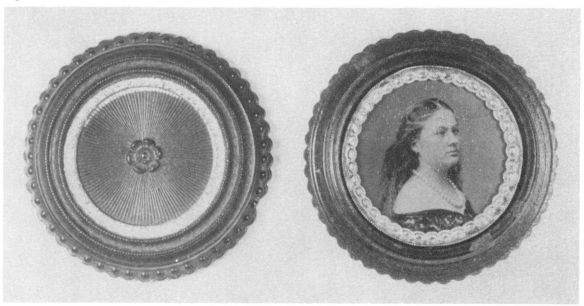

These round sweetheart cases were produced from thermoplastic during the waning years of Union case production. The case in Fig. 3-11, called the "Golden Ring," was produced in green plastic. The case in Fig. 3-12 presents a good example for why this case style is given the nickname "Oreo case" by collectors.

Fig. 3-13.

During the Civil War period, American case manufacturers turned out a number of patriotic designs in both plastic and wood-frame styles. The case shown here had the American flag embossed in gold. Although these cases were produced in large quantities, they have quickly been snatched up by collectors and are now in demand.

cut into a sheet of cardboard. The edge of the opening was pressed to give it a curved bias which was usually painted in gilt. The cover-glass was then painted on the inside, allowing only the trimmed opening of the cardboard mat to show. For such a basic process, the effect was quite impressive (Fig. 3-8).

The introduction of plastic Union cases in 1854 provided engravers with a superb new medium for their art. Thermoplastic molds were capable of producing high-relief patterns with sharp lines and extreme detail. Cases could now be formed into oval and octagonal shapes (Fig. 3-10), as well as into the classic rectangle. While plastic cases were subject to chipping, the designs were less likely to wear down than those in leather or other materials and the surface was moisture-resistant.

Considerably fewer steps were required in the production of a Union case, and therefore fewer workers were needed. Finely pulverized sawdust was mixed with shellac and color, then run between hot rollers to form a thick paste. Measured quantities of this composition were then subjected to the pressure of steam-heated dies to form the case cover and bottom separately. After cooling, the pieces were removed from the dies and any necessary cutting and polishing was performed. Hinges and clasps were attached, and the inclusion of interior trimmings completed the construction.

One interesting variation of the plastic case came along in the mid-1860s, as case production was declining. Called the "sweetheart" case, it consisted of two interlocking disks. The bottom half was designed to contain a small round tintype, and the top half was a cover which attached by either screw threads or friction. Many of these cases have an uncanny resemblance to a particular brand of cookie, inspiring the modern nickname "Oreo case."

During the Civil War, American manufacturers were turning out both wood-frame and plastic cases in large quantities, many embossed with patriotic themes incorporating flags, shields, eagles, cannons, swords, guns, and Lady Liberty. But as the war ended, so did the demand for image cases. Factories quickly retooled for other products, and the era of the cased image came to an end.

Collecting Wood-Frame and Plastic Cases

Since the time of their production, the beautiful cases that were made to contain and protect images have been admired and collected. Unfortunately, over the years this has been at a great cost to image collectors, as many who collected the case had little respect for the "old photo" found inside. Hundreds of images were lost as cases were converted to hold cigarettes, jewelry, hairpins, etc.

In recent years, there has been an increased awareness that in order to preserve the quality of these pieces as historical artifacts, all elements of the cased image must be kept original. Still, the case itself, as an *objet d'art,* has a separately determined value which can add considerably to the overall worth of a particular cased image. As is true for all nineteenth-century works of art, this separate value is based on a number of factors: identification of the artist/manufacturer, quantity produced, condition, and demand. Prices of collectible cases have risen steadily over the past decade, with the largest increase occurring in recent years.

Fig. 3-14.

The most collectible wood-frame and leather cases are those embossed with scenes from art or mythology. This motif is called "The Three Graces."

Fig. 3-15.

The advent of the Union case prompted wood-frame case manufacturers to come up with more attractive and unusual coverings. This case, appropriately called "The Golden Shield," is faced in brown velvet and has a brass shield in the center.

Availability/Value Classifications

The Common Case ($5 to $30, Plus Image)

About 75 percent of existing cases are *common* wood-frame cases with simple embossed patterns of a floral or geometric design. Most of these add $5 to $10 to the value of an image, but their primary worth is to protect the image and maintain the originality of the piece. As with images, common cases in the 1/4-, 1/2-, and 1/16-plate sizes are slightly more valuable than cases in other sizes. Early daguerreotype images were contained in plain leather cases, which (when present) can help to confirm an image's age, and therefore add considerably to its value.

The Uncommon Case ($30 to $100)

The *uncommon* category encompasses approximately 20 percent of the available market. Included are wood-frame cases with unusual coverings (painted, inlaid, etc.) and both the basic and somewhat scarce variations of Union cases.

Almost any plastic case (geometric motif) is worth $30 to $50 when in good condition.

Fig. 3-16.

Union cases with embossed scenes and motifs, such as the uncommon agricultural motif shown here, are prized by collectors. Most were produced in limited quantity, and many are quite rare.

Oval and octagonal cases are prized by collectors, and even common motifs almost always bring $50 to $75. The little round sweetheart cases commonly sell for $50 to $80, when complete and without damage. Larger-sized Union cases (1/4, 1/2, and full plate) are *uncommon*.

One-sixth plate Union cases with fruit or flower motifs are worth $50 to $75. Cases which have gilt inlays and impressions, other than trimwork, are *uncommon,* as are those covered in silk or velvet. Wood-frame cases with motifs depicting people and/or animals (not birds) can be quite valuable ($50 to $75).

The Rare Case ($100 to $500)

Examples in the rare category make up less than 5 percent of the collectible base. Collectors interested in *rare* cases should obtain the two current authoritative books (see Bibliography) and familiarize themselves with hard-to-find motifs.

Generally, wood-frame cases with unusual coverings or artistic motifs based on paintings, etc., are *rare* (a case completely covered in mother-of-pearl, with a mother-of-pearl cameo in the center, sold at the Swann Galleries 1989 sale for $358). A variety of Union

Fig. 3-17.

The most valuable Union cases are those based on works of art, such as "The Faithful Hound," shown here as a double sixth-plate case.

cases with art motifs were produced in limited quantities and are also considered rare.

The Premium Case ($500 to $2,000)

Very few cases in the *premium* category ever become available. Nearly all are Union cases, and most are 1/2-plate or full-plate size.

Case Condition and Care

To command top price, a case must be in near-mint condition. Wood-frame cases generally display some degree of wear on the embossed designs and are highly susceptible to tearing of the spine. Union cases are seldom found without tiny chips or cracks; however, obvious faults reduce the value considerably.

Both types of cases should be stored out of the light and away from heat. They can be cleaned and protected with a gently applied coat of beeswax-based polish. It is highly recommended that all Union cases be wrapped in soft cloth or acid-free paper for protection against chipping.

Fig. 3-18.

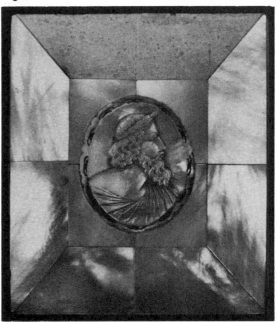

Because the cameo centers of these mother-of-pearl cases were carved by hand, they are all one of a kind. Cases with unique coverings such as this are rare; broken or missing pieces can detract from the value.

Documentation and Restoration of Cased Images

Because of the numerous elements which make up a cased image, and because of the various factors involved in the production of cased images, careful examination is necessary both before and after purchase. Often this examination can reveal variations which, once known, can add considerably to the value of the piece.

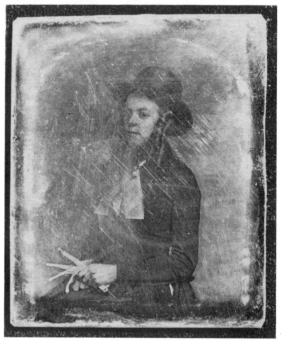

Fig. 4-1. Girl in riding outfit; 1/6-plate daguerreotype, ca. 1853, Christofle "scale" plate.

All cased images are fragile and the image surface should never be contacted in any way. This daguerreotype was virtually destroyed by an attempted cleaning. Invisible to the naked eye, the image was brought back to life in this copy through a special photographic process.

Before the Purchase

The first step in examining a prospective purchase is to determine the type of process that was used to create the image. This may sound simple, but as we shall see, it is not always easy to do. Many sellers have no idea what they are selling. An item may be labeled incorrectly or else given a general description such as "old photo." Daguerreotypes should be obvious unless the image is badly tarnished. Even then, some evidence of the silver plate will usually show through. Distinguishing between an ambrotype and a tintype, however, can sometimes be quite difficult.

If the seller will allow removal of the plate packet, the back of the metal or glass plate makes identification simple. However, when removing the image from the case is not allowed, a careful examination under bright light will reveal some "clues." In most ambrotypes, the collodion image is on the top of the plate and the black backing is on the bottom. When viewed at a certain angle, the separation between the highlights of the image on the surface and the shadows beneath is evident. Because they lack this separation, ambrotypes on coral glass are very difficult to recognize without removal from the case.

Generally, the overall appearance of a tin-

type is somewhat lackluster compared to the appearance of an ambrotype. With experience, the collector soon develops the ability to recognize an image type almost on sight.

Ambrotypes and tintypes should be examined for cracked and flaking emulsion, as these ailments are irreversible and detract considerably from the value. Scratches and rub marks on a daguerreotype usually indicate that the image has been removed from its case and the seal, if there was one, is broken. A halo of tarnish is not uncommon on daguerreotype images and can actually add to the character of the piece. However, extensive tarnish, stains, oxides (white film), or salting (green flecks) can detract from the value of an image and will

Fig. 4-2. Five men in a buggy; 1/6-plate ambrotype, ca. 1860.

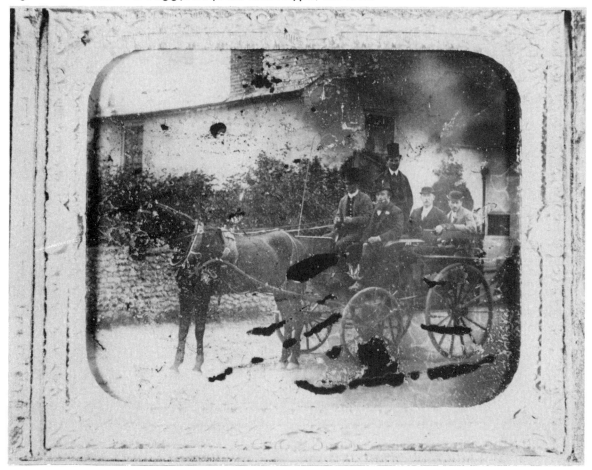

In order to eliminate the separation between the highlights on the surface of the plate and the shadows created by the black backing below, the ambrotypist who produced this image applied black varnish directly to the emulsion surface of this rare outdoor view. Over the years the varnish has begun to peel away, taking portions of the picture with it. Damage of this type is irreversible.

probably worsen with age. Daguerreotype images which show no evidence of tarnish have either been cleaned or else they are modern images. Cleaned images are less valuable because of the uncertainties involved in the cleaning process (see "Restoration," presented later in this chapter). Modern fakes usually appear as *rare* or *premium* category images selling at bargain prices.

Brass mats should be examined for name imprints indicating the photographer or gallery. Carefully go over the exterior of the case for tiny imprints of designer names. If possible, remove the image packet and look for imprinted or written information on the back of the plate and in the bottom of the case.

After the Purchase

Nearly every cased image in existence has survived for over 100 years. Through careless handling, you can destroy one in seconds!

Throughout the examination and documentation process, never allow anything to contact the image surface. Handle the plate with clean

Fig. 4-3. Elements of a cased image

(from left to right): the case, the plate, the mat, the cover-glass, and the preserver. The last four elements make up the image packet. (*Art by David White.*)

Fig. 4-4. Tapping out the packet.

The simplest way to remove the image packet is to tap the case against the thumb and fingers of a cupped hand. Great care must be taken not to damage the case spine.

hands (white cotton photo gloves are even better), and only by the edges. Stay away from moisture of any kind. Work on a large, flat surface covered with a clean, soft cloth.

Two different methods can be used to remove an image packet from its case. One is to gently tap the case against your cupped hand so that the image packet falls out into your palm (this requires practice). The other is to pry out the packet carefully with a thin-bladed table knife (a dental pick also works well), taking care not to damage the pinch pad. Regardless of which method is used, be careful not to damage the case spine (if extant) and, if the packet is not held together by a preserver, be prepared for the possibility that the elements are simply lying loose in the case. If so, the mat could scratch the plate during the removal process.

Documenting the Image

Begin your documentation by writing down a general description of the piece. Include the case design and motif, mat shape, preserver style, and any imprints you may find. If the image is a daguerreotype, make note of whether the plate has been galvanized (silver on back)

or gilded (gold tone), and also note whether the seal is intact. If the original seal still holds the plate to its cover-glass, stop here. Make sure you have written down all pertinent information and return the packet to its case. If no seal is evident, or if the existing seal is completely broken, the packet may be separated for further documentation.

Preservers must be unfolded so that the flaps are at a right angle to the back of the plate. (If they are pushed back without un-folding, the preserver may break at the corners). Once this has been done the plate can be lifted straight up and away from the mat, taking care not to scrape or touch the image surface.

Examine the front of the plate near the edges for a plate mark. Also make note of any bends, indicating the use of a plate holder (flat, heavy daguerreotype plates date from the early years of the process).

Earliest tintype plates are embossed with

Fig. 4-5.

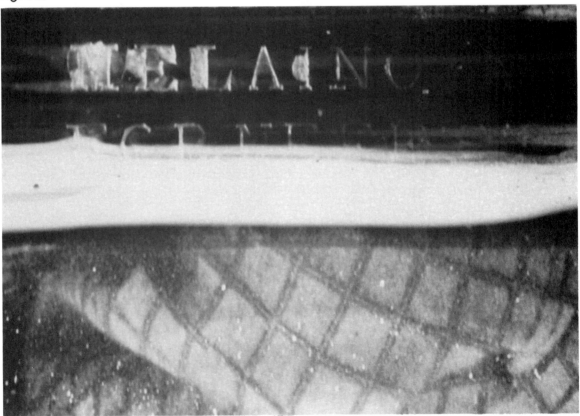

Earliest tintype plates are embossed "Melainotype Plate for Neff's Patent 19Feb1856" (shown) or "Griswold's Patented Oct 26, 1856."

either of the two rival plate makers' names and a patent date:

-MELAINOTYPE PLATE FOR NEFF'S PROCESS Pat19Feb56-

or

-GRISWOLD'S PATENTED OCT.26,1856-

Also make note of whether the tintype has been given a coat of varnish. Most tintypes taken for placement in a case were not varnished.

When examining ambrotypes, make note of the type of glass used and the method of viewing (from above or through the plate). If the ambrotype plate appears to be stuck to either the cover-glass or the backing, *do not pull it loose!* To do so may damage the emulsion and destroy the image.

Restoration

Before reassembling the image packet, remove the mat and glass for a simple cleaning. Rinse the mat with denatured alcohol and carefully wipe it with a soft cloth. Wash the cover-glass with nondetergent soap and hot water, then rinse well, first with hot water, then with alcohol. Make sure both pieces are thoroughly dry before returning them to the packet. (*Note:* To achieve maximum archival protection, the old cover-glass should be replaced with modern glass and the plate and mat sealed to it with acid-free archival type. Early glass contains chemicals which contribute to plate tarnish.) The packet can now be reassembled and the preserver flaps carefully refolded.

You will be amazed at the difference a clean cover glass can make in the appearance of a cased image. For the most part, this should be the only restoration performed by nonprofessionals.

Tintype and ambrotype images cannot be cleaned. Excessive surface dust can be removed with a gentle blast of canned air, but even this procedure can tear away loose emulsion.

Several years ago, photograph restorationists were using a chemical method involv-

ing a solution of thiourea to remove excessive tarnish from daguerreotypes. In recent years it has become evident that they were doing permanent harm to the physical structure of the daguerreotype itself. Therefore, *the cleaning of daguerreotypes by any known method is not recommended.* Excessively tarnished daguerreotypes which are proven to be of historical value should be referred to the experts at the Library of Congress, Smithsonian Institution, or George Eastman House for recommendations. Some dealers renew (clean) all common daguerreotypes as a matter of practice, believing that images on clean, shiny silver plates are more attractive to the buyer. In most cases the plates are cleaned with common commercial silver dip. Daguerreotypes renewed in this manner are subject to rapid and intense retarnishing, making additional renewal necessary. Such continuous chemical baths will eventually destroy an image. Even one chemical bath does irreparable damage to the physical structure of the daguerreotype. Collectors should avoid "renewed" examples and discourage the use of chemical cleaners.

Ambrotypes often appear to be badly damaged when the black backing is dirty or

Fig. 4-6. The captain and his ladies; 1/6-plate tintype, ca. 1858.

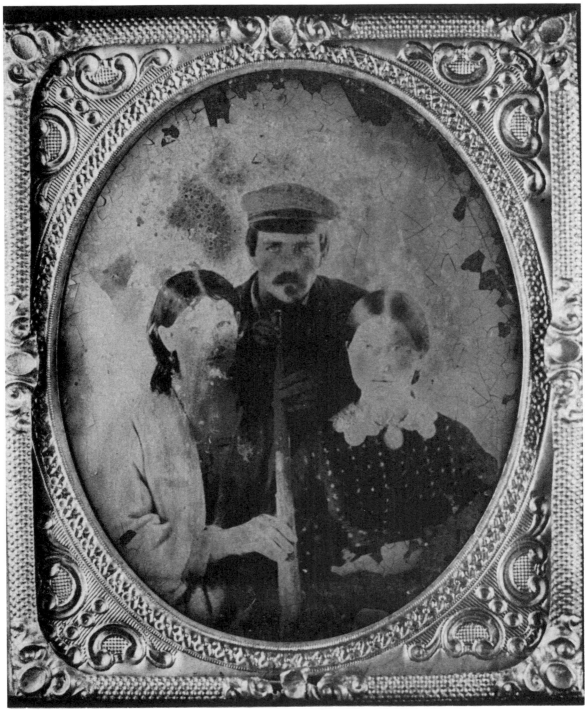

Deterioration of the type shown here is common on early tintype images. Due to poor adhesion of the Japan varnish, the emulsion is flaking off. Damage of this type is irreversible.

flaking. This backing can be replaced with a piece of totally exposed, gloss finish, black-and-white photographic paper. This replacement will provide rich blacks in the image, and the paper is acid-free. If you decide to scrape away the old black varnish from an ambrotype plate, first make sure that the image is on the opposite side of the plate, and not under the varnish. Then use extreme care not to damage the image side during the process.

Case Repair

A broken case spine can be replaced with a strip of appropriately colored construction paper, carefully glued in place. Given a coat of wax-type shoe polish, the new spine looks much like the original, and it protects the case and the image from further damage.

While it may be tempting to "beautify" an image by trading mats or cases, remember that it is important to keep all elements of a cased image original. Case, plate, mat, and preserver all play an important role in authenticating and dating an image.

Dating the Cased Image

Of all the factors used in dating an image, the case itself is the least accurate. While specific designs can be traced to certain years, many people, from the original owners to present-day dealers, may have attempted to improve the look (and salability) of an image by putting it in a better case. The case may be used, however, to *substantiate* a date arrived at by more reliable means. The image and the plate on which it rests are the best sources for dating information.

While not everyone was a slave to fashion in the nineteenth century, it is a fact that clothing styles changed from year to year, and sooner or later everyone had to buy new clothes. Consequently, sitters' styles of clothing, along with

hairstyles and beards, are the best source for estimating the dates of images. Unfortunately, the accuracy of this dating method depends greatly on a thorough knowledge of nineteenth-century fashion. The books recommended in the Bibliography should be very helpful in this area.

Hallmarks

Approximately 60 percent of existing daguerreotype plates are stamped with a hallmark. The others are "self-cut" plates, trimmed from larger plates by the operator. By studying hallmarks on daguerreotypes with documented dates, and by researching the history of plate manufacturers, historians have developed approximate dates of use for many of these symbols (see Appendix B). This provides the collector with a means of determining a "not-before" production date. For example, an image on a plate containing a Scovills "Extra" hallmark could not have been taken before 1850, which was the first year that hallmark was used.

Also used as an aid in dating are the "configurations," that is, the marks left on the plate by various tools and devices used in the process. Plate holders requiring bends were not in general use before 1849. However, beveling of plate edges was common as early as 1845. Plier marks are a less reliable source, since other devices were also used to hold the plate; however, heavy plates without plier marks may date from the early years of daguerreotypy (1839 to 1843).

Ambrotype plates bear no dating marks; however, the Cutting Patent method, requiring that a second plate of glass be sealed to the image, was generally discontinued after 1857. Also, the use of coral glass began about the same time. Early tintype plates are thick and heavy, and usually bear the imprint of the manufacturer. Chocolate-colored tintype plates were

produced after 1870, and tiny gem plates were not made in quantity before 1863.

Mat Shapes and Textures

The decorative mats which were placed between the plate and the glass were usually made of brass, although other materials were occasionally used. If the original seal is still intact, or if the shape of the tarnish/oxide pattern matches the shape of the mat, it can be assumed to be original. Because the tex-

Fig. 4-7. Charolette Rust, in mourning; 1/6-plate daguerreotype, ca. 1845, Scovills plate.

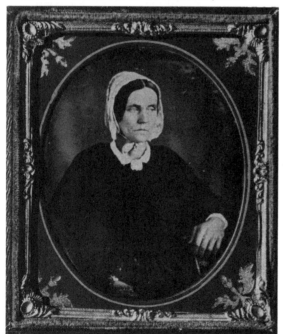

The somber pose and black paper mat suggests that this image is a "mourning portrait." Historians disagree about the purpose of such photographs. Such a portrait may have been sent to a bereaved family when the sitter could not be with the family in person. (*Note:* The preserver on this image was added at a later date.)

tures and shapes changed over the years, original mats are a good source for determining an approximate image date without extensive research.

A Catalog of Mat Shapes

The two mat shapes in Figs. 4-8 and 4-9 were very popular throughout the 1840s but were seldom used after 1850. Early versions have a pebble finish; later examples are "sandy." A few matte-finish examples were produced during the early 1850s, but these are uncomon.

Oval mats (Fig. 4-10) were produced throughout the era of the cased image, while acorn-shaped mats (Fig. 4-11) with a sandy finish were produced in limited quantities during

Fig. 4-8.

Octagonal mat.

Fig. 4-9.

Elliptical mat.

Fig. 4-10.

Oval mat.

Fig. 4-11.

Acorn mat.

the mid-to-late 1840s. Oval mats can be found in a variety of finishes and with various stamped or embossed ornamentations.

The two unusual mat shapes in Figs. 4-12 and 4-13 were produced during the late 1840s and were in use until about 1851. Early examples have a sandy finish; later examples are matte.

Production of the two shapes in Figs. 4-14 and 4-15 was begun in the mid-1840s. A sandy or matte finish was used until 1850, after which mats were produced exclusively in matte, often with stamped or engraved ornamentation. These were the two most popular shapes from the mid-1850s and were embossed with ornate designs from the late 1850s on. One variation of the double-elliptic mat dating from the early 1850s was quite heavy and was stamped with a crosshatch design near the opening.

Fig. 4-12.

Bell mat.

Fig. 4-14.

Double-elliptical mat.

Fig. 4-13.

Scallop mat.

Fig. 4-15.

Nonpareil mat.

The Changing Face of Brass Mats

As daguerreotypy became more popular and as other forms of photography were introduced, the manufacturers of brass mats became concerned with producing more attractive pieces. A variety of new shapes were introduced, and the surface of the metal itself underwent several transformations. These design changes play an important part in dating an image.

Early brass mats were comparatively thick and heavy, with a rough pebble texture. By the late 1840s mats were somewhat thinner, with more of a sandy finish. Around 1850, the sandy finish gave way to a matte finish, and occasionally a fancy decorative pattern was stamped into the surface.

With the introduction of the ambrotype in the mid-1850s, mats were made (necessarily) thinner and were almost always embossed with ornate patterns. This design would remain mostly unchanged until the end of cased image production.

Fig. 4-16.

Brass mat with pebble finish, popular from the early 1840s to the mid-1840s.

Fig. 4-17.

Brass mat with sandy finish, popular from the late 1840s to the early 1850s.

Fig. 4-18.

Brass mat with matte finish, popular in the early 1850s (shown here with acid-etched ornamentation).

Fig. 4-19.

Brass mat with stamped pattern, popular in the mid-1850s.

Fig. 4-20.

Lightweight embossed brass mat, popular from the late 1850s to the early 1860s.

Fig. 4-21.

Brass mat with patented design by H. W. Hayden, 1855.

Fig. 4-22.

Made of heavy metal, narrow in width, this style of preserver was the earliest design, dating from the late 1840s.

Fig. 4-23.

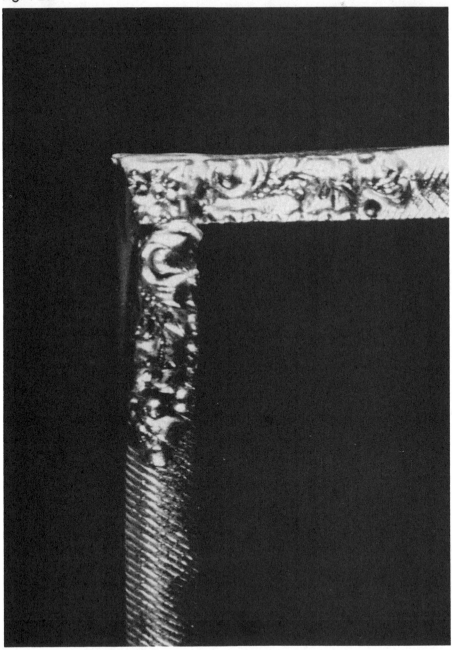

During the early 1850s, preservers were still straight and narrow, but were becoming more ornate.

Fig. 4-24.

From the late 1850s through the 1860s, preservers were very lightweight and ornate.

Preservers

Preservers were not in general use before 1847. Early versions were stiff and heavy and liable to break at the corners. After 1850, the metal of the preservers was more pliable and the color more "brassy" (less golden) than in first examples. Until the late 1850s, preservers were straight, narrow frames, embossed with simple patterns (rope, stars, daisies, etc.). With the introduction of ornate mats, a fancy light-weight preserver was also made available, with inward "points" at the corners and centers of the rectangle (Fig. 4-24).

Dating Based on Combined Elements

It is the combination of all the elements of a cased image which provides a collector with the information needed to determine an approximate date of production. While no single item can be considered totally accurate, if all of the elements point to the same date you can be reasonably certain of your dating conclusion.

Photographing Your Collection

The cased image, regardless of its monetary value, is a historical artifact and should be documented for posterity. Because cased images are one of a kind, they cannot be replaced. For this reason, it is highly recommended that you make a photographic copy of each image in your collection. This is best accomplished during your initial examination, while the image is separate from its case. The plate should be photographed without the cover-glass and mat whenever possible.

The illustrations for this book were mostly taken with a Hasselblad $2\frac{1}{4}''$ format camera; however, any good-quality 35-mm camera is sufficient for documentation. Larger formats may produce images of higher quality, but such cameras are bulky, hard to focus, and slow to use. Automatic exposure cameras work well, but they should be equipped with an exposure compensation system which allows for bracketing. You should take an initial reading from a gray card, then bracket your exposures one stop over and under.

Fig. 4-25. Portrait of a gentleman; 1/6-plate daguerreotype, 1850s.

Because daguerreotypes are one-of-a-kind images, duplicates could only be had by rephotographing the original. This image is a copy of a European daguerreotype in a passe-partout frame.

Fig. 4-26. Ceramic photograph; 1/9-plate, 1860s.

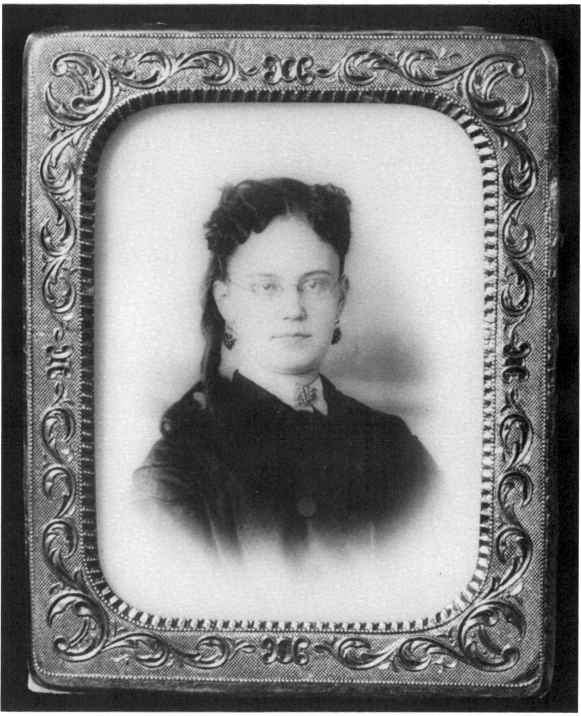

This image was produced by stripping a collodion-based emulsion, applying it to a piece of milk glass, and then sealing it with a ceramic glaze. This rare process produced a beautiful cased image variant.

Photographing daguerreotypes, like viewing them, requires some adjustment of angle and reflection. A ''shield'' must be constructed which surrounds the lens and hides all reflections from above the image. A sheet of cardboard covered with black velvet is perfect for the job. Daguerreotypes also require strong lighting for proper reproduction. A polarizing filter is also helpful. Regardless of the light source, work quickly and do not allow the plate to become heated. Return the image to the protection of its case as soon as possible.

PART 2

PHOTOGRAPHY ON PAPER 1839–1900

Calotypes

'cal o type: A positive photographic image produced on salted paper from a negative produced in the same manner. Sensitizing agent: silver nitrate; developing agent: pyrogallic acid. Invented by W. H. Fox Talbot (Britain)

Introduced	1841
Peak years	1852–1857
Waned	1859
Last made	1862

History of the Calotype

When news of the daguerreotype first reached England in January of 1839, it came as quite a shock to a British scientist named William Henry Fox Talbot. Since the fall of 1833, Talbot had been experimenting with a process using the camera obscura and chemically treated paper, hoping to "cause these natural images to imprint themselves durably, and remain fixed upon the paper."

His early experimental images, called "photogenic drawings," were actually simple contact negatives made by placing a thin object (lace, leaves, etc.) on the surface of sensitized paper and exposing it to sunlight. By 1835 he had taken pictures of his home using a tiny "mousetrap" camera (Fig. 5-1) and had succeeded in fixing the images with a sodium chloride bath. Shortly thereafter, Talbot put aside his experiments for other scientific research and writings, unaware that in France, Daguerre was only four short years from announcing his discovery.

Although the two processes were decidedly different, Talbot, upon hearing of Daguerre's announcement, rushed to London's Royal Institute with samples of his work, determined to claim anteriority over Daguerre's invention. While Talbot's early achievements could not be denied, the resulting images "paled in comparison to" those of Daguerre, an aspersion which angered Talbot and spurred him to search for improvements to the process.

In September of 1840, Talbot discovered an important principle of photography that had been paramount in Daguerre's invention: hidden on the exposed negative was an unseen image. In the calotype process, this latent image could be brought out by development in a gallo-nitrate solution. This discovery shortened exposure times considerably, since pre-viously the sensitized paper had been exposed until it darkened and the image became visible. By this time, Talbot had also discovered that a "re-reversed" or positive image could be made simply by contact-printing the negative onto a second sheet of sensitized paper.

Both Talbot and Daguerre profited from the efforts of Sir John Herschel, who discovered the arresting action of hyposulfate of soda ("hypo"). This hypo fixing bath is still used

Fig. 5-1. Talbot's "mousetrap camera."

Talbot used a number of these tiny cameras to produce talbotypes of his home several years before he and Daguerre announced their respective processes. (*Art by David White.*)

Fig. 5-2. "The Fruit Sellers," by William Henry Fox Talbot.

It might be assumed that calotypes by the inventor of the process are extremely rare, but this is not always the case. Most major sales of nineteenth-century photographs offer one or two examples by Talbot. This one sold at a 1988 London auction for £3,800 ($6,000), while others have sold for as little as $600 each. (*Courtesy of Christie's South Kensington.*)

in modern processes and was an important factor in assuring the permanence of early images. Herschel also coined the term *photography* and suggested the use of the words *positive* and *negative*.

By 1841, sufficient improvements had been achieved to make Talbot's process commer-

cially appealing and prompt him to secure a patent on February 8 of that year. Unfortunately, the heavy restrictions imposed by this patent, along with continuing unfavorable comparisons to the daguerreotype, severely hampered the spread of calotypy. Similar restrictions imposed by an American patent,

granted in 1847, destroyed any chance of the process becoming competitive with the daguerreotype in the United States.

Because of its lengthy exposure times and grainy image, in early years the calotype process was used primarily for outdoor views. Talbot himself traveled extensively throughout Europe, taking calotypes of architectural and scenic views to promote the sale of calotype licenses. While never widely accepted for portraiture, the process was not without its advocates. The first calotype portrait studio was opened on Somerset Street in London by Henry Collen in August of 1841. Because exposure times ranged from a few seconds in the summer sun to as long as 60 seconds in the winter, extensive hand-retouching was employed to provide clients with the best possible likeness. Collen, a former painter, produced excellent ''improved'' calotype portraits.

In 1844, French daguerreotypist Antoine Claudet struck a bargain with Talbot which would allow him to provide clients at his London studio with a choice of either daguerreotype or calotype portraits. In Scotland, the team of David Hill and Robert Adamson produced some of the most memorable portraits taken by this process. From classic portraits of staunch professors and clergymen to superb studies of common village characters, the calotypes of Hill and Adamson are to Great Britain what the daguerreotypes of Southworth and Hawes are to America.

Today, many calotypes are found in travelogue-type albums or tipped in to printed pages of books. Talbot himself oversaw the production of thousands of images to illustrate his six-part volume entitled *The Pencil of Nature* (1844 to 1846). Later his printers would produce some six to seven thousand images for insertion in the *Art Union,* a periodical. It is probably due to the lack of quality control during these large-scale projects that many of these calotypes are now extremely faded.

Fig. 5-3. Portrait of James Linton, by Hill and Adamson.

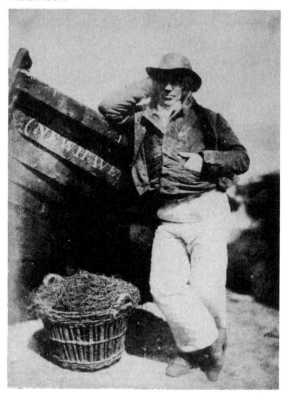

David Octavius Hill and Robert Adamson were two of the earliest and most prolific practitioners of the calotype process, photographing a wide variety of subjects. This example brought £450 ($700) at a 1988 London auction. (*Courtesy of Christie's South Kensington.*)

The problem of calotype fading was obvious from the very beginning. Great care was required in the washing stage of the process to achieve any degree of permanence. While Talbot seems to have been quite lax in this area, Hill and Adamson, as well as many French calotypists, took great pains to assure image stability.

In 1844, Louis-Désiré Blanquart-Evrard presented to the French Académie a modified

Fig. 5-4. Image of Palais de l'Ecole Nation des Beaux-Arts à Paris; Blanquart-Evrard imprint.

When Frenchman Louis-Désiré Blanquart-Evrard introduced an improved calotype process in the 1840s he began producing prints from the negatives of numerous artists for commercial sale. This image is a salt print, produced from a glass negative during the early 1850s. (*Courtesy of Swann Galleries, Inc.*)

calotype process which used chemically impregnated paper. This process produced superior tone and detail in the image, while providing improved permanence as well. Also, because this process required shorter exposures, Blanquart-Evrard was able to produce large quantities of calotype prints for both display and publication.

The greatest advance in calotypy came in 1851 through the efforts of another Frenchman, Gustave Le Gray. Le Gray's method of waxing the negative resulted in improved transparency, shortened print times, and increased image detail. Moreover, sensitized paper could be prepared several weeks in advance and did not require immediate development. For travel photographers, Le Gray's process was a godsend. For the calotype, this improvement, along with Talbot's relaxation of patent enforcement, marked the beginning

of the formative years (1852 to 1857). Both amateurs and professionals began using the process extensively for architectural and travel documentation. In England, a Royal Photographic Society was created with such prominent names as Charles Eastlake, Roger Fenton, and Charles Wheatstone on its roster. Several new calotype cameras were devised, some even with roll magazines.

It was also during this period that a number of paper prints were made from the new collodion or albumenized glass negatives. Because these images are not true calotypes, they are now called "salt prints" to differentiate them from images produced via paper negatives.

While the calotype was enjoying more than moderate success throughout Europe, at-

Fig. 5-5. House on Powell Street, San Francisco; photographer unknown, ca. 1852.

This image is one of the earliest paper photographs of San Francisco, California, and was possibly taken by George Fardon, one of the few photographers in the American west producing salt prints. An image of this type would usually bring $500 or more at auction. (*Courtesy of Swann Galleries, Inc.*)

tempts to stir American interest failed. The Langenheim brothers of Philadelphia purchased the U.S. rights from Talbot in 1849 and attempted to solicit licensees. However, by this time the license-free daguerreotype process was already firmly implanted in the American enterprise system. Daguerreotypists saw no reason to buy a license for a slower process that produced fuzzy images.

In fact, America's foremost calotypist was a Frenchman, Victor Provost. Provost's early images of New York City landmarks are an important historical record of that great city. His high-quality paper negatives have survived to this day in excellent condition.

In Philadelphia, the Langenheims quickly turned their efforts to other areas, introducing a glass negative process in 1849 and popularizing the stereograph beginning in 1850. In 1851, the Langenheims were forced to file bankruptcy because of back payments still owed to Talbot. It was here that the calotype's short, unprofitable visit to America ended.

The discovery of the collodion wet-plate process in 1851 marked the beginning of the end for both the daguerreotype and the calotype worldwide. Although in 1851 their most important years were yet to come, by the 1860s both processes were obsolete.

The Calotype Process

The specifics of the calotype process changed considerably from its inception in 1833 to the improved process of the 1850s. To make his "photogenic drawings" Talbot used common writing paper, bathed in salt water, followed by a strong solution of silver nitrate. He then placed an object directly in contact with the paper and exposed the object and paper to sunlight. The areas of the paper not covered would darken, leaving the impression of the object in white. This negative image, called a "reversed copy" by Talbot, was then fixed, either with an additional bath of salt water or a solution of potassium iodide. Many of the images fixed by this method faded away within a few years.

In 1839, Talbot learned of Sir John Herschel's hypo solution, which dissolved silver salts and would "arrest the further action of light." By 1840, Talbot was producing the *talbotype,* a positive image created by placing a reversed copy (negative) in contact with a second sheet of sensitized paper and exposing them to sunlight. The positive print that was created was called a "re-reversed copy."

With Talbot's discovery of the latent im-

age in 1841, his process changed considerably and the first true calotype was produced. Rather than waiting for the paper to darken and the image to become visible, an exposure was made by uncapping the lens for a predetermined length of time and then bringing the invisible image out (developing it) in a solution of pyrogallic acid. This negative was fixed and contact-printed as before, but using the new exposure/development method. Both exposure and printing times were considerably shortened by this method, making the calotype a viable photographic process.

The two primary complaints still voiced were the graininess of the image and the lengthy printing times. Both of these problems were somewhat altered by the introduction of "waxed negatives" in 1851 by Gustave Le Gray. With Le Gray's method, after the paper was soaked in melted wax and pressed flat, it was sensitized in successive baths of potassium iodide and silver nitrate. Following exposure and development, the nearly transparent waxed paper negative could be printed in considerably less time and the resulting prints were nearly

free of the annoying graininess inherent in earlier calotypes.

Most high-quality calotypes still in existence were produced after the improvements of 1851. Waxed paper negatives have also survived in reasonably good condition and are often used to produce modern prints.

Salt Prints

After the introduction of albumen and collodion plates, a large number of glass negatives were printed on "salted paper" in the style of the calotype. These images are generally much sharper, lacking the fibrous texture always evident, to some degree, in prints produced from paper negatives. As noted in the section on collecting calotypes, these "salt prints" date from about the same period as calotypes (approximately 1850 to 1860) and are equally as valuable. There has always been some confusion over these two image types, and the names are often used interchangeably.

Even more confusing are "albumenized salt prints," which have a glossy surface and may be mistaken for standard albumen prints. Careful examination of an image will show that the image of a salt print appears to be imbedded in the paper, while an albumen image lies on the surface.

Collecting the Calotype

All calotypes which have survived in good condition are *rare* or *premium* photographs.* Even faded and damaged examples are not at all common. There is always the possibility of discovering a previously unknown work at a flea market or estate sale (European collectors have a much better chance of this), however availability is almost always limited to photographic auctions and dealer sales. Serious collectors should subscribe to the various catalogs offered by those who deal in rare photographs.

Calotypes are seldom made available for less than $300, and those offered at this end of the price scale are often unattributed and/or inferior quality examples. You can expect to pay $500 to $1,000 for good, investment-quality pieces and upward of $5,000 for a *premium* specimen. Although this talk of high price and low availability may sound discouraging, there is no better time than now to invest in calotypes. Prices have increased as much as tenfold since 1970 and are expected to continue to rise as more and more calotypes make their way into permanent collections.

Recent sales include a Blanquart-Evrard print of a young man and a horse which went for $1,100 (Swann Galleries, 4/24/89) and a Parisian view, attributed to Charles Marville, which brought a reasonable $889 (Sotheby's, 11/1/88). Two calotypes by the inventor of the process, Fox Talbot, brought $605 at the same sale.

During recent years, a number of calotype fakes have been discovered. As for all rare photographs, a collector should deal only with reputable sources and, when possible, demand the provenance of an image (that is, where did it originate and who were its previous owners?). Collectors should also be wary of "intensified" images. While professional opinions differ, it is the general consensus that all pho-

* While salt prints are technically a separate type of image and are usually given separate treatment by auction houses, information pertaining to the collecting of salt prints is identical to that of the calotype as listed here.

Fig. 5-6. Mosque de Sultan-Hacan by Maxime Du Camp; ca. 1850.

Using the Blanquart-Evrard process, Du Camp and other French artists produced views in large quantities for exhibition and sales. Salt prints of this type usually bring at least $750 at auction. (*Courtesy of Swann Galleries, Inc.*)

Fig. 5-7. Group of Croat chiefs, by Roger Fenton; ca. 1856.

Fenton was a prolific British photographer who produced images in quantity and variety. This superb documentary portrait sold at a 1989 auction for $2,420. (*Courtesy of Swann Galleries, Inc.*)

tographs should be left in their natural state (except for basic cleaning). Therefore, prospective buyers should beware of richly toned calotypes which are offered for below market value.

Calotypes are the most delicate of paper photographs and should not be openly displayed. They should be kept in acid-free archival sleeves and/or boxes, in complete darkness, and (under optimum conditions) in a constantly maintained atmosphere of 60°F and 40% relative humidity. As with all photographic images, light, heat, moisture, and careless handling are the calotype's primary enemies.

The Wet Plate and Albumen Prints

al 'bu men print: A positive print produced from a glass negative on paper coated with egg whites. Sensitizing agent: silver nitrate; developing agent: pyrogallic acid. Wet-plate negative invented by Frederick Scott Archer (Britain). Albumen print invented by L.-D. Blanquart-Evrard (France).

Introduced	1850
Peak years	1860–1890
Waned	1890s
Last made	1910

History of the Wet Plate and Albumen Prints

The wet-plate process actually forms the foundation for a number of image types discussed in this book. The ambrotype, tintype, carte de visite, cabinet card, and nearly all paper prints produced from 1860 until 1880 made use of the collodion wet-plate process. Of these, only the tintype did not employ the use of a glass plate.

Glass was the logical choice as a base on which to produce negatives, and experiments to that effect were performed as early as 1839 by Sir John Herschel. His method of simply allowing the silver salts to settle on the plate, however, proved to be both inconsistent and impractical. Another type of glass negative was developed by Claude F. A. Niépce de Saint-Victor (nephew of Daguerre's partner) using albumen (egg whites) as the fixative. This process achieved moderate acceptance and was used in the production of many salt prints prior to the announcement of Archer's collodion process in 1851.

Frederick Scott Archer was an English sculptor who had learned the calotype process in 1847 and had experimented with collodion-coated paper negatives in 1848. The failure of these trials did not discourage his experimentation, and in 1851 he announced the details of a collodion-on-glass process.

Collodion, a mixture of guncotton, alcohol, and ether, was invented in 1847 by Messieurs Minard and Domote of France. Poured over a surface and allowed to dry, the viscous liquid formed a tough, transparent film and the substance was quickly seized upon by the medical profession as a sort of liquid bandage.

In Archer's process, collodion was poured onto a glass plate and then sensitized, exposed, and developed before the coating could dry. Because of their extreme transparency, collodion negatives were much quicker to print than paper negatives, while also providing better detail and tonal quality.

During the early years (1851 to 1855), most collodion negatives were printed on salted paper, just as Talbot's paper negatives had been, but with an astonishing improvement in quality. These "salt prints" comprise the bulk of paper prints made in France and the United States during this time period (also see Chapter 5). In England, the calotype shared its continuing popularity with the new wet-plate process until the advent of the carte de visite and stereograph after 1856.

As if by providence, at the same time that Archer was perfecting the collodion negative, French calotypist Louis-Désiré Blanquart-Evrard was working on a new printing paper which would soon become an integral and inseparable companion to the wet-plate process. Described before the French Academy of Sciences on May 27, 1850, the process used paper coated with a combination of egg whites mixed with ammonium chloride. This "albumen paper" could be dried and stored, for later sensitizing in a silver nitrate bath. The wet plate–albumen print process produced crisp images with superb tonal qualities. Moreover, numerous prints of consistent quality could be produced from one original negative. In 1855, James Waterhouse introduced a method of toning albumen prints with gold chloride which improved image quality even more.

Use of albumen paper skyrocketed during the late 1850s. Factories began to produce pre-coated paper which photographers could purchase in reams and then cut to size and sensitize as needed. A large number of these manufacturers were located in Dresden, Ger-

many, a town that would become known worldwide as the center of albumen paper production.

As the 1860s approached, itinerant and travel photographers found the wet plate–albumen print process well suited for photography on the trail. Throughout Europe, expeditions were sent out to bring back images of the great architectural and scenic views to be found in the Middle East, the Orient, and other "far-off lands." These images would be mass-produced in giant "picture factories" for publication or for sale to the general public.

The factory of Francis Frith, in Reigate, England, maintained a stock of over 1 million albumen prints. Frith himself undertook an arduous yet productive expedition to Egypt, the Sinai, and Jerusalem, which resulted in the production of a magnificent book, completely illustrated with original 15″ × 20″ albumen prints. Images from this undertaking were also produced for smaller books, and as stereographs.

With the outbreak of the Civil War, America's photographers turned their lenses toward a grim new subject, death and destruction. On

Fig. 6-1.

The work of Briton Francis Frith is representative of the top wet-plate photographers of the 1850s and 1860s. Images were often produced as stereographs or card photographs, tipped-in to books or folios, or pasted to large cardboard mounts for display. Figure 6-1 is a Frith file print used as a reference. (*Courtesy of California Museum of Photography, Riverside.*)

Fig. 6-2.

Fig. 6-3.

Frith was well known for his wonderful travel images. Shown here are the cover and a plate from a travelogue produced in the late 1850s. (*Courtesy of California Museum of Photography, Riverside.*)

the battlefield, the wet-plate photographer was put to the test of producing quality images of an important historical event, under extremely difficult conditions, and in great danger of personal injury. The most famous of these photohistorians was Mathew Brady. Almost killed at the battle of Bull Run, he survived to establish Brady's Photographic Corps, which consisted primarily of himself, Alexander Gardner, Timothy O'Sullivan, and George N. Barnard. In 1863, a riff caused by Brady's unwillingness to give specific photographic credit to his associates resulted in the disbanding of the group; however, all four continued to document the war until its conclusion.

After the war, O'Sullivan, Gardner, and

Barnard set off with heavily laden pack-mules to document westward expansion. Spectacular views of vast, unspoiled lands and the native Indians who resided there were brought back from the several expeditions taken well into the 1870s. Also prominent among western photographers was William Henry Jackson, who left his studio in Omaha, Nebraska, to document the route of the transcontinental railway. Photographing the back trails of California were Carleton Watkins and Eadweard Muybridge.

In Europe, Charles Marville documented the streets of old Paris (1864); Thomas Annan did the same in Glasgow, Scotland (1868); and Briton John Thompson traveled to the Orient, producing the four-volume *Illustrations of China*

Fig. 6-4.

While the other works shown here are quite valuable, some Frith prints, such as this view of St. Paul's cathedral identified by the Frith blind stamp (see Glossary) shown enlarged in Fig. 6-5, can be purchased for as little as $35.

Fig. 6-5.

and Its People, published in 1873. Other notable European wet-plate artists included Carlo Ponti in Italy, Charles Clifford in Spain, Gustave Le Gray in France, and Herman Crone in Germany.

Among the thousands of photographers who used the albumen print process, only a few names are truly deserving of the title "artist." These individuals knew how to make use of camera angles, lighting, and artistic poses to create superb documentary and allegorical scenes and portraits.

In the portrait field, Julia Margaret Cameron was unsurpassed. Using a soft focus and unusual lighting styles, Cameron created pho-

tographs that gave the appearance of fine black-and-white paintings. Cameron was born in England in 1815 and took up photography relatively late in life. Most of her work was produced between 1865 and 1875 (Fig. 6-10).

Best known among allegorical photographers of the period were British photographers Oscar Gustave Rejlander and Henry Peach Robinson. Rejlander (active in the 1850s through the 1870s) produced complicated scenes, using many models, by photographing small groups and then printing several negatives onto one print (combination printing). He was a vocal advocate of photography as an art.

Fig. 6-6. Bee Hive Geysers, by William Henry Jackson; ca. 1873.

Jackson was famous for his views of Yellowstone, which were used to convince Congress to set aside the area as a National Park. This image sold at auction in 1989 for $1,210. (*Courtesy of Swann Galleries, Inc.*)

Robinson's approach followed closely that of Rejlander. Robinson's famous combination print, the controversial "Fading Away" (1858), required five separate negatives to create the image of a dying girl and her bereaved family. Robinson believed that any manipulation the photographer wished to use in order to achieve the desired results was acceptable.

Even though a "dry plate" was introduced as early as 1864, it took until the late 1870s to produce a dry-plate system which could compete with the collodion wet-plate process. At the same time, production of gelatin emulsion paper marked the beginning of the end for albumen prints. Still it would take more than 20 years for the transition to take place. The wet plate–albumen print marriage had been a long and solid one, and most of the photographers who used these processes remained loyal to the end.

Fig. 6-7. "Poor Old Man," by Oscar Gustave Rejlander.

While Rejlander was best known for his elaborately staged "combination" photographs, this image exhibits a somewhat simpler artistic quality. At a 1989 auction this piece sold for $550. (*Courtesy of Swann Galleries, Inc.*)

The Wet Plate–Albumen Print Process

The collodion wet-plate negative was used in the production of a number of photographic variants. (These processes are discussed in the appropriate chapters.) However, from the wet-plate negative's early years, the standard objective was the creation of a contact print on albumen paper. When a large print was desired, a large camera and plate were used. This was the type of camera commonly carried on expeditions to the American west and used by European travel and art photographers.

The traveling photographer required a portable system which would include a large wet-plate camera; a collection of clean and well-protected glass plates; bottles of collodion and chemicals; various trays and utensils; and some

sort of darkroom (a wagon for some, a tent for most). While most of the printing was done back at the photographer's place of business, he or she might wish to bring along some paper and chemicals to produce presentation prints for the locals. If the use of a wagon was impractical, all of this equipment was carried by mule or horse. At each destination, the camera was set up and the darkroom and chemicals prepared for use. With the camera positioned and focused, the photographer poured a small amount of collodion onto a glass plate. When the sticky liquid reached the edges, the excess was carefully drained back into the bottle. The plate was then quickly taken to the tent or wagon darkroom to be sensitized in a waiting

tray of silver nitrate. Still dripping, it was then placed in a shield and rushed to the camera for exposure.

For scenic views, a lens with a small aperture was used to produce a wider depth of field. This meant lengthy exposure times were required, even in bright sunlight. Although the plate could be cleaned and used again, it was important for a photographer to be well-versed in determining required exposures to avoid wasting time on retakes.

After the exposure was made, the plate was quickly taken back to the tent or wagon darkroom for development in pyrogallic acid. After being fixed in hypo solution, the finished negative was left to dry in a dust-free area, then placed back in the plate transport case.

For the most part, prints of these negatives were made upon the photographer's return, in an outdoor print rack and a standard darkroom. After 1872, albumenized paper could be purchased presensitized and ready for use. Prior to that date, photographers purchased the paper in reams, cut the sheets to size, and sensitized them in a silver nitrate bath. When necessary, sensitized paper could be prepared one or two days in advance, but best results were achieved with freshly sensitized paper.

To make a print, the collodion negative was placed in direct contact with a sheet of the sensitized paper and locked in a printing frame. The frame was then taken to an area where it could receive exposure to direct sunlight for a period of 10 to 30 minutes. This process was carefully monitored so that the print would achieve the proper degree of darkening before being taken in for toning and fixing procedures.

While several different toning methods were used, the one most commonly practiced was a gold chloride–alkaline bath. This process produced rich, purplish-brown tones in the finished image. After toning, the albumen print was fixed in hypo solution, rinsed, and mounted. Because albumen paper was thin and subject to curling, prints were almost always mounted on cardboard using a carefully applied starch or flower paste. Even during these early years of photography it was known that ordinary glues were harmful to the long-term stability of an image.

As the twentieth century approached, many improvements were made to the wet plate–albumen print process, mostly to refine the system and make it more convenient. On the whole, however, the basic operation remained unchanged until the advent of gelatin-bromide technology at the turn of the century.

Collecting the Albumen Print

No other category of nineteenth-century images provides a larger base of availability than albumen prints. Between the years 1850 and 1900, millions of images were produced by portrait artists, itinerants, and amateurs. Nearly every subject one can imagine has been documented by the albumen print.

For the purpose of this chaper, we confine ourselves to all albumen prints *not* mounted in the style of the card photograph (i.e., prints that do not fall into the categories of carte de visite, cabinet card, or stereograph). Albumen prints ranged in size from 1″ × 1″ to 20″ × 24″ or larger. These prints were either mounted in albums, "tipped-in" to books, or attached to cardboard mounts. Examples can be found at flea markets and antique stores and through dealers and auction houses on a regular basis.

Almost every home has at least a few albumen prints in the family album or picture box.

Albumen prints are easily recognizable by the deterioration that is visible on nearly every example. Fading and yellowing (especially near the edges) are the most common defects, followed by stains and "foxing" (brown spots). Because most albumen prints were toned, the dark areas of the image are almost always brown or purplish in color.

What to Look For

The value of an albumen print is often highly affected by the identification of the pho-

Fig. 6-8.

Large albumen prints should be carefully examined for the photographer's embossed blind stamp. This blind stamp reads "Lav Paolo Lombardi, Siena, Fotografo," indicating that the image was produced by Paolo Lombardi of Siena, Italy.

tographer. Prints bringing high prices are almost always quality examples by well-known artists. Often these prints were produced as part of a series, with the number, series title, and photographer's credit embossed or printed on the print or mount. Occasionally an image without a credit can be attributed to a specific photographer by comparison to other works of a similar type, subject, and/or photographic style.

Fig. 6-9. Der Dom zu Mainz, by C. Hertel.

Nearly every town of size in Europe had one or more photographers who produced images of local landmarks in stereo or as mounted prints like the one shown here. In good condition this type of print usually brings $25 to $50.

Availability/Value Classifications

The Common Albumen Print (25 cents to $5)

Millions of images of homes, businesses, towns, people, and animals, produced by both professionals and amateurs, make up 97 percent of the available base of albumen prints and are mostly considered *common*. A collector may be drawn to a particular image because he or she finds some personal connection or aesthetic appeal. Except for this personal appeal, and some occasional rare "finds," the *common* albumen image has no appreciable monetary value.

The Uncommon Albumen Print ($5 to $100)

While the uncommon albumen image makes up only about 2 percent of the available base, it must be remembered that the overall base is very large. Included in this category are "collectible" images such as those containing horse-drawn carriages, Indians or blacks, people in costume or uniform, and identifiable businesses, streets, towns, etc. Also in this category are mass-produced works by famous photographers. Certain well-known images by Francis Frith, George Washington Wilson, Alexander Gardner, and others can occasionally be found in the under-$100 price range. Portraiture (other than cartes or cabinets) by Nadar, Lewis Carroll, and Antoine Salomon can also be found from time to time.

The Rare Albumen Print ($100 to $2,500)

Rare albumen prints are a great starting place for the investor in nineteenth-century photography. Quality works by major photographers are now bringing $200 to $300 at auc-

Fig. 6-10. "The Kiss of Peace," by Julia Margaret Cameron.

Cameron felt that this image was "the most beautiful of all [her] photographs." It was purchased at auction in 1988 for $2,400. (*Courtesy of Sotheby's.*)

tion, with values steadily increasing. Recent sales by Swann Galleries and Sotheby's included many superb works by Americans O'-Sullivan, Gardner, Barnard, Jackson, and Muybridge ($220 to $2,210) and European artists John Thomson, Francis Frith, and James Anderson ($440 to $1,540). Some excellent books and folios illustrated with original albumen prints are still selling for prices well under $1,000. Within a few years these rare portfolios and series will be bringing twice that.

As with all *rare* images, watch for fakes and reprints. Deal with reputable dealers only

and, when possible, request the photograph's written provenance.

The Premium Albumen Print ($2,500 and Up)

This category consists primarily of books illustrated with original prints, rare series, and unique portraits. The most notable recent example was a complete copy of *Gardner's Photographic Sketch Book of the War*. This rare volume contained 100 prints by 10 different photographers documenting the American Civil War. At the April 1989 Swann Galleries auction, the volume brought over $30,000. At that same sale, a copy of *Egypt, Sinai, and Jerusalem*, with 14 original mammoth prints by Francis Frith, brought $6,820. Portraits of General U. S. Grant ($4,400), Abraham Lincoln ($9,350), and a superb autographed Brady portrait of Robert E. Lee ($10,450), were also sold at that auction. From an investment point

Fig. 6-11. Navajo Indians, by Timothy O'Sullivan; ca. 1873.

This image is one of a series taken when O'Sullivan accompanied the Wheeler Survey during the 1870s. This exceptionally high-quality albumen print brought $3,520 at auction in 1989. (*Courtesy of Swann Galleries, Inc.*)

Fig. 6-12. Asylum inmate, by Dr. Hugh Diamond.

As superintendent of the Surrey County Asylum, Diamond photographed a number of his patients. This rare example was offered at auction in 1988, bringing $8,800. (*Courtesy of Sotheby's.*)

of view, these items could easily double in value by the time offerings of this type are made again.

Above all the talk of art and investment value, there is one often-forgotten factor concerning the albumen print. Spanning the second half of the nineteenth century, it documented 50 important years of world history. The changes in fashion, architecture, transportation, and lifestyle were all etched in silver on albumen. Despite their perceived value (or lack thereof), these early paper prints should be preserved and studied as the historical artifacts they are.

Cartes de Visite

carte de vis 'ite: An albumen print measuring $2\frac{1}{2}''$ by $3\frac{1}{2}''$ mounted to a card measuring $2\frac{1}{2}''$ by $4''$. Popularized by André-Adolphe-Eugène Disdéri (France).

Introduced	1854
Peak years	1859–1866
Waned	1870
Last made	1905

History of the Carte de Visite

While the exact origins of cartes de visite are unknown, it is a fact that they did not come into extensive use until their introduction by Frenchman André-Adolphe-Eugène Disdéri in 1854. Disdéri had devised a rotating camera back which, using the recently invented col-

Fig. 7-1. Portrait of I. K. Brunel, by Robert Howlett.

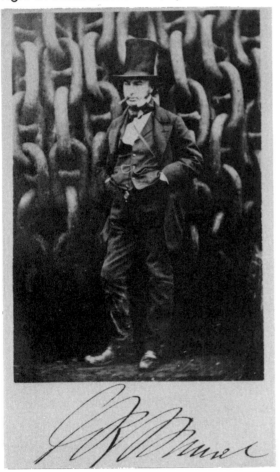

This unique carte de visite was published by the London Stereoscopic Company during the late 1850s or early 1860s. The image, with another of Captain J. V. Hall and one of the steamship Great Eastern, sold for £130 ($200) in 1988. (*Courtesy of Christie's South Kensington.*)

Fig. 7-2. Portrait of a lady, by C. D. Fredricks.

C. D. FREDRICKS & Co., NEW YORK

Already well known for his work in daguerreotypy, Fredricks was one of the first and most active promoters of the carte de visite in America. His imprint on this image, produced during the early 1870s, makes it more valuable than other common images by unknown photographers.

lodion wet plate, could produce eight individually exposed images on a single negative. After printing on albumen paper, the images were cut apart and glued to calling card–sized mounts. These tiny portraits were left by visiting friends, inspiring the name *carte de visite* (French for "visiting card").

During the early years (1854 to 1857), the "carte" was popular on a limited basis throughout Europe. By 1858 it had spread to America, and by 1860 photographers around the world were producing more cartes de visite than any other type of photograph. In August of that year, John Mayall, an American working in England, advanced the notoriety of the carte de visite when he published 60,000 sets of his Royal Family album (Queen Victoria herself was an avid carte collector).

Former daguerreotypist Charles D. Fredricks was one of the earliest promoters of the carte de visite in America, having introduced the new format in his gallery as early as 1859. During the years 1860 to 1865, Americans learned all too well the ability of the photograph to capture and hold a memory. The carte de visite portrayed sons and fathers gone to war, wives and children left behind, and the visages of heroes, both alive and fallen. Photography was so popular during the Civil War that a special revenue bill was passed requiring a tax stamp to be affixed to most photographs (see Chapter 11).

Between 1861 and 1865, 15 patents were issued for albums to hold the new card photographs. Generally they contained cardboard pages with slots into which the carte was in-

Fig. 7-3.

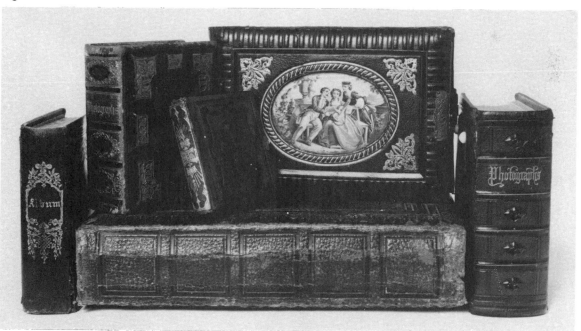

Thousands of carte de visite and cabinet card album styles were produced from 1860 until after the turn of the century. A sampling of early leather albums is shown here.

serted on each side, back to back. The album covers were usually made of cloth or embossed leather, with numerous adornments (painted insets, porcelain knobs, brass and sometimes gold latches). This style of album would remain popular well into the next century.

The largest photographic supplier in the United States, Edward Anthony, was among the first to realize the potential of mass-produced "collector" cartes. Negatives of famous people and places were purchased from various amateur and professional photographers for publication as cartes de visite. Among the primary supplier of celebrity portraits was Mathew Brady. His images of Jenny Lind, Tom Thumb, President Lincoln, and various Civil War personages were as popular then as they are with collectors today. Other important portrait artists from the daguerreotype era re-

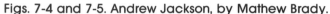

Figs. 7-4 and 7-5. Andrew Jackson, by Mathew Brady.

Photographs of celebrities, like this image, were as popular with Victorians as they are with collectors today. Brady copied many of his early daguerreotypes for publication as cartes de visite. The primary publisher of this material was E. and H. T. Anthony and Co. of New York. Images with this imprint are sought after by collectors. (*Courtesy of California Museum of Photography, Riverside.*)

mained popular as carte de visite photographers. Samuel Broadbent, John Whipple, Abraham Bogardus, and Southworth and Hawes all maintained busy carte studios.

During the 1870s and 1880s, Napoleon Sa-

rony became America's premier celebrity photographer, producing thousands of imaginative portraits of leading actors and performers on both the carte de visite and the cabinet card. The distinctive signature of Sarony (Fig. 8-6)

Fig. 7-6.

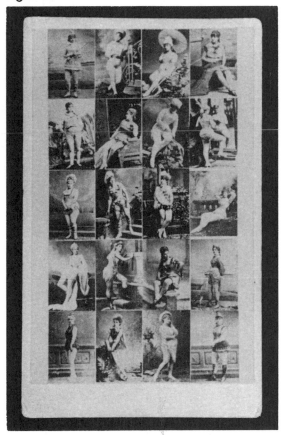

Fig. 7-7.

Miethke & Wawra in Wien.

Actors, actresses, and circus performers were among the many celebrities photographed for cartes de visite. These images were sold by the photographer for mass-production and were used by the subjects to advertise their talents. Fig. 7-6 is a "composite carte" with 20 separate images of various actresses. Today, images of the type shown here and on the next page are very collectible, and complete albums of actors and/or performers are quite valuable. (*Courtesy of California Museum of Photography, Riverside.*)

Fig. 7-8. An actress.

Marie Williams. [Over.]

Fig. 7-9. Circus performers.

imprinted on the mount usually means that the sitter was someone of importance. The practice of imprinting the photographer's signature on the mount was copied by many, including Sarony's imitative protégé, Mora, who also photographed stage celebrities and was famous for his elaborate backgrounds and accessories.

A number of French portrait photographers were also well known for their cartes de visite. Etienne Carjat, Reutlinger, and Nadar all produced superb card photographs, as did the originator of the format, Disdéri. A number of French firms published mass-produced cartes of architecture and artwork.

In England, former daguerreotypists Antoine Claudet and John Mayall took up the carte de visite with great success. Also important among British carte producers were Jabez Hughes, William Kilburn, Camille Silvy, and the firms of Elliot & Fry, Hill & Sanders, Nigretti & Zambra, and Maull and Polybank. (*Note:* These names appear again in reference to the cabinet card and to the stereograph. Most firms produced all three formats and mass-produced images for each style of mount.)

Fig. 7-10. Miss Leslie, advertising carte de visite.

Photographs of this type were included with several male-oriented products as a method of advertising. The image was almost always of a young lady with obviously questionable intentions, showing more stocking than was usually permissible in public. (*Courtesy of California Museum of Photography, Riverside.*)

The Tintype as Carte de Visite

With the advent of the American Civil War, demand was high for inexpensive portraits which were easy to carry or mail. The carte de visite fit that description perfectly. In order to compete, tintypists began to produce small ''gem'' portraits which could be placed in carte

Fig. 7-11.

During the Civil War years, American photographers often placed tintypes in Potter's patent paper sleeves. These holders were embossed with patriotic designs and provided a means of selling tintypes as cartes de visite.

de visite–sized sleeves. (Prior to this time, tin-types had always been sold in standard plate sizes as cased images.)

A multilens camera with a rotating back, patented by Simon Wing in 1860, was capable of producing large numbers of "gems" on a single plate. Wing also introduced a mounting card with an oval window cutout to contain the tiny portraits. Also popular were the Potter's Patent sleeves (Fig. 7-11) with embossed patterns, and small albums which held 100 or more images (Fig. 2-9).

After the war, larger tintypes were produced and the carte de visite sleeves had much larger openings. Although use of the tin-type for portraiture declined in the late 1870s, tins were made in the carte format by beach and boardwalk photographers until the early 1900s.

If a complete directory of carte de visite

Figs. 7-12 and 7-13.

This photographer devised a fanciful means of turning a tintype into a carte de visite, by attaching a tiny brass frame to the card mount. The back of this image contains a Civil War–period revenue stamp, cancelled with the photographer's name ("Jacoby") and the date ("Aug. 2, 1865").

photographers were ever published, it would be a massive volume including hundreds of thousands of entries from the Americas, Europe, Asia, and even the South Pacific. While production of the carte was reduced by the introduction of cabinet cards in 1866, large quantities continued to be made by photographers worldwide until just after the turn of the century.

The Carte de Visite Process

Of paramount importance to the carte de visite process was the multilens camera with repeating back. Using a "four tube" camera (four lenses), the photographer could produce four separate exposures on one-half of the plate, then shift the back and take four more exposures on the other half. With the option of either uncapping all four lenses at once or each one individually, the resulting negative could contain either eight identical images or eight separate poses. Regardless of how the exposures were made, they had to be done quickly,

Fig. 7-14.

The back of this Civil War–period carte indicates the variety of services offered by a major gallery.

because the sensitivity of the collodion wet plate was steadily changing as the coating began to dry.

After development (see Chapter 6), the full-plate negative containing eight $2\frac{1}{2}'' \times 3\frac{1}{2}''$ images was contact-printed onto a freshly sensitized sheet of albumen paper. Larger galleries had rooftop printing racks which could be adjusted to the angle of the sun. Assistants were hired to periodically examine the prints for proper image intensity. When intensity was judged to be correct, the print was taken inside to be fixed and toned. Then the individual prints were cut apart, trimmed, and mounted to the card mounts ($2\frac{1}{2}'' \times 4''$). As with brass mats, preservers, and other "adornments" of nineteenth-century photography, early cards were very plain, becoming constantly more elaborate as the years passed (see the next section, "Collecting Cartes de Visite").

After the initial printing, the original negative was usually kept on file by the photographer for future reorders. Many extant cartes have a number penciled on the back which corresponded to the file number on the original negative.

Sitting for a carte de visite portrait was not much different from previous sitting processes except that the carte sitter was surrounded by many elaborate "furnishings." Pillars, pedestals, ornate velvet settees, elegant draperies, and detailed painted backdrops were all tools of the trade for a carte photographer. The ever-present head rest was always hiding somewhere, and its "third foot" often made an appearance in standing portraits (Fig. 7-9).

By the 1870s, accessories were varied and abundant, almost to the point of absurdity. Rustic gates and fences, rowboats, wishing wells, a jungle of plants and flowers, and even snow adorned the studio setting.

The carte de visite gallery also provided a number of services other than standard portraiture. Copies were made of daguerreotypes and other early images, as well as paintings and artwork. Most major galleries carried a line of commercially produced cartes which could be added to an album to impress friends. These included portraits of celebrities, foreign scenes, famous landmarks, works of art, etc.

Fig. 7-15. "Back of Man with Derby & Umbrella," by C. L. Lochman.

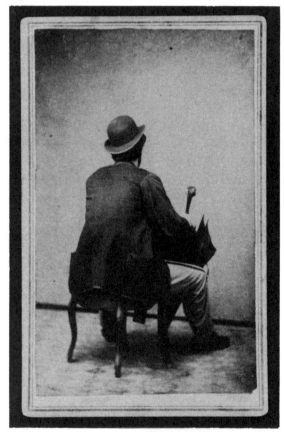

Even during the 1850s, photographers were producing unusual images to boost sales. Cartes of this type are prized by collectors. (*Courtesy of California Museum of Photography, Riverside.*)

Fig. 7-16. A country home, maker unknown; ca. 1860.

This superbly photographed scene may have been the photographer's home, or a place of historic importance. It may even have been an early use of photography in real estate sales. Regardless of its original intention, it is now a valuable historical document of early American architecture. (*Courtesy of California Museum of Photography, Riverside.*)

The carte de visite was also the first commercially viable method of photographing the various individual members of groups, such as university faculty, senators and representatives, or members of clubs. Like the ambrotype before it, the carte de visite was even used for "mug shots."

When you understand the difficulties in producing images by the wet-plate process, you also realize that it was no small effort that produced the millions of cartes de visite made from 1860 to 1900 and that it is no small miracle that millions of superb examples still exist in reasonably good condition. The carte de visite is also a tribute to the men whose separate visions were combined in its conception: Frederick Scott Archer (collodion negatives), Louis-Désiré Blanquart-Evrard (albumen paper), and André-Adolphe-Eugène Disdéri (card photographs).

Collecting Cartes de Visite

More people collect the carte de visite than collect any other form of photography. Carte images are widely available at flea markets, estate sales, and antique shops at very reasonable prices. Just as the carte was the "poor man's portrait" in the nineteenth century, it is now the poor man's collectible, with even "uncommon" examples going for as little as $5.

This is not to say that cartes do not bring premium prices. An individual carte de visite of Abraham Lincoln was purchased by a well-known actor in 1977 for $700. A recent offering of a Lincoln carte by Alexander Gardner brought $385 at the Swann Galleries April 1989 auction. Highest prices are paid for complete albums, such as the Spanish album containing 511 cartes of various celebrities which brought $1,430 at Sotheby's (11/2/88, #523). Two albums containing autographed cartes of various notables (including Lincoln) sold for a com-

Fig. 7-17. "The Waiting Carriage," by C. D. Fredricks.

It is likely that Fredricks took this photograph during one of his trips to Cuba, where he had maintained a daguerreotype studio. Images of this type are historically important and valuable. (*Courtesy of California Museum of Photography, Riverside.*)

bined $2,800 in 1975. If these same albums were to appear on today's market, they would probably sell for that much individually.

What to Look For

Carte de visite collectors are usually subject collectors. They spend endless weekends searching through dusty boxes and albums for that elusive carte of a little girl holding a doll, or a nameless Civil War soldier. Some collect portraits of famous people, just as the Victorians did 100 years ago. Still others are watching for the famous imprints of Brady, Nadar, Sarony, Disdéri, etc. While thousands of these cartes exist, their popularity as a collector's item makes them hard to find, and therefore valuable.

Generally speaking, for a carte de visite image to attain more than *uncommon* status it must have significant historical value and/or be appreciable as an artistic piece. Historical images could be "original" portraits of politicians, celebrities, and royalty or documentary views of historical events and landmarks. Artistic cartes are "original" portraits and allegorical views by Cameron, Rejlander, Robinson, Carroll, and so on. *Original* in this context means "as produced by the photographer or his publisher" (that is, not a pirated copy).

Availability/Value Classifications

The Common Carte de Visite (25 cents to $5)

The *common* carte is a portrait whose value relies solely upon its antiquity and inner charm (if any). It is an accurate record of fashion and style, as well as nineteenth-century class struc-

Fig. 7-18. Portrait of a young black woman, by H. D. Garns.

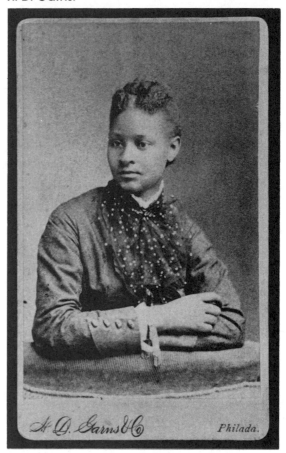

A. D. Garns & Co *Philada.*

Persons belonging to a minority ethnic group were seldom photographed prior to the turn of the century; therefore images of this type are uncommon. (*Courtesy of California Museum of Photography, Riverside.*)

tures. All carte de visite portraits should be examined for signatures or notations which identify the subject. This is especially true of cartes in albums, where the backs of the cards are not visible. One such album, purchased by the author for $15, contained 35 seemingly

Fig. 7-19. "The Empty Chair," by Downes.

Nearly every conceivable subject was photographed for the carte de visite at one time or another, to which this image attests. One can only speculate as to the importance of this well-worn chair. Images such as this are prized by collectors. (*Courtesy of California Museum of Photography, Riverside.*)

common cartes. When the portraits were removed and examined, the backs were found to contain Civil War period tax stamps and notations identifying the subjects as the family of U.S. General George McClellan.

The Uncommon Carte de Visite ($5 to $100)

Uncommon cartes are the "collectibles," which make up around 15 percent of the available base. On the lower end of the value range are scenics ($12–$20), theatrical subjects ($5–$25), and children with toys or pets ($5–$35). In the mid-to-upper range are occupational portraits ($25–$75), images of musicians and bands ($25–$100), death portraits ($20–$50),

Fig. 7-20. "The Banjo Player," by M. K. Tripp.

All images containing musical instruments are sought after by collectors.

historical images ($50–$100), and ethnic images (blacks, Indians, etc.) ($25–$100).

Certain carte de visite subjects can be found in nearly every price range, depending on specifics of the individual piece. These subjects include artwork and architecture, celebrities, military, and works by well-known photographers. Collectible cartes which do not contain a photographer's imprint are probably pirated, and pirated prints are worth considerably less than originals.

The Rare Carte de Visite ($100 to $1,000, Including Albums)

Although they represent only about 5 percent of the available base, *rare* cartes and albums are not difficult to locate through dealers or auctions. Individual examples are usually unique or limited-production celebrity portraits or photographic art. *Rare* carte de visite albums are often filled with images of celebrities, politicians, royalty, famous landmarks, artworks, and so on, collected by wealthy Victorians for prominent display in the parlor. One such album, containing 20 cartes of U.S. presidents and statesmen and bearing the Brady/Anthony imprint, sold for $440 at the Swann Galleries 1989 sale. An album of 10 cartes of artists and photographers (many by Napoleon Sarony) also brought $440. At that same auction, an individual autographed carte of John Mosby (noted Confederate colonel) sold for $880.

The Premium Carte de Visite ($1,000 and Up, Including Albums)

An album of Brady cartes of the type mentioned above sold at auction in 1978 for $2,200. What pushed this album into the *premium* category was the fact that it contained not 20, but

191 portraits and bore Brady's initials on the cover. Occasionally an individual carte will bring in excess of $1,000. Usually it is a unique piece, accompanied by an autograph or other important historical papers.

Fig. 7-21. An art study, maker unknown.

This image is one of a group of 17 cartes de visite of nude women which sold at a 1989 auction for $605. Since the beginning of photography, many erotic images have been produced under the guise of "art studies." While more widely accepted in some European countries, images such as this were kept hidden in America. (*Courtesy of Swann Galleries, Inc.*)

Dating the Carte de Visite

A number of characteristics of the carte de visite mount can be used as an aid in determining the approximate date of the image it contains. Early cartes (1860 to 1868) were attached to thin cardboard stock with square

Fig. 7-22. Portrait of a gentleman, maker unknown; ca. 1863.

During the mid-1860s some cards were imprinted with the representation of a frame, into which an oval cut image was glued.

corners and usually with one or two gold lines imprinted as a border. After 1863, some cards were imprinted with a representation of an oval picture frame (Fig. 7-22), into which the image was glued (see also Figs. 11-6 and 11-7).

After 1869 a thicker card was used, and after 1871 the corners were rounded. Various colored card mounts were introduced around 1873, and by 1875 beveled edges trimmed in gilt were in use. By 1880 the card stock was thick and sturdy, and rich, dark colors were common. The backs of these cards contained the photographer's logo, incorporated into elaborately printed designs. In 1890, cards were again made thicker, with scalloped or other fancy edges.

It is always a treat for the collector to discover a date written on the back of the card by some thoughtful ancestor; however, this is the exception, rather than the rule. By using the above guidelines, a collector can arrive at an approximate production date, adding to the value and interest of the image. With collecting experience, the recognition of time periods becomes second nature.

Documentation and Storage

Like the cased image, the carte de visite has various elements which should be documented. This is especially important if the card is contained in an album where frequent removal and insertion can be harmful. Notations should be made as to the dimensions and thickness of the mount and whether the corners are rounded or square. The color of the front and back, as well as the texture and trimwork, are also important. The photographer's name and address should be documented and the logo (if any) described. Finally, any markings, attachments, or written notations should be recorded and a simple description of the image given.

Rarely can the entire history of an image, including previous owners, be determined. If such a provenance is available for an image, the information is extremely important and should be kept.

Like all paper images, the carte de visite is susceptible to excessive heat and moisture, oils, acids, and fading. Since even many museums cannot afford proper photographic storage facilities, it is enough to say that collectors should do the best they can to avoid these dangers. Loose cartes are best kept in Mylar sleeves or pages. Images in original albums can be given some degree of protection by the insertion of acid-free paper between the pages. If you must write on any paper image or its mount, use a soft lead pencil and write lightly, near the edge.

The carte de visite appears to provide the collector with a seemingly endless supply of undiscovered treasures. In fact, the value and historical importance of this photographic medium is overlooked for just that reason. Thousands of these "old photos" are tossed away annually. Still thousands more are ruined by mishandling and improper storage. It is important for those who are interested in the preservation of photography and of our heritage to include the carte de visite in collection and preservation efforts.

Fig. 7-23. The last carte, maker unknown; 1860s.

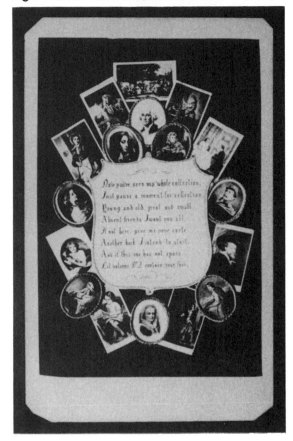

This clever carte de visite advises the viewer that he or she has reached the end of the album and asks that the viewer leave his or her own carte.

Leaves from a Post–Civil War Album

It is apparent that an etiquette developed concerning the arrangement of images in the Victorian album. A study of original albums shows that many began with the U.S. president and various celebrities of the day, followed by autographed images of friends and business associates and then family pictures. At the end of the album were travel views, pictures of European royalty (often Queen Victoria), and, finally, images of various works of art. The following pages contain a sampling from one such album.

Fig. 7-24.

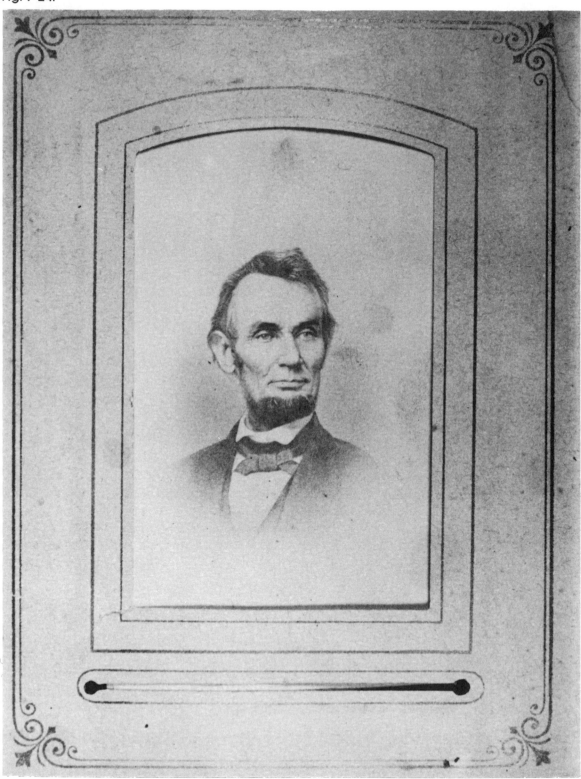

President Abraham Lincoln.

Fig. 7-25.

President Andrew Johnson.

Fig. 7-26.

General Ulysses S. Grant.

Fig. 7-27.

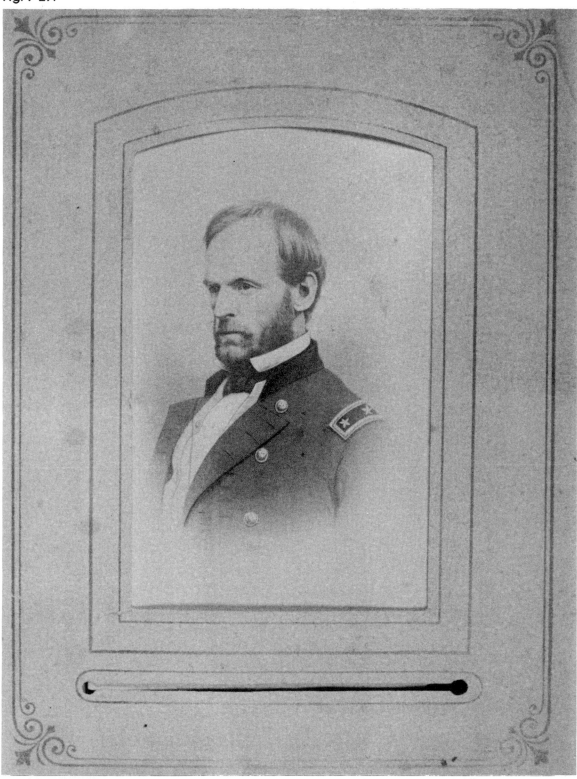

General William T. Sherman.

Fig. 7-28.

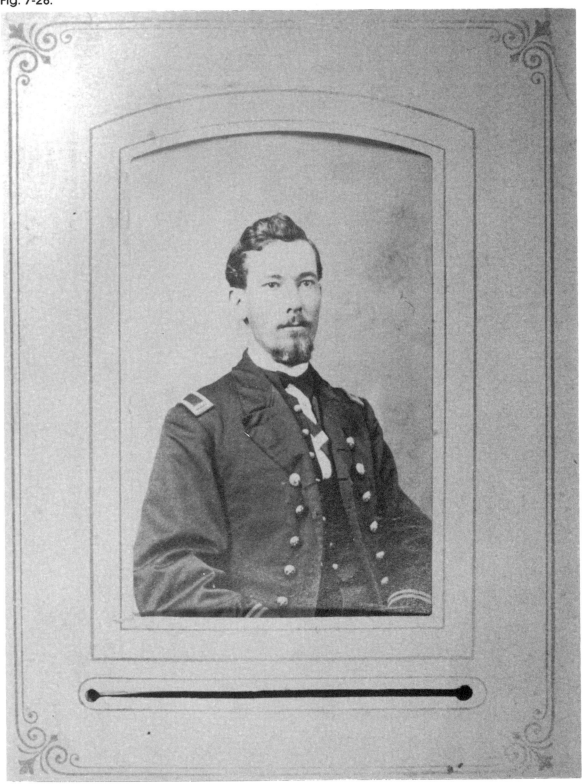

A Civil War lieutenant (family member).

Fig. 7-29.

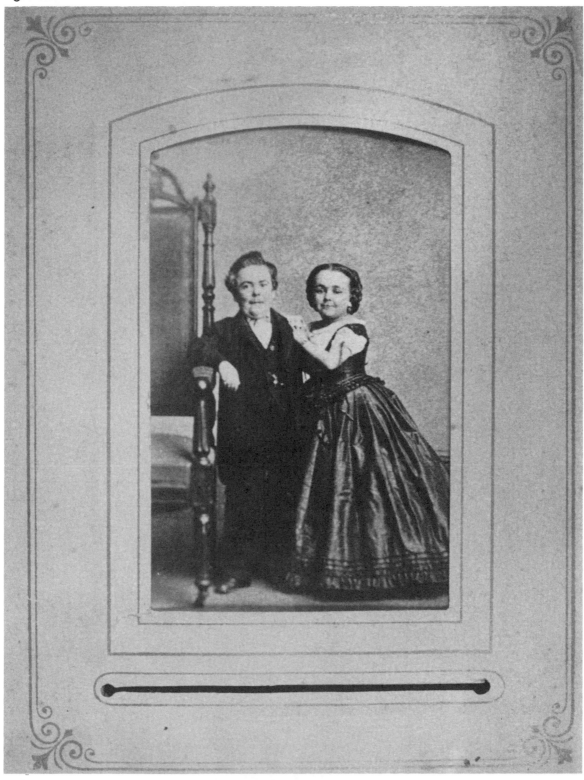

Tom Thumb and his wife Lavinia.

Fig. 7-30.

J. P. Willard (autographed carte).

Fig. 7-31.

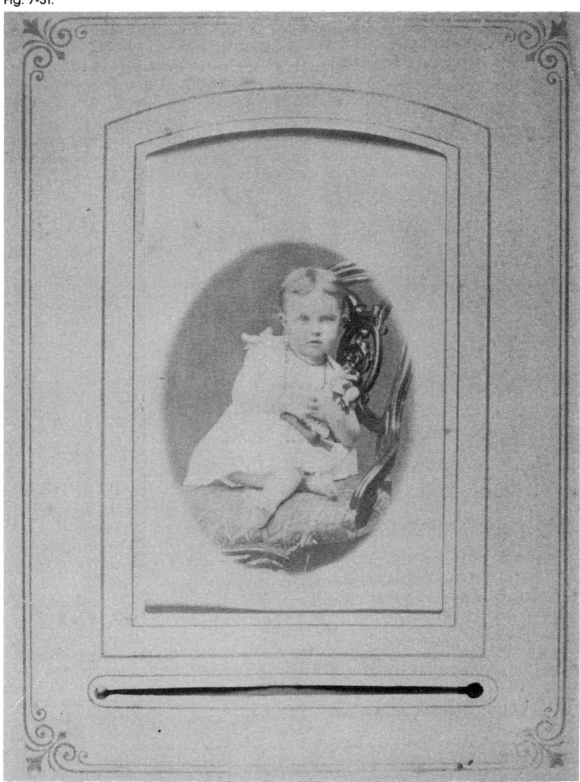

Little girl with doll.

Fig. 7-32.

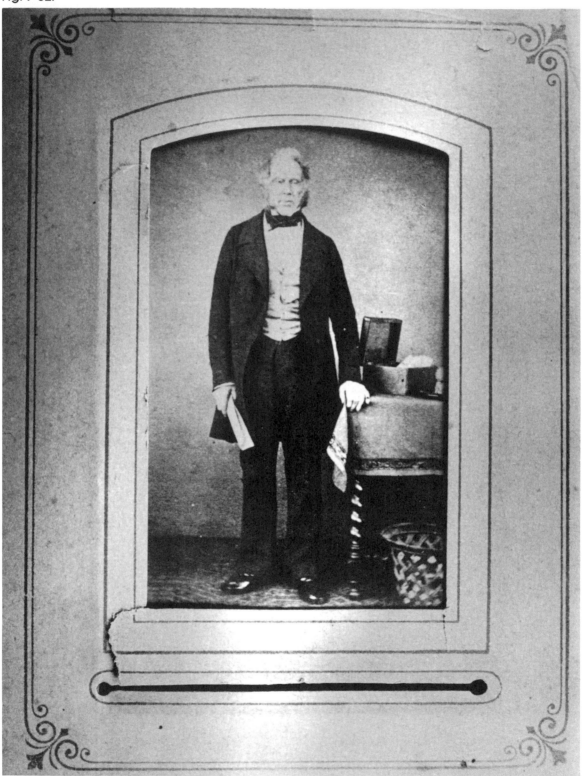

Lord Palmerston of the British Parliament.

Fig. 7-33.

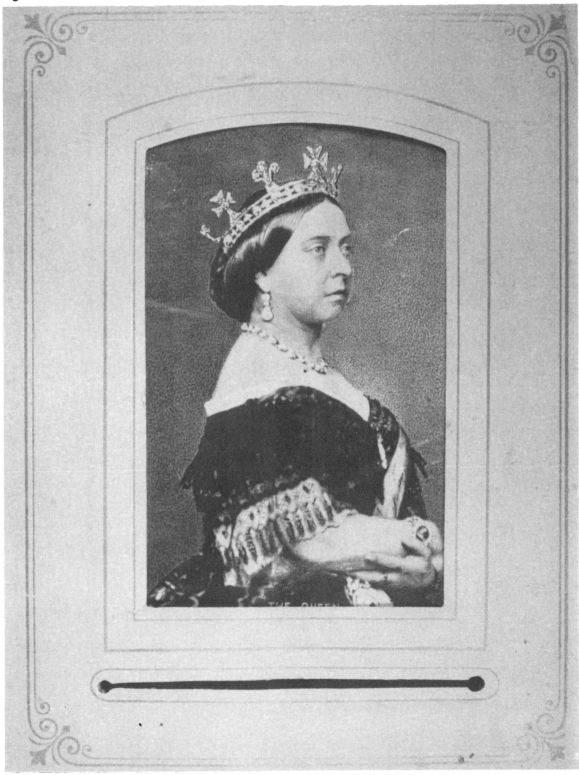

Queen Victoria.

Fig. 7-34.

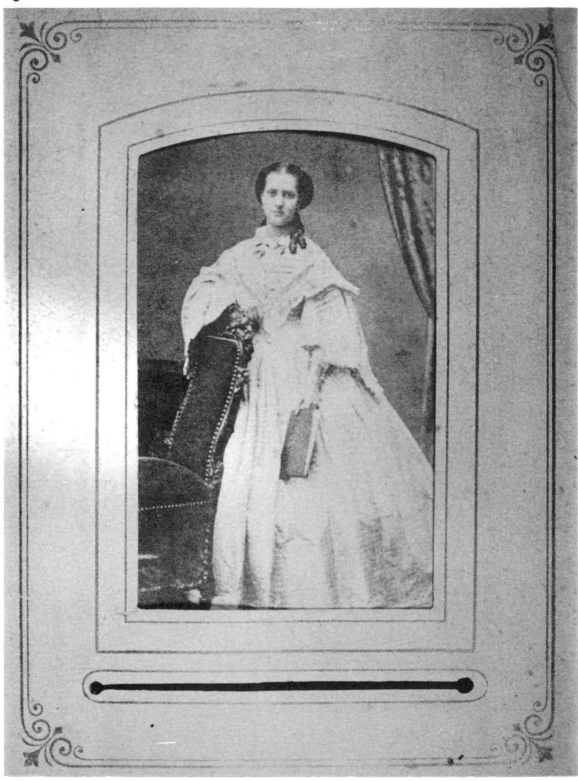

Princess Alexandria.

Fig. 7-35.

"Resignation" (a Palmer marble).

Cabinet Cards

cabinet card: A photographic print measuring $4'' \times 5\frac{1}{2}''$ attached to a cardboard mount $4\frac{1}{4}'' \times 6\frac{1}{2}''$. Popularized by Windsor & Bridge (Britain).

Introduced	1863
Peak years	1870–1900
Waned	1905
Last made	1920s

History of the Cabinet Card

The early history of the cabinet card and specifics of the process are closely related to those of the carte de visite. Also, the value of collectible cabinet cards is determined in a similar manner. Therefore, a thorough study of both chapters is advised.

Despite the great success of the carte de visite during the early 1860s and its continued popularity thereafter, demand was high for a new larger type of portrait which could be made for a reasonable price. Whole-plate and "imperial photographs" (see Glossary) were too costly to produce in volume, and they required framing. The public had quickly become accustomed to the family album, but the tiny cartes just seemed too small (Victorians were used to doing everything in a big way).

The answer came, not from the French this time, but from the London studios of Windsor & Bridge. In 1863, Windsor & Bridge announced a new large card photograph (4 times larger than the carte) consisting of a $4'' \times 5\frac{1}{2}''$ albumen print on a $4\frac{1}{4}'' \times 6\frac{1}{2}''$ heavy cardboard mount. Prior to the production of albums for the new format, the large cards were prominently displayed in the drawing room cabinet, thus inspiring the name *cabinet card*.

Photographers were delighted with the new images, which were produced in pairs on a full-plate negative. Most galleries continued to offer the carte de visite, giving the customer a choice of sizes, and, as the cabinet card became more popular, larger albums were created with pages to accommodate both formats.

As usual, American photographers waited for the innovation to prove itself before taking up the new format in 1866. Names that were already known for their cartes de visite (Sa-

Fig. 8-1.

This elaborate leather album, made in Germany during the early 1870s, was designed to contain both cartes de visite and cabinet cards. Many albums were covered in velvet, and some even played music like a music box. Even bibles sometimes contained pages for card photographs.

Fig. 8-2. Portrait of a lady, by Abraham Bogardus; cabinet card, ca. 1876.

Bogardus was one of the many famous daguerrean artists who maintained studios well into the era of the card photograph. (*Courtesy of California Museum of Photography, Riverside.*)

rony, Mora, Gurney, and so on) quickly became known for their carefully posed, well-accessorized, and deftly retouched cabinet portraits.

Retouching was an important feature of the cabinet card process. The large negative could be carefully doctored by the artist to eliminate wrinkles, blemishes, and stray strands of hair, as well as to correct any photographic defects. The art of photography, which upon its conception had inspired the quote "from this day painting is dead," now relied on the painter's craft as an integral component of its newest process.

The practice of including various accessories and backgrounds in a portrait reached almost absurd proportions in cabinet card studios. Photographers felt that this new large for-

Fig. 8-3. Dog with painted backdrop, by E. V. Brand, Franklinville, N.Y., ca. 1880s.

Although cabinet card portraits of animals are more common than those taken by earlier processes, they are still sought-after by subject collectors.

mat could handle elaborately detailed sets. To us, in the twentieth century, these settings appear quite gaudy and unnecessarily ornate. However, contemporary photographs of Victorian homes show that this was very much the style of the period.

Beginning in the late 1880s, a declining interest in carte and cabinet card portraiture prompted an increase in the production of art, travel, and celebrity images for sale to the public. However, the discovery and subsequent development of the halftone printing process brought the same subjects to the readers of books, magazines, and newspapers. By the turn of the century, photomechanized printing would effect the demise of commercially produced card photographs. After 1900, only stereographs would continue to use mass-produced photographic images in their manufacture.

Cabinet card portraiture continued to receive moderate use until the beginning of World War I. By that time, the wet-plate process was a thing of the past, albumen paper had been replaced by gelatin-silver, and modern enlarging techniques made full-size framable portraits the format of the twentieth century.

Fig. 8-4.

Like stereographs and cartes, some cabinet cards were produced for advertising or entertainment purposes. This photographic copy of a high-quality litho print is entitled "The Drummer's Latest Yarn" and has a complete short story printed on the back. Copies could be purchased from the publisher for a hefty 25 cents.

The Cabinet Card Process

Cabinet cards of the nineteenth century were primarily produced as cartes de visite were, using a wet-plate negative printed on albumen paper. The major difference was the camera, which, in the production of the cabinet card, was a standard full-plate camera employing twin lenses to produce either two identical prints or two separate poses, side by side on one plate. The negative was printed onto factory-sensitized proof paper which required no chemical processing. This print was used by the artist as a guide for retouching the negative, after which a second "improved" print was shown to the sitter. Once the order was taken, multiple prints were produced on standard albumen paper and mounted to the cardboard mounts.

After the introduction of the dry-plate system around 1880, cabinet card photographers used factory-sensitized plates which could be exposed throughout the day, then processed all at once. Even with the advent of gelatin-based papers, albumen prints remained the choice of most cabinet portrait artists until after the turn of the century.

Other processes used in the production of cabinet cards (and, to a lesser degree, cartes de visite) included platinum prints, bromide prints, carbon prints, Velox, mezzotint, and photomechanical prints such as woodbury-types and collotypes.

Collecting the Cabinet Card

Most cabinet cards currently being held in private collections are there because of some personal appeal the image has for the collector, not because of real or perceived monetary value. This is not to say that there are no valuable cabinet cards, as we shall see. However, 95 percent of the available market of cabinet cards can be considered to be in the *common* category.

A good example of the prevailing attitude toward cabinet cards can be seen at flea markets and antique shops, where more than half of all albums which originally contained cartes de visite are sold empty because the images have been removed for separate sale. At that same location, however, you will find nearly every cabinet card album filled with its original images.

Because they are from a later time period, cabinet cards do not display the historic look of cartes and other early images. Generally, in comparison to the carte the cabinet card has a sharper image, a shinier finish, and is in cleaner condition. In short, for the collector of antiquarian images, the cabinet card is just too new.

It is this attitude which makes the cabinet card one of the best starting places for beginning collectors. The true potential of the cabinet card is just now starting to be recognized. Just as we are looking forward to a new century today, the world of the 1880s and 90s was also. It was a time of invention, transition, and moreover, a time of affluence and high spirits. The statesman, the thespian, the scientist, the Gibson Girls—feathers and lace and a glimpse of stocking—were kept in elaborate velvet albums to remind future generations of a time when life was a whole lot lighter.

Fig. 8-5. Man in Oriental costume, by Anderson.

Fig. 8-6.

Early photographs of people in costume are uncommon and are sought after by collectors. This image is especially interesting because it shows an actor in Oriental makeup.

The distinctive signature of Napolean Sarony on a mount usually means that the subject was someone of importance. This gentleman is William Freeman Vilas, active politican and senator from Wisconsin during the early 1890s.

What to Look For

The current trend in cabinet-card collecting centers on the photographer. Imprints of Sarony, Mora, Nadar, Brady, Disdéri, and others are in great demand. Scenic and documentary cabinets (often identical to stereograph images) are also in collecting vogue. Early cabinet cards are becoming harder to find, especially those made at or near the end of the Civil War.

Availability/Value Classifications

The Common Cabinet Card (25 cents to $5)

Common cabinet cards are often used to fill fancy albums and/or as conversation pieces.

Many are enjoyable as chronicles of fashion and late Victorian gaudery (see also "Cartes de Visite" Chapter 7). When looking through stacks of common cabinet cards at flea markets or antique shops, watch for imprints of important photographers and imprinted or written names indicating celebrities or notables.

The Uncommon Cabinet Card ($5 to $100)

The *uncommon* cabinet card includes pets, children with toys, people in theatrical costumes, late military scenes and portraits, scenics, and art objects ($5–$40). The *uncommon* category also includes portraits by well-known photographers and documentary images ($10–$100). On the upper end of the scale are portraits of celebrities and notables ($50–$100).

The Rare and Premium Cabinet Card ($100 and Up, Including Albums)

Occasionally, wealthy Victorians put together specialty albums containing extensive collections of cabinet cards by famous travel, art, or celebrity photographers. When found in good condition, these albums can command high prices. At the 1989 Swann Galleries sale, an album containing 30 cabinet cards of Rus-

Fig. 8-7. The Kiowa Indian Camp at Fort Sill, by Irwin.

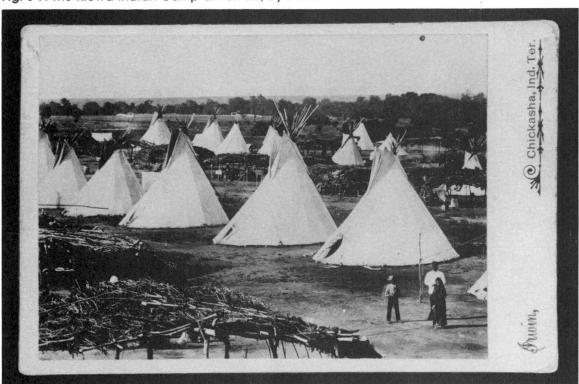

Photographs of this type were often produced both as cabinet cards and as stereographs. Figs. 8-7 and 8-8 are important historical documents, as well as being prized collectibles. (*Courtesy of California Museum of Photography, Riverside.*)

Fig. 8-8. Mother and child from the Kiowa Indian Camp at Fort Sill.

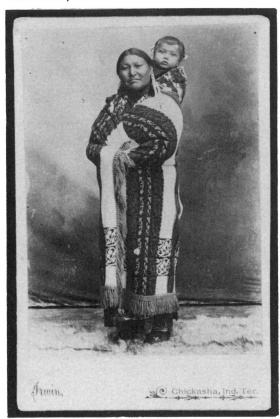

sian portraits and views sold for $220; a group of 9 cabinets of American Indians brought $303; and an individual cabinet card of the famous Indian lawyer Elias Boudinot realized $275. Most *rare* cabinet cards are of and/or by famous people.

Dating the Cabinet Card

Earliest cabinet card mounts were lightweight and light in color, often with a thin red line about ⅛″ from the edge. After 1880, various colors were used, and the area below the image usually contained the photographer's imprint. Cards with gold, beveled edges date from the period 1885 to 1892 (approximately). Maroon-faced cards were produced during the 1880s, and cards from the 1890s often had scalloped or notched edges and were imprinted with elaborate patterns on the back. Because the time periods for these various features often overlapped, cabinet cards are slightly more difficult to date than cartes de visite.

Although cabinet cards were made by several different processes, most are albumen prints and are subject to fading and foxing; therefore, they should be stored in sleeves or between sheets of acid-free paper, away from light, heat, or moisture.

CHAPTER 9
Stereographs

ster ′e o graf: A pair of photographs, usually taken with a binocular camera, mounted for three-dimensional viewing in a stereoscope. Concept by Charles Wheatstone; popularized by Sir Charles Brewster (Britain).

Introduced	1851
Peak years	1858–1905
Waned	1910
Last made	1925*

* Continuously produced by hobbyists to this day.

History of the Stereograph

Stereographs were produced by nearly every photographic process invented during the nineteenth century. (The details of these individual processes are discussed under appropriate chapters.) Stereographs are also referred to as *stereotypes, stereoviews, stereoscopic views,* and *stereo cards.*

Although cartes de visite and cabinet cards were produced to some degree as amusements, the primary use of these card formats was portraiture. Stereographs, on the other hand, were produced solely for entertainment and informational purposes (the few individually produced existing stereo portraits are rare exceptions). Today the stereograph is quickly becoming recognized as an excellent source for firsthand information about the people, places, and events of the nineteenth century.

The principle of the stereoscope was actually arrived at one year before the announcements of the daguerreotype and talbotype. A British physicist, Charles Wheatstone, introduced the concept using binocular engravings. The images were made to combine by the use of mirrors, resulting in a three-dimensional effect. The system was quite impractical, and the discovery went unheralded until the Crystal Palace exhibition of 1851.

The Great Exhibition at the Crystal Palace in London could be described as the first world's fair. The latest inventions, as well as scientific and artistic innovations, were displayed in grand

Fig. 9-1. The Crystal Palace; calotype stereograph, early 1850s.

The Crystal Palace Exhibition of 1851 introduced stereography to the world. The Palace itself was the subject of both daguerreotype and calotype stereographs. Early stereographs of this type are scarce and are quite valuable. (*Courtesy of the California Museum of Photography, Riverside.*)

146

style. Among the various instruments on exhibit was a stereoscope, invented by Sir Charles Brewster, containing binocular daguerreotypes taken with a twin-lens camera. Brewster's binocular camera had been described in the *Journal of the Franklin Institute* in 1849, but it was the exhibition which introduced stereo photography to the world.

Many early stereo images were made either by moving the camera to produce two plates exposed from different angles or by taking separate exposures on two cameras sitting side by side. In 1855, American John Mascher discovered a method for producing two images on one plate through the use of "pinhole" photography (see Glossary). Unfortunately, the images were reversed and had to be cut apart for insertion in a viewer.

Mascher's viewer, introduced in 1852, used the design of the basic wood-frame daguerreo-

type case. He replaced the inside cover pad with a hinged, fold-out leaf containing two magnifying lenses through which the image was viewed. This design was infinitely more convenient than Brewster's viewer of 1851, which was actually an enclosed box with lenses at the top and the daguerreotypes mounted inside on the bottom.

Around 1854, the Langenheim brothers of Philadelphia began one of the first commercial stereograph businesses, selling views of Niagara Falls produced on paper and on positive glass transparencies, which they called "hyalotypes." That same year, the London Stereoscopic Company was started by George Swann Nottage. By 1858, the company had a stockpile of over 100,000 different stereo images printed on albumen paper from wet-plate negatives. Two other British firms, Gladwells and Negretti & Zambra, also produced large

Fig. 9-2.

The business of stereography often involved many people. The image on the other side of this stereocard was taken by an unknown photographer, published by the Langenheim Brothers and distributed by Scovills. (*Courtesy of the California Museum of Photography, Riverside.*)

numbers of commercial stereo views during the late 1850s.

In France, several firms were making "tissue" stereographs. By printing an image on very thin paper, it could be viewed by transmitted light, like a transparency. Colors could be added by applying tints to a second sheet of tissue which was then sandwiched to the image before placement in a cardboard frame. This type of stereograph was also produced in England and America on a lesser scale. While they were most popular during the late 1850s, tissue stereographs were produced throughout the nineteenth century on a limited basis.

By 1860, the advent of the wet plate–albumen print process had revolutionized photography, and millions of albumen stereo views were in homes around the world. Large production firms in England, France, and America were manufacturing thousands of stereocards per day. The E. and H. T. Anthony and Company imported large stocks of stereographs and purchased original negatives directly from professional and amateur photographers to be printed and mounted in the company's own production facilities.

One of the early promoters of the stereograph was American physician and author Oliver Wendell Holmes, who, along with his friend Joseph Bates, designed what would become the most popular style of stereo viewer. The Holmes-Bates stereoscope incorporated a movable card holder and shielded lenses (Fig. 9-4), and, because it was never patented, it was produced by numerous manufacturers until well after the turn of the century.

In the late 1860s, manufacturers began selling mass-produced "series" stereographs.

Fig. 9-3. "Valley of Chamouni," by William England; tissue stereograph.

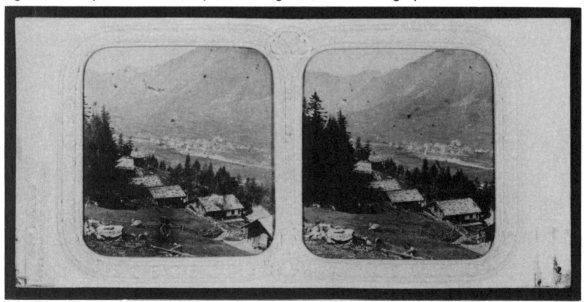

This "French tissue" was actually produced in England by the London Stereoscopic Company during the late 1850s. Because these lightweight images were subject to tears and punctures, those in good condition are uncommon and are sought after by collectors. (*Courtesy of the California Museum of Photography, Riverside.*)

Fig. 9-4.

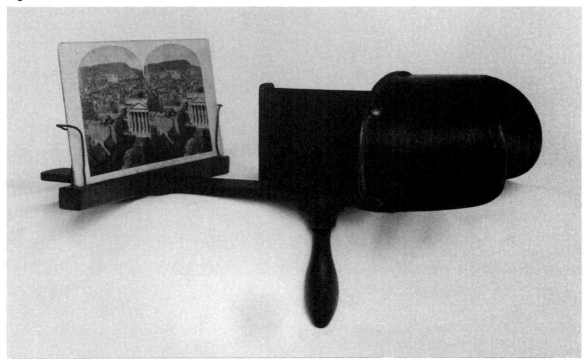

A large number of stereographic viewers (stereoscopes) were invented during the era of the stereograph. The most popular version was devised by author Oliver Wendell Holmes in 1859. Shown here is an 1878 "improved" version of the Holmes-Bates stereoscope.

A series was a complete set or several sets of related stereo cards with a single theme or subject. The firms or Charles Pollack (Boston), B. W. Kilburn (New Hampshire), Underwood & Underwood (Kansas), and Keystone View (Pennsylvania) were the major producers of series stereographs from 1870 until World War I.

Series themes are too varied and numerous to allow for an exhaustive list here, but the following are a few examples of series titles:

"Niagara Falls"
"The White Mountains of New Hampshire"
"Great Cities"

"California and the West"
"Crystal Palace"
"Churches and Cathedrals"
"Egypt and the Middle East"
"American Civil War"
"Johnstown Flood"
"Chicago Fire"
"Indians"
"Slavery"
"Famous Paintings"
"Sculpture"
"Tools"

In addition, there were numerous staged series in which actor/models posed for "genre" photographs depicting romantic, dramatic, or co-

Figs. 9-5 and 9-6. "Montreal, Canada," by the London Stereoscopic Company; albumen stereograph.

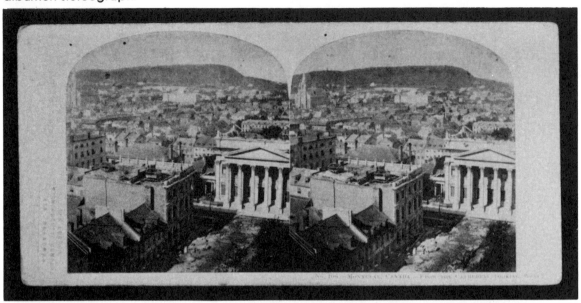

Early views of major cities are historically important. This image bears the blind stamp of London Stereoscopic Company's New York branch (see Fig. 9-6).

Fig. 9-7. "Full Moon," by H. Draper; albumen stereograph.

Stereographs of the moon were quite popular at the turn of the century. Many people had not yet seen the moon through a telescope, and the three-dimensional effect of the stereograph provided a realistic substitute for actual viewing.

Fig. 9-8. "Prospect Point, Niagara," by J. J. Reilly; albumen stereograph.

Niagara Falls was one of the most photographed views in the world. This angle clearly shows the camera stand at Prospect Point where Daguerre's agent Francois Gouraud operated in the early 1840s and where later Platt Babbitt was granted a monopoly in tourist photography. The photographer who produced this stereograph was one of only a few individuals granted license to operate at Niagara.

medic stories. Titles representative of this style include ''Little Red Riding Hood'' (1858), ''Gems of American Life'' (1871), ''The Night Before Christmas'' (1870), ''Young Ideas'' (1870), ''Hansel and Gretel'' (1872), ''The Wedding'' (1897), and ''The New French Cook'' (1900).

The stereograph has been described as ''Victorian television.'' While that is a considerable exaggeration, there are many similarities. Almost every middle- and upper-class home had one or more stereoscopes and many stereoscopic cards. Children fought over who got to look first and which series would be viewed. The stereograph was at times a form of entertainment for family and friends, and at other times a quiet and private way to escape to some foreign and mysterious land.

A history or geography book could, without difficulty, be illustrated exclusively with stereographs. And, because they were made using every popular form of photography from 1850 to 1925, they provide in themselves a complete history of photography.

The Stereograph Process

Between 1850 and 1925, 10 different types of photographs were used to produce stereographs. Stereo daguerreotypes and calotypes were commonly made by placing two separately exposed images side by side in the viewer; however, a few single-plate stereographs were

Fig. 9-9. "Frame of Snow Covering," by Carleton Watkins; albumen stereograph.

After the Civil War, American photographers turned their cameras toward westward expansion. In California, Carleton Watkins followed the line of the Central Pacific Railroad. This image was obviously produced for its three-dimensional effect.

made in these media during the mid-1850s using "binocular" cameras. Stereo daguerreotypes and ambrotypes were usually novelty portraits or still lifes, contained in Mascher or Kilburn folding stereo cases or mounted under glass.

Tissue stereographs were paper transparencies, printed on very thin albumenized paper from wet-plate negatives. An outline of the original image was then traced onto a second sheet of translucent paper so that tinting could be added. The two sheets were then sandwiched together in a cardboard frame for protection and rigidity. Tiny pinholes were sometimes punched in the tissue to represent points of light such as candles. When viewed by transmitted light, this three-dimensional colored image presented a stunning effect.

During the nineteenth century, more stereographs were produced by the wet plate–albumen print process than by any other method. Stereograph manufacturers sent teams of wet-plate photographers to locations around the world. In addition, original negatives were purchased from free-lance professionals and amateurs. Large factories were erected, employing hundreds of workers, to print, mount, sell, and ship albumen stereographs. Massive sun-printing frames were built to handle the huge volume of print work. Thousands of stereographs were produced each day, in addition to an often equal volume of cartes de visite and/or cabinet cards. During the peak years, stereographs were available from most major stores and mail-order houses, as well as from door-to-door canvassers.

Several photomechanical processes were also used to produce stereographs from the

Fig. 9-10. Mosque of Sultana Valide, by Francis Frith; collotype stereograph.

This stereograph from an 1858 Frith negative was published by the Langenheim Brothers. The collotype process produced poor-quality photomechanical reproductions and thus was not widely used. Early collotype stereographs of this type are uncommon. (*Courtesy of the California Museum of Photography, Riverside.*)

early years through the twentieth century. The least common of these were xylographs (from wood engravings) produced during the late 1850s. Another early photomechanical method was the *collotype* (not to be confused with calotype), which was used to produce stereographs from the 1850s until the turn of the century. In the collotype process the original negative was attached to a glass plate containing a film of dried bichromated gelatin and then exposed to bright light. The gelatin hardened in proportion to the amount of light received. When used as a printing plate, the areas of gelatin which were less hardened (highlights) held less ink than the hardened (shadow) areas. Well-made collotypes are sometimes difficult to distinguish from photographs unless they are placed under magnification.

Halftone printing (screen printing) is usually thought of as a twentieth-century process; however, stereographs were printed by this method during the 1890s, and some were even printed in color. Before that time, stereographs were hand-tinted, although color collotypes were produced with dubious results. Some hand-tinted stereos are startlingly realistic.

Other stereograph variants included glass positives, cyanotypes, and porcelain prints.

Collecting the Stereograph

Because the stereograph was produced over 75 years of the nineteenth and twentieth centuries, and because of the thousands of theme series that were produced, this format offers more variety for the collector than any other. Nearly every imaginable subject was covered by the stereograph at one time or another. Those collectors interested in travel photography will find endless supplies. While there are a few rarities among albumen stereos, premium prices are usually reserved for those produced by early, one-of-a-kind processes (daguerreotype, ambrotype, tintype).

What to Look For

Early stereographs are usually quite valuable and, fortunately, are easy to identify. While stereo images on glass or metal are almost never found outside of dealers and auction houses, calotype stereographs are occasionally discovered hidden among common cards. Stereographs from the 1850s were mounted in paper frames or, more commonly, on thin cardboard mounts with square corners.

Condition is an important factor in stereo card values. Even in the *common* category, pre-1880 cards in near-mint condition command higher prices. Unless the image is unusual, a stereograph with stains, creases, dog-eared corners, or folds is essentially worthless as a collectible.

Availability/Value Classifications

The Common Stereograph ($1 to $10)

Approximately 75% of all stereographs on the market are *common*. These are primarily travel images and images from narrative or genre series. Many are mechanically printed images dating from the 1880s and later. A patient collector can often accumulate complete series at a very low cost by diligently searching through the stacks of stereo cards always found at flea markets and in antique shops.

Fig. 9-11. "Old Betz," by Illingworth; albumen stereograph.

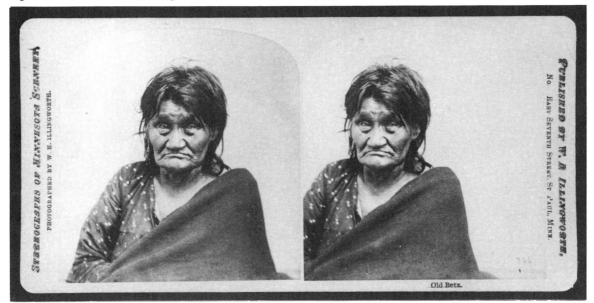

W. H. Illingworth became famous for his images of the American Indian, as he made western excursions during the 1860s and even accompanied Custer's expedition into the Black Hills. Images of Indians and those relating to westward expansion are sought after by collectors. (*Courtesy of the California Museum of Photography, Riverside.*)

Stereo cards with original photographic prints attached are almost always more valuable than printed cards. Those containing albumen prints (distinguished by a reddish-brown tone) in mint or near-mint condition are also more valuable.

Among the most interesting *common* stereographs are those made by amateurs just prior to the turn of the century. Well-made amateur stereos of unusual subjects are valuable because they are in most cases one-of-a-kind images.

The Uncommon Stereograph ($10 to $100)

Most stereo cards in this category date from the period 1850 to 1880 and account for approximately 25% of the available base. These include views from the American Civil War ($30–$100) and documentary images of early disasters ($15–$50). Stereographs of famous expeditions to the Middle East, Africa, and the American west are occasionally found in partial or complete series ($60–$100 per set). Stereographs of policemen, firemen, animals, blacks, Indians, sports, and transportation are sought after by "subject" collectors and are therefore *uncommon*. Occasionally, early calotype or tissue stereographs can be found for under $100.

The Rare Stereograph ($100 to $1,000, Including Sets)

Many of the individual items listed above as *uncommon* could be categorized as *rare* when contained in partial or complete series. For

Fig. 9-12. "Onward and Upward over the Chilcoot Pass," by James Davis; albumen stereograph.

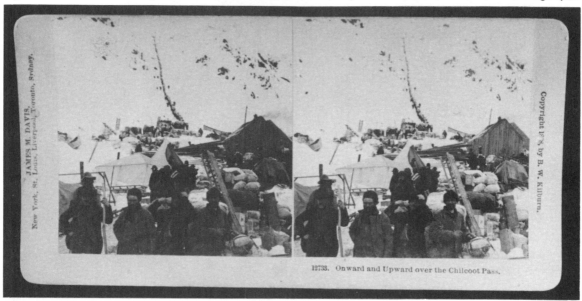

Stereographs of this famous scene were as popular in 1898 as they are with collectors today. This one depicts a group of miners preparing to join the "stairway of men" headed for the Klondike during the Alaskan Gold Rush.

example, a group of 12 stereographs from the Wheeler Survey (images of the American west taken by Timothy O'Sullivan and William Bell) sold at auction for $550 (Swann Galleries, April 1989). At that same sale, a group of 50 cards of mixed subjects brought $110 (considerably less than expected).

Very early stereographs (1850 to 1855) are *rare*. Daguerreotype and ambrotype stereographs are usually portraiture, still-lifes, or art studies (nudes), and these seldom go for less than $200 to $300. At the 1989 Swann Galleries sale, a stereo daguerreotype of a man in a top hat with a bird cage, contained in a Mascher case, sold for $495.

Interestingly, the tintype is the rarest of early stereo formats, primarily due to the domination of other, more suitable media during that period.

The Premium Stereograph ($1,000 and Up)

A very small number of stereographs appear in this value range. A few very rare stereos of Lincoln and other notables have brought $1,000+, and occasionally a unique collection will be offered which commands a premium price. Also, some very early images have sold in this price range.

Investment Potential

Nearly all stereographs in the *uncommon* and *rare* categories have more than doubled in value during the past decade. Because there are more stereograph collectors today than ever before, even basic "collectibles" are becoming harder to find. The next five to ten years

Fig. 9-13. The Corliss Engine at the International Exhibition.

The Centennial Exhibition, held in Philadelphia in 1876, featured the giant Corliss engine as the exhibition's centerpiece display. The engine was the highlight of the fair, and this stereograph was the most popular of the Centennial series.

will see many stereo images finding their way out of the antique/collectible market and into rare photography sales.

Dating Stereo Cards

Daguerreotype, ambrotype, tintype, and calotype images date from the period of their popularity, mostly before 1860 (see specific chapters on these processes for details). Glass transparencies date from the period 1850 to 1875. Most mechanically reproduced stereographs (which have the image imprinted directly on the card-mount surface) date from after 1875, although collotypes were made in limited quantities beginning in 1853. Collotype stereos are usually hand-tinted and present a very coarse image.

Albumen stereographs, which make up the bulk of collectible stereo images, were produced from the mid-1850s until around 1900. They are dated by changes in mount shapes and colors. As previously mentioned, earliest cards were lightweight, square, and flat. Colors were pale grey, cream, and white. Starting in the 1860s, a heavier cardboard was used and corners were rounded. Yellow was the most popular color, pale at first, then becoming brighter in the 1870s. A variety of other colors was also

Fig. 9-14. Still-life, by T. R. Williams; stereoscopic daguerreotype, 1850s.

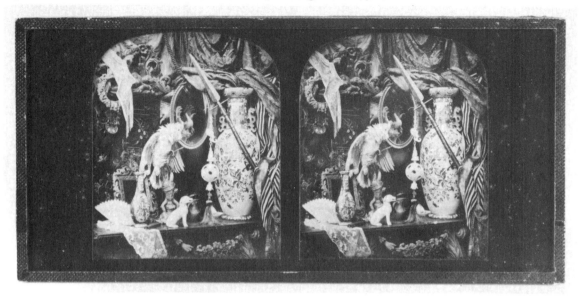

Daguerreotype stereos were produced in very small quantities and are therefore quite rare. Most of these were either portraits or still-life views of various arrangements, as is the one shown here. This image sold for £400 ($650) at a London auction in 1988. (*Courtesy of Christie's South Kensington.*)

used during this period, including a popular orange.

Stereo cards from the 1870s are difficult to date, since this was a transitional period, with a variety of colored mounts holding albumen originals, copy prints, and photomechanical reproductions. In the late 1870s, mount cards were warped (given a lengthwise curve) to increase the illusion of depth and to improve stability. This warped mount became the standard for all stereograph cards manufactured after 1880.

Many stereographs produced after 1890 were lithographic prints, some in color. Some manufacturers continued to use mounted prints, now mostly on silver-bromide paper, exhibiting rich blacks and fine grey tones. These were usually mounted to heavy, warped, dark grey or black mounts.

The stereograph has provided entertainment and information to nearly 150 years of collectors and devotees. In the next decade, it will also bring substantial financial gains to those who have made a wise investment in this most diverse of image collecting fields.

Dry Plates and Gelatin Prints

gelatin print: A photographic print on gelatin-coated paper. Sensitizing agent: silver bromide or silver chloride; developing agent: metol hydrochinon. Introduced by Richard Maddox (Britain).

Introduced 1871
Peak years 1880–?*

* A modified version of this early process is still in use today.

History of the Dry Plate, Gelatin Prints, and Other Late-Nineteenth-Century Printing Process Developments

Despite the overall popularity of and the extensive use of the collodion wet-plate process, photographers never ceased complaining about the inconvenience of this messy process. Plate holders and cameras frequently gummed up with sticky collodion residue, and hands were constantly stained from contact with silver nitrate. Traveling photographers had to carry mounds of chemicals and equipment and then, upon locating a prospective scene, quickly unload and set up the portable darkroom so that a plate could be sensitized.

Numerous experiments aimed at producing a dry-plate process were attempted throughout the 1860s and 1870s. British physician Richard Maddox conceived the idea of gelatin-based photographic plates in 1871, but it was not until improvements were made by Maddox in 1873, and Charles Harper Bennett in 1878, that commercial dry-plate production could become a reality. By 1880, several British manufacturers were producing factory-sensitized, high-speed (for this time period), ready-to-use photographic plates in quantity. However, photographers were slow to convert to the new plates, mostly because of poor first trials and rumors of inconsistent results.

In the winter of 1880, several tests of the new dry plate were performed by members of the Photographic Association of America, whose report was published in January of 1881. The committee announced that for quality and ease of use, the dry plate was superior in every way to the old wet-plate system of photography.

Still, the high cost of this new plate kept

Fig. 10-1. Advertisement for Carbutt Dry Plates, ca. 1900.

By the turn of the century, numerous companies were producing gelatin dry plates for amateur and professional use. The "flat cut films" advertised here were the forerunner of the modern photographic process.

it from achieving overnight success. Each plate had to be purchased from the manufacturer, while with the wet-plate system the glass could be cleaned and reused. It must be remembered that the wet-plate process had been in extensive use longer than any other photographic media to that day. Early trials by photographers well-entrenched in the old system were wrought with costly and discouraging failures.

For the amateur, however, the dry plate was a godsend. Early manufacturers aimed their promotions toward the nonprofessional and even began producing easy-to-use hand-held cameras.

One of these amateurs, working as a bank clerk in Rochester, New York, became interested in dry-plate production, and in 1880 he withdrew his life savings to begin manufacturing plates for E. and H. T. Anthony and Co. Despite early setbacks, the young man turned his small manufacturing business into a photographic empire which today is the largest and most recognized supplier of image-making materials in the world. The man's name was George Eastman.

Eastman's competitors during those early years were John Carbutt (Keystone Plates), Cramer and Norden of St. Louis, and Edward Anthony (Defiance Plates). Despite this hefty competition, Eastman was able to hold his own in the dry-plate business, while at the same time developing gelatin roll film (1884) and the Kodak detective camera (1888). The name *Kodak* was conceived by Eastman because it was easy to pronounce and remember. So many varieties of Kodak cameras were produced during the early years that a collector's guidebook has been published covering just this one brand of camera.

In 1880, while the Photographic Association was testing dry plates, a British firm was introducing a new type of printing paper with a similar gelatin-based emulsion. Called bromide (or silver-bromide) paper, it surpassed albumen paper in both speed and convenience. Like the dry plate, bromide paper achieved early success in England, but it was not well known in America until 1887, when a court battle erupted between former associates George Eastman and Edward Anthony. Suits were brought by both sides for infringement of patent rights relating to the manufacture of the new gelatin-based paper. An out-of-court settlement was made which allowed both sides to continue production.

There were many problems with stability and quality control in the early gelatin papers (the faded condition of many extant bromide prints bears witness to this). By the turn of the century, many professionals were using the more permanent and more expensive Velox (see below) and carbon prints for their important work, leaving bromide paper for "cheap" prints. Many photographers still considered albumen paper superior, but nevertheless opted for the convenience of bromide.

Velox

Velox was a gelatin-chloride paper which came on the market around 1893. Some photographers (especially amateurs) preferred it because it was less sensitive than bromide papers and could be handled in dim light. Bromide papers required complete darkness or special safelights. Because they were printed by artificial light sources, Velox and other chloride papers were given the nickname "gaslight paper."

Carbon Prints

The basic concept of the carbon print had been around since the 1830s and was patented by Frenchman Alphonse Poitevin in 1855. However, the process produced poor tonal gradation, a failing remedied by Joseph Swan in his modified carbon process of 1866. Now

Fig. 10-2. "Jacob's Ladder," by G. A. Douglass; chloride print, ca. 1896.

By the middle of the 1890s, most professional photographers had turned to the dry plate–gelatin print process. The image could be contact-printed and mounted in the style of the cabinet card (as shown) or enlarged to suit the customer's needs.

capable of superb tonal range and extreme permanence, carbon prints were popular for exhibition images by art photographers at the turn of the century.

Platinum Prints

The platinum print process was also experimented with during the early years of photography, but it did not achieve notoriety until a paper was published by two Austrian photographers in 1882. Relying on elaborate chemical reactions, the process produced an image consisting of pure platinum. Prints produced by this process exhibit superior tonal qualities and are extremely stable and permanent.

The innovations discussed here were forerunners of the modern photographic process, and, in fact, some of these methods are still in use for exhibition printing. The top photographic suppliers of the era, such as Anthony and Scovills (later Ansco) and Eastman Kodak, helped make photography an essential element of twentieth-century life.

The Dry-Plate, Gelatin Print, and Platinum Print Processes

At the turn of the century, photographers had their choice of three types of cameras: one which used dry plates, one which used roll film, or one which used both. Because roll film did not come into extensive use until after the turn of the century, we concern ourselves here with dry-plate photography as practiced beginning in the late 1880s.

Dry plates were purchased from a supplier in a light-tight container. In a darkroom, by the dim glow of a safelight called a "ruby lamp," the plates were inserted into plate holders. Because it was difficult to tell which side of the plate was which, the photographer would touch his tongue to an area near the edge, knowing that the film side of the plate would be tacky.

One by one, the film holders were inserted into the camera and the various exposures made. By this time, cameras were equipped with adjustable diaphragms and shutters, allowing easy adjustment for changes in light intensity. When the photographic session was over, the holders containing exposed plates were carried back to the darkroom for developing.

A number of developing solutions were used during the early years. Ferrous oxalate and pyrogallic acid ("pyro") were among the first. Amateurs, who in their enthusiasm produced large quantities of images, complained about developer stains and the constant changing of spoiled pyro. This prompted the introduction of other formulas, primarily metol hydrochinon ("metol"), which could be produced from powders as needed. After development, the plate was fixed in hypo, washed, and dried.

Although enlargers were at this time coming into use, contact printing was still the common method. Two different types of paper could be used: developing paper (bromide or chloride) or printing-out paper (aristotype, lithium, or albumen). Developing papers (exposed by gaslight) required a developing agent to bring out the latent image, while printing-out papers (exposed in sunlight) darkened with exposure and required toning. The developer for paper was the same metol solution used for plates. Finished prints were fixed, then washed and dried as usual. As part of the mounting process, prints were often burnished—that is, run

Fig. 10-3. Child by wall of photos; Kodak gelatin print, 1890s.

The first Kodak cameras produced a round image which was processed and mounted by the Kodak company. As many as 100 of these photographs could be taken on a single roll of film.

between hot rollers to induce a hard, glossy finish.

As more and more amateurs became involved in photography, commercial processing plants were opened to save snapshot takers from the mess of developing. One early Kodak film camera came preloaded with film. After the roll was exposed the entire camera was shipped back to Kodak for film development, mounting, and reloading. As the new century approached, photography appeared to have reached the ultimate in convenience.

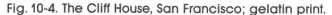

Fig. 10-4. The Cliff House, San Francisco; gelatin print.

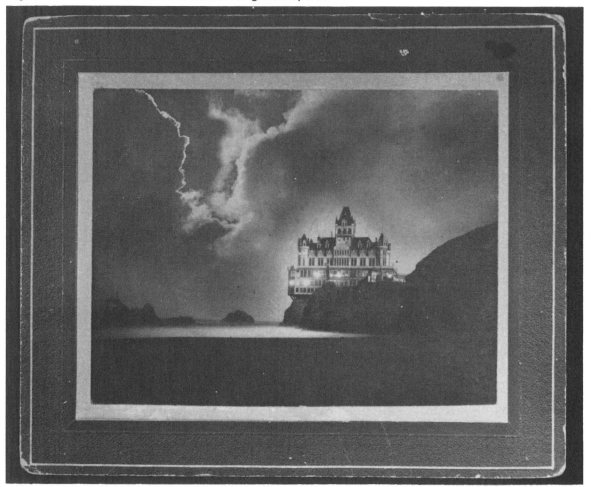

Encouraged by the convenience of the new photographic processes, amateurs were producing some spectacular images, such as this superb time exposure taken as a thunderstorm approached. Because the photographer is not identified, images such as this can be purchased at very reasonable prices.

Collecting Gelatin and Platinum Prints

While bromide- and chloride-based gelatin prints were produced in quantity by amateurs and professionals, "permanent" print processes, such as carbon and platinum, were used primarily by professionals for works which they considered important. Therefore, most bromide- or chloride-based prints are considered *common,* while most carbon or platinum prints can be classified as *uncommon* or *rare.*

Identification of Gelatin Emulsion and Platinum Prints

Early bromide and chloride prints are subject to fading and "silvering" (that is, the silver appears to have surfaced, usually near the edges, exhibiting a metallic sheen). These prints do not ordinarily display the tonal range of carbon or platinum prints.

Fig. 10-5. "Gathering Waterlilies," by Peter Henry Emerson; ca. 1855.

One of the most published nineteenth-century photographs, this image was the earliest of Emerson's works to be made commercially available, first as a photogravure and then as a platinum print in the publication *Life and Landscape on the Norfolk Broads* (1886). The gravure shown here sold at a 1988 London auction for £550 ($880). (*Courtesy of Swann Galleries.*)

At first glance some carbon prints can look very much like well-made bromide prints, except that they do not exhibit the same symptoms of deterioration. When a carbon print is held at a certain angle to the light, the shadows of the image should appear shinier than the highlights and should appear to lie on the surface of the paper, not in it.

Platinum prints exhibit a richness and broad tonal quality unequaled in other processes. Blacks are usually cold black, and greys are silvery (although some brown-toned prints were produced). The surface of the paper has a matte finish, and, under magnification, the image can be seen to be imbedded in the fibers.

Availability/Value Classifications

The Common Gelatin Print ($1 to $10)

Bromide and chloride prints, produced in quantity by amateurs and professionals, encompass a variety of subjects and scenes. All good-quality gelatin prints which can be specifically dated to the period 1880 to 1900 are valuable as being representative of the early years of the process. Some beautifully artistic images, produced by ''unknown'' photographers, are available for very low prices. While they will probably never command high prices, these images are now receiving appreciation for their aesthetic and historic merit.

Uncommon Gelatin and Platinum Prints ($10 to $100)

Bromide prints of exceptional note and those produced by well-known photographers will bring higher prices ($25–$75). Because of the nature of their use, unattributed carbon and platinum prints are valuable as being representative of the processes ($25–$50). When identified, even those by lesser known artists can bring $75 to $100.

Rare Gelatin and Platinum Prints ($100 to $3,000)

Prints of unusual merit and/or attributed to well-known photographers are offered by dealers and auction houses at nearly every photographic sale. An early Thomas Annan carbon print, produced in 1878, was sold by Swann Galleries for $660 (4/24/89, #162). Platinum prints by artists such as Thomas Eakins (portraits) and Frederick Evans (architecture) frequently bring in excess of $1,500. Books and albums containing these prints can be quite

Fig. 10-6. "Chief Kills-Close-to-the-Lodge," by Gertrude Käsebier; ca. 1889.

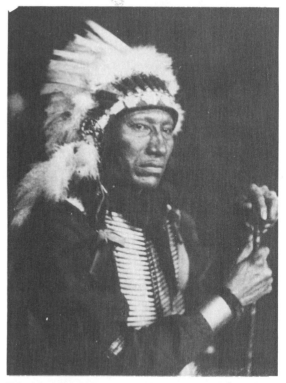

This 6″ × 8″ platinum print brought over $3,000 at auction in 1989. High-quality platinum images by important photographers from the turn of the century often fetch two to five thousand dollars. (*Courtesy of Swann Galleries.*)

valuable, as are series, such as the Indo-Chinese studies which recently sold for $248 (nine carbon prints by Hocquard, Swann Galleries, 4/24/89, #359). At that same sale, a portfolio containing 25 platinum print studies of flowers brought $2,860, even though the images were unattributed.

Premium Gelatin and Platinum Prints ($3,000 and Up)

Several examples in this category presented themselves at both the fall 1988 Soth-

eby's and the spring 1989 Swann Galleries auctions. A beautiful platinum print plate from Peter Henry Emerson's *Life and Landscape on the Norfolk Broads* (1886) sold for $4,950; an album containing 20 platinum prints of Indians by F. A. Rinehart brought $3,575; and a bromide print of Rodin's statue "The Thinker," signed on the negative by Rodin and the photographer Eugene Druet, realized $4,400, nearly four times the estimate.

Fig. 10-7. Photographic variant; cyanotype, ca. 1900.

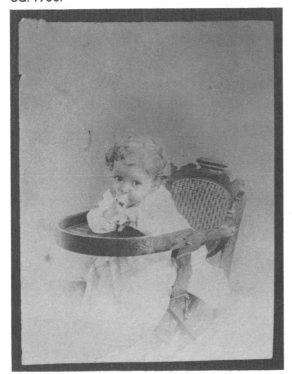

In color, this image is composed entirely of blue lines on a white background. The cyanotype process achieved its greatest popularity among amateurs at the turn of the century and was the forerunner of the modern blueprint process.

Fig. 10-8. Photographic variant; woodbury-type, 1870s.

This image once graced the page of a book on actors and their various roles. Woodburytypes were the most popular early form of photomechanical reproduction prior to the introduction of halftone printing in the 1890s.

Although these processes received more extensive use after 1900, for the collector of nineteenth-century images they represent the culmination of 60 years of photographic experimentation and progress. Throughout the 1800s, photography had been very much a personal experience for those involved. The elaborate processes required individual patience and diligence to achieve any sort of quality in the finished image. There were amateurs, but even they had to be dedicated to the art, for those who were not quickly gave up in frustration.

With the advent of hand-held cameras, dry plates, roll film, and presensitized paper, photography became easy. Anyone who could aim a lens and push a button could take a picture. This meant that those who called themselves "photographers" now had to prove their worth. The degree of their success is reflected today in the value we have placed on their works.

American Civil War Images

American Civil War images were produced by ambrotype, tintype, carte de visite, and albumen print processes. War-related images were made as early as 1858, and as late as 1870, even though the war itself lasted from 1861 to 1865.

Fig. 11-1. Alex and Belle; tintype (left), ambrotype (right), ca. 1862.

This double case containing images of a Civil War sergeant and his beau is a valuable collector's item, but even more important is its intrinsic value. Behind the ambrotype is a note which reads: "Alex's picture given to Belle. I will keep it and think of thee Alex, Belle."

Collecting American Civil War Images

A unique area of photograph collecting involves images produced in America during the period of the American Civil War. Although hundreds of thousands of images relating to the conflict were produced, demand from museums, historians, and collectors makes them relatively scarce and comparatively expensive.

Of the various formats which make up the collectible base for this field, the largest percentage are cartes de visite (50%), followed by tintypes (25%), stereographs (15%), ambrotypes (10%), and large albumen prints and daguerreotypes (less than 1%). The values of Civil War images reflect this relative availability—cartes are the easiest to locate and the least expensive, while war-related daguerreotypes and albumen prints are seldom found outside of dealer and auction houses, where they are in great demand.

Tintypes are found both in carte de visite–sized mounts and cased in the style of daguerreotypes. Collectors are cautioned that tintypes are often not original to their cases, having been placed there to improve their appearance and value. Original-case tintypes command higher prices than loose or sleeved examples, especially if case elements indicate that the image was made early in the war.

Ambrotypes were produced less frequently as the war progressed, and therefore most existing ambrotype images are from the early part of the war. Special attention should be given to ambrotypes of officers, since most soldiers who achieved rank early were rapidly promoted and, if they survived, may have become important high-ranking officers by the war's end.

Cartes de visite of individual soldiers were produced in large quantities when new recruits heading for battle lined up to have portraits made in their new uniforms. As troops on the march passed through various towns along the way, the gallant lads would often head for the nearest photographic establishment, eager to show off a scruffy new beard or well-earned gold stripes. Thousands of images were sent by mail in both directions. Often the photog-

Fig. 11-2. Daddy's little soldier; ambrotype, ca. 1862.

Too young to be a drummer boy, this youngster is showing his patriotism through the wearing of a Union kepi. War-related images of children are quite uncommon.

Fig. 11-3. A Union captain; 1/6-plate ambrotype, ca. 1861.

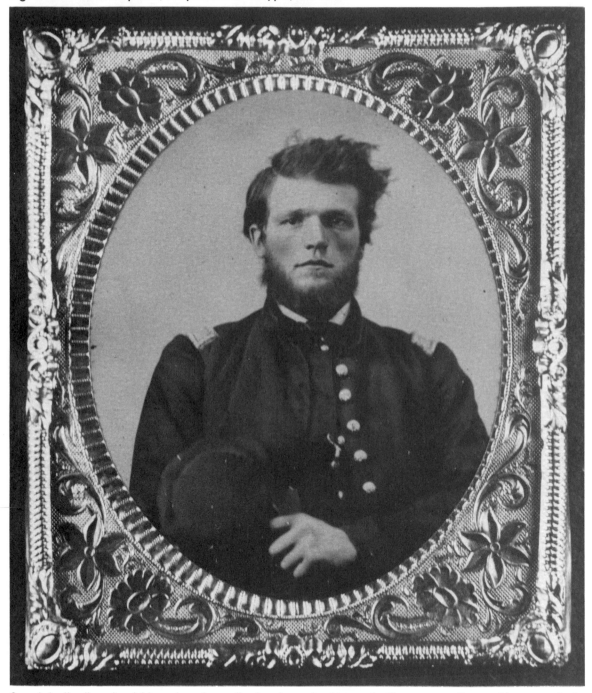

Special attention should be given by collectors to ambrotypes of officers, even those of lesser rank. As the war progressed, those who survived often rose to high positions.

Fig. 11-4.

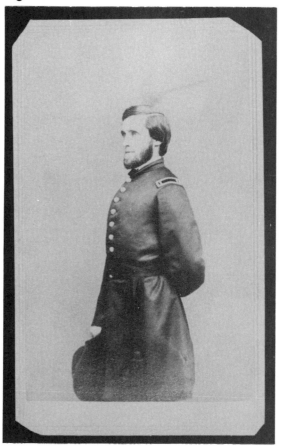

Fig. 11-5.

Civil War uniforms are not always recognizable at first glance. A careful study of published photographs helps a collector to recognize a military image that someone else may pass up. Shown here are a Union lieutenant (Fig. 11-4), a Confederate private (Fig. 11-5), a Confederate soldier of unknown rank (Fig. 11-6), and a private of unknown sympathies (Fig. 11-7).

rapher would include mailing services in the cost of the portrait.

As the war progressed, manufacturers of mass-produced cartes and stereographs began to take advantage of the excellent images being produced by Brady, O'Sullivan, Gardner, and other battlefield photographers. Primary among distributors of war-related images was E. and H. T. Anthony and Co., who marketed battle and encampment scenes, as well as portraits

of military heroes, until well after the end of the war.

Availability/Value Classifications

The Common Civil War Image ($5 to $25)

This category consists entirely of cartes de visite and sleeved or loose tintype portraits

Fig. 11-6.

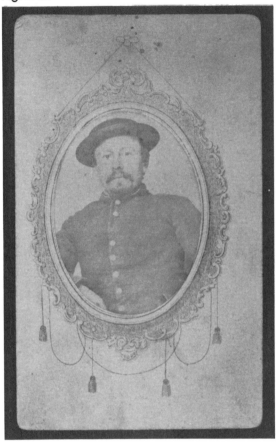

Fig. 11-7.

and makes up approximately 75% of the collectible base. These are occasionally available at flea markets and antique shops, or they can be purchased from photographica and military artifact dealers. Carte de visite portraits of soldiers are sometimes found in albums or stacks of cards that have not yet been thoroughly scrutinized by collectors. Civil War uniforms were varied and are not always easily recognizable as being of military origin (especially uniforms of the Confederacy). Seasoned collectors learn to recognize the "look" of a military image (see Figs. 11-4 through 11-7). A popular current trend is the collecting of identified portraits of common soldiers.

The Uncommon Civil War Image ($25 to $100)

Primary to this category are cased images, identified portraits of officers, portraits containing weapons and accoutrements, and "production" cartes and stereographs. Specific prices are based primarily on the changing factors of supply and demand of the particular type of image in question. About 20% of ex-

Fig. 11-8. "The Empty Sleeve"; carte de visite, ca. 1866.

Fig. 11-9. A Union sergeant; 1/9-plate tintype, ca. 1864.

Basic tintype portraits of soldiers were once quite common; however, in today's market any image relating to the Civil War is quickly snatched up by collectors. Cased tintypes such as the one shown here commonly bring $50 to $100.

After the conclusion of the war, manufacturers continued to produce war-related stereographs and card photographs. This litho carte was intended to evoke a feeling of sadness and is successful in doing so.

isting Civil War images can be considered *uncommon*.

The Rare Civil War Image ($100 to $1,000)

This category represents one of the strongest areas of photographic investment. Offerings at recent auctions have often surpassed their high estimates, and some are bringing two and three times the expected price. Primary in this category are images by well-known photographers and portraits of important military figures. Individual plates from (Alexander) *Gardner's Photographic Sketch Book of the War* are selling for around $1,000 each, and a portrait of Union Colonel Burnside recently sold for $660.

Certain original cartes de visite (not pirated copies or engravings) of Generals Grant, Sherman, McClellan, and others can bring $200 and up. Complete albums of Civil War–period cartes have been selling for $500 and up. A

Fig. 11-10. A Union corporal; 1/6-plate tintype, ca. 1863.

Especially valuable among unidentified portraits are those which contain weapons and accoutrements. This image also sports a valuable patriotic mat.

Fig. 11-11. A handsome soldier; 1/6-plate tintype, ca. 1863.

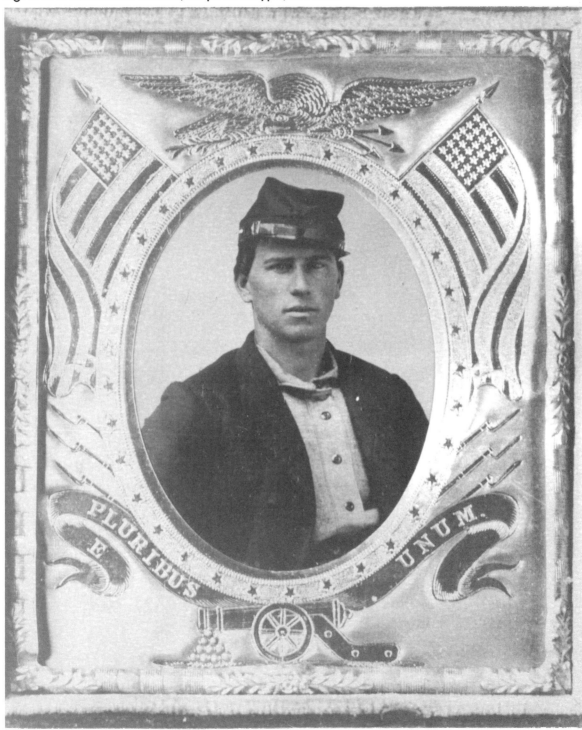

The beautifully embossed mat which surrounds this image leaves no doubt as to where this soldier's sympathies lay. Quality cased images of this type are quickly becoming scarce.

Figs. 11-12 and 11-13. "Ruins of Richmond, April, 1865"; albumen stereograph; image ca. 1865, published 1893.

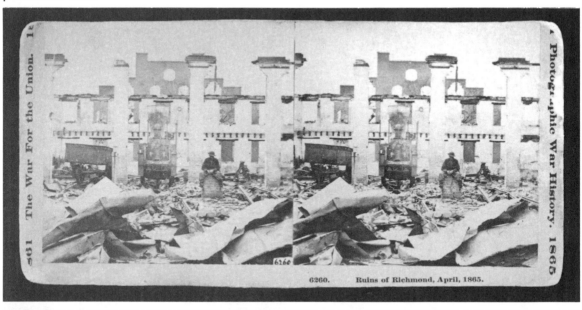

After the war, demand for this type of image quickly subsided. As the turn of the century approached, several companies attempted to renew interest with the republication of the original war views previously published by E. and H. T. Anthony & Co. Although the idea was commercially unsuccessful at the time, it did provide modern collectors with additional images from the original negatives.

collection of 42 cartes de visite of Union officers accompanied by an albumen print of the headquarters of the Army of the Cumberland sold for $935 at the November 1989 Sotheby's sale.

The Premium Civil War Image ($1,000 and Up)

High-quality war-related daguerreotypes and ambrotypes, unique albums and collections, and a few very rare individual images valued in excess of $1,000 are considered to be *premium* examples. One such image, an albumen print entitled ''Bodies of Federal Soldiers . . . Gettysburg,'' by Timothy O'Sullivan, sold at auction in 1988 for $3,850, more than twice its high estimate (Sotheby's 11/2/88, #405). The highlight of the Swann Galleries 1989 sale was a complete copy of *Gardner's Sketch Book of the War* with 100 albumen prints, which sold for a record $30,800.

Civil War Revenue Tax Stamps

During the period from August 1864 to August 1866, the U.S. government instituted a law requiring that a tax stamp be attached to the back of specific types of photographs, and that it be canceled by the selling establishment at the time of the sale. The denomination of the stamp was proportionate to the cost of the photograph: 2 cents for images that cost less than 25 cents each; 3 cents for images that cost 25 to 50 cents; 5 cents for images that cost 50 cents to $1; and 5 cents for each additional dollar of cost.

Many types and colors of stamps were used, however the blue 2-cent ''playing cards'' stamp is significant because it was used during the summer of 1866. While images with this stamp can be specifically dated to the summer of that year, other stamps can also be significant when the cancellation includes a date (Fig. 7-13). All photographs with Civil War tax stamps affixed are slightly more valuable because they can be positively dated to that period.

In accordance with the law, this card mount bears two cents' worth of revenue stamps, cancelled by the photographer with the stroke of a pen. One-cent stamps were used only when the appropriate denomination was not available.

Fig. 11-14. Reverse of Civil War–period carte de visite.

The collector who chooses to specialize in American Civil War images should become familiar with all aspects of that conflict. A knowledge of uniforms, ensignias, weapons, and accoutrements is a must. More than a basic knowledge of names and locations is required (military leaders, heroes, battles, and towns). As with all historical photographs, Civil War images can only gain in value as time passes. This specialty is both demanding and rewarding.

Discovered within an album of ordinary images, this identified carte was found to be of historical importance. Phelps was a member of the notorious band called Jennison's Jayhawkers who terrorized the Missouri–Kansas border in 1861 and 1862. This image was taken after the 7th Kansas had been "banished" to Mississippi in 1863.

Fig. 11-15. J. W. Phelps, 7th Kansas, C. S. A., by Armstead & White, Cornith, Mississippi; carte de visite, ca. 1863.

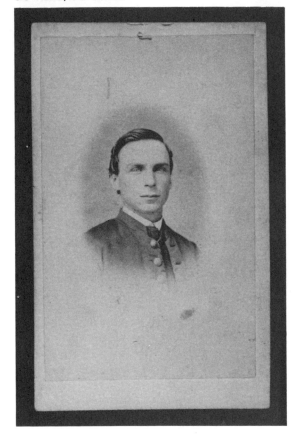

APPENDIXES

Nineteenth-Century Photographers of Note

Several million people were involved in the production of photographic images during the years 1839 to 1900. A large number of these were superb artists whose works have survived to this day, much to the delight of collectors. However, only a handful of these photographers made their mark on photographic history, and these are the names that collectors' dreams are made of. Dates given throughout are "in business" dates for each photographer.

Adamson, Robert. Scotland; 1842–60; calotypes.

Some of the best early photographic work was done by the team of Hill & Adamson, primarily portraiture and architectural views. *Rare* and *premium*. (See Fig. 5-3.)

Alinari, Fratelli. Italy; 1850s to 1880s; albumen prints.

Famous for architectural views of Italian landmarks. *Rare* and *premium* (albums).

Allen, Amos. United States; 1852–93; daguerreotypes, albumen prints, card photographs.

Famous for daguerreotype profile portraits and later for documentation of Pennsylvania mining towns. *Uncommon* and *rare*.

Anderson, James. Italy; 1850s to 1860s; albumen prints.

Produced views of Roman architecture. *Rare*.

Annan, James Craig. Scotland; 1890s; carbon prints.

Son of Thomas Annan, James was also known for his architectural photography. *Rare*.

Annan, Thomas. Scotland; 1868–77; carbon prints.

Famous for his photographs of the streets of Glasgow which were published in volumes around 1878. *Rare*.

Anson, Rufus. United States; 1851–67; daguerreotypes, ambrotypes, card photographs.

Unlike most early photographers, Anson often imprinted his name on his works on the plate and/or mat, making them more valuable to today's collectors. His heavily patronized gallery was in New York City. *Uncommon.*

Anthony, Charles J. United States; 1850s; daguerreotypes.

Inventor of the "magic background" vignetting process, which produced unusual patterns around the image. Unfortunately, his work is rarely identified. *Rare.*

Anthony, Edward. United States; 1850–74; daguerreotypes, stereo, albumen, and card photographs.

A prominent figure in American photography, Anthony produced daguerreotypes at a New York gallery until 1847 at which time he started concentrating on manufacture and supply of photographic materials. Daguerreotypes by his hand are *rare*: cartes de visite and stereos with his imprint are *uncommon*. (See Fig. 7-5).

Atget, Jean-Eugène-Auguste. France; 1890s; gelatin print.

While primarily a twentieth-century photographer, Atget's early works are especially in demand. Mostly exteriors, statuary, fountains, etc. *Rare*.

Babbitt, Platt D. United States; 1853–70; daguerreotypes, albumen prints.

Operated an outdoor gallery at Niagara, with the falls as backdrop. Daguerreotypes *rare* and *premium;* other work *uncommon*.

Baldus, Edouard-Denis. France; 1850s to 1860s; calotypes, albumen prints, salt prints.

Produced exterior views, fountains, statuary, etc. Early works (calotypes, salt prints) *rare* and *premium;* later albumen and reprints *uncommon*.

Ball, James P. United States; 1845–74; daguerreotypes, albumen prints, card photographs.

Well-known early black daguerreotypist practiced in Cincinnati, Ohio. Documented slave trade and plantation life. *Rare*.

Barnard, George. United States; 1850s to 1880s; daguerreotypes, albumen, and card photographs.

Member of ''Brady's Photographic Corps'' famous for photographing the people and places of the American Civil War. Daguerreotypes *premium;* war-related prints *rare;* others *uncommon*.

Bayard, Hippolyte. France; 1850s; daguerreotypes, calotypes, albumen prints.

One of the early pioneers of photography. *Premium*.

Beard, Richard. England; 1840s to 1850s; daguerreotypes.

One of London's leading early daguerreotypists. *Premium*.

Bedford, Francis. England; 1850s to 1860s; albumen and cartes de visite.

Specialized in cathedrals and British landscapes. *Uncommon,* some *rare*.

Bell, William. United States; 1870s; albumen prints.

One of a group of well-known photographers who documented expansion into the American West. Specialized in expansive views. *Rare*.

Bisson, Auguste-Rosalie and Louis-Auguste. France; 1840s to 1860s; calotypes and salt prints, daguerreotypes, albumen prints.

Known for their spectacular Alpine views, these brothers also photographed cathedrals. *Rare*.

Black, James. United States; 1845–70; daguerreotypes, albumen prints.

Partner in daguerreotype gallery of John Whipple. Took first aerial photographs (wet plate) in 1860. *Rare*.

Blanquart-Evrard, Louis-Désiré. France; 1846–67; calotypes, salt prints, albumen prints.

Introduced the albumen print in 1850. His firm produced a number of illustrated books and mounted images by various photographers in both salt and albumen prints. *Rare* and *premium* (books). (See Fig. 5-4).

Bogardus, Abraham. United States; 1846–87; daguerreotype, ambrotype, tintype, albumen, cartes de visite, cabinets.

This well-known New York daguerreotypist later became the first president of the National Photographic Association. Cased images *rare*; others *uncommon*. (See Fig. 8-2).

Bonfils, Felix. France; 1870s; albumen prints.

Made photographic excursions throughout the Middle East from his studio in Lebanon. Work includes views of landmarks and architecture. *Rare*.

Boughton, Alice. United States; 1890s; platinum and gelatin prints.

Primarily a portrait photographer at the turn of the century. Associated with Gertrude Kasebier. *Rare*.

Bourne, Samuel. England; 1860s; albumen prints.

Famous for his views of landmarks and landscapes of India. Produced small-format albumen studies (4″ × 8″). *Rare*.

Brady, Mathew. United States; 1843–90; daguerreotypes, ambrotypes, tintypes, albumen prints, cartes de visite, cabinets.

Probably the most recognized name in nineteenth-century American photography. Produced many daguerreotypes of celebrities and politicians of the period. Famous for photographs of the Civil War, although many images which bear his name were not taken by him. Cased images and albumen prints *rare* or *premium;* others *uncommon*. (See Figs. 7-4 and 7-5).

Braun, Adolphe. France; 1840–70; daguerreotypes, albumen prints, stereographs, and cartes de visite.

Took mountain and landscape views of Switzerland. Famous for instantaneous street scenes (stop-action). *Rare*.

Britt, Peter. United States; 1870s to 1880s; daguerreotypes, albumen prints.

Britt was one of the earliest daguerreotypists to open a studio in the American northwest (Jacksonville, Oregon, 1852). In later years, he helped to document westward expansion. *Rare*.

Broadbent, Samuel. United States; 1840–80; daguerreotypes, ambrotypes, cartes de visite, cabinets, stereographs.

This accomplished daguerreotypist operated studios in Georgia (1843–47), Delaware (1848–50), and Philadelphia (1851–80). For many of his daguerreotype portraits he used a distinctive painted backdrop. Cased images *rare;* others *uncommon*. (See Fig. 1-9).

Cameron, Julia Margaret. England; 1860s to 1870s; albumen prints.

One of the most recognized names in late-nineteenth-century photography, Cameron produced superb "character" portraits, especially of children. Her images were often softly lit and focused, giving the effect of a Renaissance painting. Even though her prints were commercially produced in some quantity, the high demand from collectors has made them *rare*. (See Fig. 6-10).

Carjat, Étienne. France; 1855–75; albumen prints, cartes de visite.

Well-known and influential French portraitist, a contemporary of Nadar. Their works, published in Galerie Contermporaine, are sought after by collectors, as are individual cartes de visite. *Uncommon* or *rare*.

Carroll, Lewis. England; 1850s to 1860s; albumen prints, cartes de visite.

The author of *Alice in Wonderland* also produced some superb artistic photographs, primarily portraits and "staged" scenes. *Rare* or *premium*.

Carvalho, Soloman. United States; 1849–80; daguerreotypes, albumen prints, cartes de visite.

One of the earliest photographers to accompany an expedition to the American west (John C. Fremont expedition, 1853–54). Operated galleries in Baltimore and in New York City. Daguerreotypes and albumen prints *rare;* cartes de visite *uncommon.*

Chase, Lorenzo. United States; 1844–56; daguerreotypes.

Unlike that of most daguerreotypists, Chase's work can often be identified by an imprint in the brass mat, making his work *uncommon* or *rare.*

Claudet, Antoine François Jean. France/England; 1841–54; daguerreotypes, calotypes, albumen prints, cartes, stereographs.

The premier British daguerreotypist. *Rare* and *premium.*

Clifford, Charles. Spain; 1850s; albumen prints.

Produced views of Spanish landscapes and architecture, as well as photographs of armor. *Rare.*

Cook, George Smith. United States; 1840–80; daguerreotypes, ambrotypes, tintypes, cartes de visite, albumen prints.

Very active in daguerreotypy, especially in Charleston, South Carolina. One of the best-known Confederate photographers during the Civil War. *Rare;* cartes de visite *uncommon.*

Daguerre, Louis-Jacques-Mandé. France; 1838–51; daguerreotypes.

As the inventor of the process which bore his name, and due to his early death, Daguerre's works are priceless. *Premium.*

Day, Fred Holland. United States; 1880s to 1890s; platinum prints.

Progressive and controversial turn-of-the-century photographer famous for his photographic reenactment of the "Passion of Our Lord" (1898). *Rare* or *premium.*

Delamotte, Philip H. Britain; 1840s to 1850s; calotypes.

One of several important amateur calotypists, Delamotte is known for his documentation of the construction of the Crystal Palace. *Rare.*

Demachy, Robert. France; 1880s to 1890s; platinum prints.

This prominent French photographer of the period produced highly artistic images in the style of the Photo-Secession group. *Rare.*

Disdéri, André-Adolphe-Eugène. France; 1854–89; daguerreotypes, albumen prints, cartes de visite, stereographs.

Known for popularizing the carte de visite. Early images *rare;* later works *uncommon.*

Du Camp, Maxime. France; 1840s to 1850s; calotypes.

One of a group of superb French calotypists whose works often appeared as Blanquart-Evrard plates. Images include Middle-Eastern views. *Rare.* (See Fig. 5-6).

Eakins, Thomas. United States; 1880s to 1890s; platinum prints.

Produced motion studies, portraits, and nudes in the artistic style of a painter-cum-photographer. *Premium,* some *rare.*

Eastman, Walter. United States; 1848–56; daguerreotypes.

Accomplished daguerreotypist whose name appears as successor on Plumbe gallery advertising cards attached to the backs of certain images. *Uncommon.*

Edwards, Jonas. United States; 1841–46; daguerreotypes.

Partner in the "National Portrait Gallery" with Edward Anthony. *Rare.*

Emerson, Peter Henry. England; 1880s to 1890s; platinum prints.

Vocal supporter of the "naturalist" school in art photography, precursor of the Photo-Secession group. Known for his series *Life and Landscape on the Norfolk Broads. Rare.* (See Fig. 10-5).

Evans, Frederick. England; 1880s to 1890s; platinum prints.

Another of the pre-Secessionist "art" photographers, Evans specialized in superb architectural views of cathedrals. He also did portraits of art and literary notables. *Rare.*

Fenton, Roger. England; 1850 to 1860s; calotypes, albumen prints, stereographs.

This prolific British photographer, the first to document the hazards and effects of war (Crimea 1855), is also famous for his still-life images. Fenton also produced many excellent travel and architectural views. *Rare* or *premium.* (See Fig. 5-7).

Fitzgibbon, John. United States; 1846–82; daguerreotypes, ambrotypes, tintypes, cartes de visite, cabinets.

Well-known St. Louis portraitist and early western itinerant daguerreotypist. Long and successful career produced many excellent images. Early work *rare;* later work *uncommon.*

Fontayne, Charles. United States; 1846–58; daguerreotype.

Specialized in full-plate daguerreotype panoramas and life-size paper photographs. *Rare.*

Fredricks, Charles De Forest. United States; 1852–94; daguerreotypes, ambrotypes, cartes de visite, cabinets.

Eminent New York daguerreotypist who later helped popularize the carte de visite in America. Had branch gallery in Cuba (1850s). Cased images, often identified by imprint on brass mat, *rare;* later images *uncommon.* (See Figs. 1-15, 7-2, and 7-17).

Frith, Francis. England; 1850s to 1880s; albumen prints.

Well-known and prolific British photographer produced excellent series of images depicting "Egypt, Sinai, and Jerusalem." Primarily a travel photographer. *Rare* and *premium;* some *uncommon.* (See Figs. 6-1 through 6-5 and Fig. 9-10).

Gardner, Alexander. United States; 1860s to 1880s; albumen prints, cartes de visite, stereographs.

One of the premier photographers of the American Civil War, *Gardner's Photographic Sketch Book of the War* series is prized by collectors (*premium*). Later Gardner produced images of westward expansion. Individual western and war-related images, *rare;* stereos and cartes de visite *rare* and *uncommon.*

Gouraud, Francois. France; 1839–48; daguerreotypes.

Agent for Daguerre, Gouraud produced numerous "sample" images and practiced portraiture at Niagara Falls in 1842. *Premium.*

Griswold, Victor. United States; 1850–72; daguerreotypes, ambrotypes, tintypes.

Best known as the inventor of ferrotype plates, competitor to Neff's melainotype (tintype). *Rare.*

Gurney, Jeremiah. United States; 1840–85; daguerreotypes, ambrotypes, cartes de visite, cabinets, albumen prints.

One of the most active and honored American portrait photographers. *Rare;* some cartes de visite and cabinets *uncommon.*

Haynes, Frank Jay. United States; 1870s to 1890s; albumen prints.

One of a group of photographers docu-

menting westward expansion. Employed by the Northern Pacific Railroad. *Rare.*

Hesler, Alexander. United States; 1847–90; daguerreotypes, ambrotypes, cartes de visite, cabinets, albumen prints.

Noted American photographer for almost half a century. Hesler's daguerreotype of Minnehaha Falls was the inspiration for Longfellow's epic poem *Hiawatha.* Pioneered dry-plate photography in the United States. Early work *rare;* cabinets and cartes de visite *uncommon.*

Hill, David Octavius. England; 1840s to 1850s; calotypes.

The team of Hill and Adamson was to British calotypy what the Southworth and Hawes team was to American daguerreotypy. Both portraits and views are prized by collectors. *Rare* and *premium.* (Watch for modern prints from the original negatives which are of considerably less value). (See Fig. 5-3).

Hill, Levi L. United States; 1845–60; daguerreotypes.

New York photographer who produced daguerreotypes in the "colors of nature" in 1850 and was never able to repeat the process. *Rare;* color images *premium.*

Hillers, John K. United States; 1870s; albumen prints, stereographs.

One of a group of photographers who documented expansion into the American west. *Rare.*

Jackson, William Henry. United States; 1860 to 1880s; albumen prints, stereographs.

One of the most famous photographers of the American west, known for his early views of Yellowstone. A number of western towns and landmarks are named after him. *Rare.* (See Fig. 6-6).

Johnson and Wolcott. United States/England; 1839–43; daguerreotypes.

John Johnson and Alexander Wolcott opened the first daguerreotype studio in the United States in March 1840, after development of the speculum camera. They were partners with Richard Beard in the first London gallery, opened in October 1840. Despite dedicated contributions to the art, they switched their efforts to other areas in 1844. *Rare* and *premium.*

Käsebier, Gertrude. United States; 1890s; platinum prints.

Opened fashionable portrait studio in New York in 1897. Received "rave reviews" for her artistic, "unadorned" images. Photographed Sioux Indians in 1898. *Rare.* (See Fig. 10-6).

Kurtz, William. United States; 1870s to 1880s; cabinet cards.

One of a group of very prestigious New York cabinet portrait photographers, Kurtz popularized the use of "Rembrandt" lighting. Portraits of notables *rare.*

Langenheim, William and Frederick. United States; 1842–74; all areas of photography.

Began practicing daguerreotypy in Philadelphia in 1842. Became American patent holders for calotype process in 1847. Patented photographs on glass ("hyalotypes") in 1850. Also produced glass stereographs and magic lantern slides. Works identified as Langenheims are *rare* or *uncommon.*

Laurent, Juan. Spain; 1860s to 1870s; albumen prints.

Produced albums and series relating to architecture and landscapes of Spain and Portugal. Also Spanish arms and armor. *Rare.*

Lawrence, Martin. United States; 1844–60; daguerreotypes.

Well-known New York daguerreotypist who specialized in large-plate images. *Rare.*

Le Gray, Gustave. France; 1840s to 1850s; calotypes, albumen prints.

Inventor of the waxed-negative improvement to the calotype. Identified works by Le Gray are *premium*.

Le Secq, Henri. France; 1840–80; calotypes, cyanotypes.

Produced calotypes of Egyptian scenes. *Rare* and *premium*.

MacPherson, Robert. Italy; 1850s to 1860s; albumen prints.

Famous for his views of Roman architecture. *Rare*.

Martin, Paul. England; 1890s; carbon and platinum prints.

British portrait photographer who produced candid street scenes using a concealed camera. *Rare*.

Marville, Charles. France; 1850s; calotypes, albumen prints.

Documented mid-nineteenth century Paris through views of the city, its cathedrals, and its back streets. *Rare*.

Maull and Polyblank. England; 1860s; cartes de visite.

Produced portraits of British notables for mass-distribution and sales. Cartes de visite of important figures *uncommon*.

Mayall, John. United States/England; daguerreotypes, cartes de visite, and stereographs.

This London photographer achieved early notoriety as a superb portraitist. He took excellent daguerreotype views of the Crystal Palace. Early work *rare* and *premium;* other work *uncommon*.

Meade, Charles and Henry. United States; 1842–58; calotypes, daguerreotypes, stereographs.

Two of the most active and influential American daguerreotypists, the Meades visited France in 1848 taking calotypes and daguerreotypes, including some of Daguerre. Most prolific of daguerreotype stereographers. *Rare* and *premium*.

Muybridge, Eadweard. United States, 1856–80; albumen prints, stereographs.

One of a group of photographers documenting expansion to the American west. Later became famous for his photographic studies of animal locomotion, published in several volumes (*premium*). His images of Yosemite and the west, as well as individual motion studies, are *rare*.

Nadar. France; 1850s to 1880s; Albumen prints, cartes de visite, cabinets, salt prints, and carbon prints.

One of the most famous of French photographers, specializing in "character" portraits of celebrities and politicians. Also produced aerial images and photographs by artificial light. His larger prints (including work published in "Galerie Contemporaine") are *rare;* card photographs *uncommon* and *rare*.

Negre, Charles. France; 1850s; calotypes, albumen prints.

Produced a variety of architectural, scenic, and documentary works, including studies of the Midi area of southern France. *Rare*.

North, Walter. United States; 1850–80; daguerreotypes, cartes de visite, cabinets, albumen prints.

An early specialist in negative retouching, North taught and wrote about the subject and received awards in the 1870s. *Rare*.

Notman, William. Canada; 1850s to 1870s; daguerreotypes, albumen prints, platinum prints, stereographs, cartes de visite, cabinets.

Most famous Canadian portrait and landscape photographer. *Rare;* stereographs and cards *uncommon*.

189

O'Sullivan, Timothy. United States; 1860 to 1880s; albumen prints, cartes de visite, stereographs.

One of the most famous members of Mathew Brady's Photographic Corps, O'Sullivan documented the American Civil War and westward expansion. Most of his work is *rare*. (See Fig. 6-11.)

Plumbe, John. United States; 1840–48; daguerreotypes.

Maintained the largest chain of galleries in the United States, with branches in England and France. Was the most active early daguerreotypist and supplier. Imprint on brass mat. Many galleries continued to use his name after they were sold to the operators in 1847. Verified work by Plumbe is *rare;* attributed works are *uncommon*. (See Fig. 1-4.)

Ponti, Carlo. Italy; 1858–75; albumen prints.

Produced prints and series of Italian scenery and Roman architecture, also documentary images of Venetian beggars (1860s). Complete albums *premium;* others *rare*.

Quinet, Archille. France; 1870s; albumen prints.

Known for albums and folios of Paris views. *Rare*.

Rehn, Isaac. United States; 1848 to 1860s; daguerreotype and ambrotypes.

Active in the introduction and promotion of the ambrotype process. *Rare,* especially large-plate ambrotypes.

Rejlander, Oscar Gustave. England; 1850s to 1860s; albumen prints.

One of the early leaders in the "art" movement in photography. His "pictorial" images were often staged, using models. *Rare*. (See Fig. 6-7.)

Richards, Frederick De Bourg. United States; 1844–67; daguerreotypes, cartes de visite.

One of the earliest carte de visite photographers in America. Early works *rare;* later cartes de visite *uncommon*.

Riis, Jacob August. United States; 1887 to 1890s; gelatin prints.

Famous for his depictions of immigrant life in New York. Most images which come to market are later reprints from the original negatives. *Rare*.

Robertson, James. England; 1850s; calotypes, albumen prints.

Covered the Crimean War with Fenton. All early documentary images of this type are *rare*.

Robinson, Henry Peach. England; 1850s to 1860s; albumen, platinum, and carbon prints.

With Gustave Rejlander, Robinson was an early promoter of "art" photography, using models and combining negatives to produce somewhat theatrical scenes. *Rare*.

Root, Marcus. United States; 1843 to 1860s; daguerreotypes, ambrotypes, albumen prints, cartes de visite.

Very active and influential daguerreotypist and photographer. Produced microscopic images, used Whipple's innovations (crayon daguerreotypes and crysallotypes from glass negatives), and authored several books on photography. *Rare*.

Russell, A. J. United States; 1860s to 1870s; albumen prints.

The only official military photographer of the Civil War. Produced album documenting military railroads (*premium*), then was hired by the Union Pacific to document transcontinental construction (1868–69). *Rare*.

Salzmann, Auguste. France; 1850s; calotypes.

Produced studies of Jerusalem to be printed and distributed by Blanquart-Evrard. *Rare*.

Sarony, Napolean. United States; 1860s to 1890s; albumen prints, cartes de visite, cabinets.

Famous for portraits of celebrities and stage performers. Portraits of well-known subjects *rare;* others *uncommon.* (See Fig. 8-6.)

Savage, Charles R. United States; 1859–83; albumen prints, cartes de visite, stereographs.

Famous photographer of the American southwest. Documented the driving of the "golden spike" completing the transcontinental railroad at Promontory, New Mexico (1869). His larger prints are *rare;* some cartes de visite and stereographs are *uncommon.*

Shew family: William, Myron, Jacob, and Trueman. United States; 1841–1900; daguerreotypes, cartes de visite, cabinets, albumen prints.

This family of pioneering photographers and case makers operated galleries in New York, Boston, and Philadelphia, and finally settled in San Francisco (1850s). Cased images *rare;* card photos *common* and *uncommon.*

Silvy, Camille. Britain; 1850s to 1860s; albumen prints, cartes de visite.

Produced startlingly artistic landscape images of England and France, as well as superb portraits. Large prints *rare;* cartes de visite *uncommon.*

Southworth and Hawes. United States; 1840 to 1870s; daguerreotypes, albumen prints.

The team of Josiah Johnson Hawes and Albert Sands Southworth produced some of the most spectacular large-plate daguerreotype images ever made. Their use of lighting and poses to bring out the personality of the sitter was unrivaled, as was their ability to produce unique views and group daguerreotypes. *Rare* and *premium.*

Stieglitz, Alfred. United States; 1880s to 1890s; platinum and carbon prints.

Leader of the Photo-Secessionist movement, Stieglitz was dedicated to producing realistic imagery using natural lighting. Although most of his work was produced after the turn of the century, his early work is prized by collectors. *Premium.*

Stone, John Benjamin. England; 1890s; platinum prints.

Produced extensive study of British peasants and folk festivals. Advocated the use of photography as a record of people, landscapes, and architecture. *Rare.*

Sutcliffe, Frank M. England; 1870s to 1890s; albumen, platinum, carbon, and gelatin prints.

Known for images of the people and landscapes of the seaport of Whitby, England. *Rare.*

Talbot, William Henry Fox. England; 1840s; calotypes.

The inventor of the calotype process. Unfortunately, many of his works have not survived in good condition. *Rare.* (See Fig. 5-2.)

Thomson, John. Scotland; 1860s to 1880s; albumen prints and woodburytypes.

Known for his images of the Far East and for his illustrated books depicting the people of China and the "Street Life in London." *Rare.*

Upton, Benjamin Franklin. United States; 1847–98; daguerreotypes, albumen prints, and stereographs.

Photographed the Indian settlements in Minnesota and Florida. *Rare.*

Vance, Robert. United States; 1850–60; daguerreotypes.

Provided important early documentation of California and the gold fields. Owned major San Francisco gallery. A large number of his views remain undiscovered. *Rare* and *premium.*

Watkins, Carleton. United States; 1850s to 1880s; daguerreotypes, albumen prints, stereographs.

Photographed the early American west, specializing in California landscapes. *Rare* and *premium;* stereos *uncommon.* (See Fig. 9-9.)

Whipple, John. United States; 1844 to 1880s; daguerreotypes, ambrotypes, albumen prints.

Very active daguerreotypist, inventor, and photographic pioneer. Produced crayon daguerreotypes (vignetted) and early paper photographs from glass negatives called "crystallotypes." Experimented with microphotography and celestial photography. *Rare* and *premium.*

Whitehurst, Jesse. United States; 1842 to 1860s; daguerreotypes, ambrotypes, albumen prints.

While his name is not as well known as that of John Plumbe, Whitehurst was equally involved in promotion and advancement of the art. He owned a large number of galleries along the East Coast and was the recipient of numerous awards. *Rare* and *premium.*

Wolcott, Alexander. United States/England; 1840s; daguerreotypes.

Co-owner of the world's first portrait gallery. Helped Richard Beard develop his chain of London galleries. *Rare* and *premium.*

Manufacturers and Their Marks

Daguerreotype Plate Manufacturers

The plate hallmarks shown here were taken from an examination of 200 randomly chosen daugerreotypes. The bold figure in parentheses in the caption accompanying each hallmark indicates the quantity of plates which bore that mark. In addition, 60 plates did not exhibit any evidence of a hallmark and were classified as self-cut plates, and 6 contained partial hallmarks which could not be positively attributed.

Anthony—Edward Anthony & Co., New York City

In addition to the Anthony hallmark plates shown here, this major distributor sold various other French and American-made plates, as well as cases, chemicals, cameras, etc.

Fig. A-1.

Edward Anthony & Co. hallmark from the late 1840s (**2**).

Fig. A-2.

Edward Anthony & Co. hallmark from approximately 1850 (**1**).

Fig. A-3.

Edward Anthony & Co. hallmark from the 1850s; there was no "40" used after 1853 (**2**).

Binsse—Louis B. Binsse & Co., New York City

One of the earliest suppliers of daguerreotype plates and apparatus.

Fig. A-4.

Louis B. Binsse & Co. hallmark from the early 1840s (attributed) (**2**).

Fig. A-5.

L.B.BINSSE & C<u>O</u>N.Y.

Louis B. Binsse & Co. hallmark from the mid-to-late 1840s **(2)**.

Christofle—Christofle Scale Plates, France
The first plate manufacturer to produce factory-galvanized plates, starting in the early 1850s.

Fig. A-6.

CHRISTOFLE

Christofle Scale Plates hallmark **(2)**.

Corduan—Joseph Corduan; Corduan, Perkins, & Co., New York
The earliest American plate manufacturer. Plates bearing the Corduan hallmark date from the period 1839 to 1843 and are rare.

Fig. A-7.

CORDUAN & C^O N.Y.

Corduan, Perkins, & Co. hallmark **(1)**.

French—Benjamin French, Boston, Massachusetts
Primary supplier to Southworth & Hawes in the late 1840s and early 1850s.

Fig. A-8.

B.F. 40

Benjamin French hallmark **(1)**.

Gaudin—A. Gaudin, France
Popular plate used during the early 1850s.

Fig. A-9.

A. Gaudin hallmark **(15)**.

H.B. plates—France
One of the most popular plates with daguerreotypists throughout the 1850s. The actual name is unknown.

Fig. A-10.

H.B. 40

H. B. hallmark **(20)**.

Holmes, Booth, & Hayden (Israel Holmes, John Booth, Henry Hayden); Waterbury, Connecticut, and New York City
One of the largest and most active photographic supply houses in the United States. Began to produce daguerreotype plates in 1853.

Fig. A-11.

Holmes, Booth, & Hayden hallmark from the mid-1850s **(4)**.

Fig. A-12.

Holmes, Booth, & Hayden hallmark ("Wreath Plate") from the late 1850s (**6**).

Houssemaine—Unknown European plate-maker, late 1840s.
HOUSSEMAINE—GARANTY (**1**)

J.F.S.—France
Popular plate, known among daguerreotypists as the "star" plate. Produced mid-to-late 1850s.

Fig. A-13.

J.F.S. hallmark (**8**).

J.P.—France
Very popular French plate produced during the mid-1850s.

Fig. A-14.

J.P. hallmark (**20**).

N.P.—France
Another popular French plate produced from 1849 through the 1850s.

Fig. A-15.

N.P. hallmark (**5**).

Norton—J.W. Norton, New York City
Supplied plates and daguerreotype apparatus during the late 1850s.

Fig. A-16.

J. W. Norton hallmark (**2**).

Scovills—William and Lamson Scovill, Waterbury, Connecticut
One of the largest distributors of photographic supplies in America, from 1839 into the twentieth century (merged with Anthony & Co. in 1901 to form Ansco).

Fig. A-17.

SCOVILLS

Scovills hallmark from the late 1840s (**18**).

Fig. A-18.

SCOVILLS Nº2

Scovills hallmark from the early 1840s (**1**).

Fig. A-19.

Scovills hallmark from the 1850s (**8**).

W.H.H.—Unknown American maker of daguerreotype plates popular during late 1840s and early 1850s.

Fig. A-20.

W.H.H. hallmark (**3**).

White—Edward White, New York City
Daguerreotypist, case maker, and supplier who sold his plates through various major distributors throughout the 1840s.

Fig. A-21.

E. WHITE MAKER N.Y.

FINEST QUALITY A Nº. 1

Edward White hallmark (**2**).

***40**—Unknown French platemaker. A popular plate from 1848 through the 1850s.

Fig. A-22.

Hallmark of an unknown French platemaker (**8**).

Case Makers and Designers

Brady, Mathew (New York City)
Designed and manufactured several cases during the early 1840s, the most valuable of which has the image of a harp in the center and is embossed with the words "Mathew B. Brady, Casemaker, N.Y."

Chapman, Levi L. (New York City)
Manufactured a number of designs during the early 1850s, including several "book-style" cases, some with the Chapman label inside the front cover.

Critchlow, Alfred P. (Florence, Massachusetts)
Began producing plastic cases in 1853. Cases bearing the Critchlow label date from the period 1853 to 1857, at which time the name of the firm became Littlefield, Parsons, & Co. (see Florence Manufacturing Co., below).

Eichmeyer, H. A. (Philadelphia, Pennsylvania)
Famous for designing the "band" case, a bookstyle case with a rounded spine and two embossed bands encircling the case. Many variations were produced by other firms.

Florence Manufacturing Co. (Florence, Massachusetts)
Name used by Littlefield, Parsons, & Co. on plastic cases produced after 1866.

Gaskill & Copper (Philadelphia, Pennsylvania)
Produced papier-mâché cases during the late 1850s; tiny embossed name appears in the motif.

Holmes, Booth, and Hayden (New York City)
Manufactured plastic cases in the late 1850s and after. (See also previous section, "Daguerreotype Plate Manufacturers.")

Littlefield, Parsons, and Co. (Florence, Massachusetts)
Major case manufacturer, successor to Critchlow. Plastic cases with this name on the label date from the period 1858 to 1866.

Loekle, Charles (Philadelphia, Pennsylvania)

Engraver. Some cases, produced during the mid-1850s, have his name embossed in the design.

Paquet, Anthony C. (Philadelphia, Pennsylvania)

Engraver. Embossed his name on case designs during the mid-1850s.

Peck, Samuel (New Haven, Connecticut)

Credited with having designed and produced the first plastic case in 1852. Coined the name "Union case." Partner in Scovill Manufacturing Co. from 1851 to 1857. Peck's name was removed from the Scovill label sometime after 1857.

Plumbe, John (New York City)

Famous daguerreotypist and promoter. Produced wood-frame cases until 1847, often imprinting his name on a label inside. (See also "Nineteenth-Century Photographers of Note.")

Pretlove, David (New York City)

Engraver. Name incorporated into several leather case motifs.

Scovill Manufacturing Co. (New York City)

Produced plastic cases under Peck's patent from 1854 until 1857, at which time Peck's interests were bought out. Production continued into the 1860s. (See also previous section, "Daguerreotype Plate Manufacturers.")

Shew family: Myron, Jacob, and William (Boston, Massachusetts)

Produced wood-frame cases during mid-to-late 1840s, usually with identifying label in back. Condition of extant cases indicates poor construction methods. (See also "Nineteenth-Century Photographers of Note," Appendix A.)

Smith, J. (New York City)

Engraver. Name incorporated into motifs of plastic cases during late 1850s.

Glossary

Definitions are also provided for terms appearing in *italic* in the descriptions.

accessories: Items in a photograph other than the sitter, e.g., canes, cigars, hats, chairs, pedestals, drapery, etc. See also *furnishings*.

album: A group of pages bound together like a book designed to contain photographs. Albums of the nineteenth century were enclosed in fancy leather or velvet covers. (See Figs. 2-10, 7-3, and 8-1.)

albumen: The white of a chicken egg, used in photography as a base for holding light-sensitive silver solutions to paper or glass.

allegorical photograph: A "staged" photograph depicting a story or event with a deeper, underlying meaning. Also referred to as *genre* photographs.

ambrotype: A photographic process in which a negative image is formed on collodion-coated glass, then viewed as positive by the inclusion of a black backround. (See Figs. 2-1, 2-2, 2-5 through 2-7, 2-11, 2-13, 2-14, 4-2, and 11-1 through 11-3.)

aristotype: Popular brand name for presensitized *chloride printing-out paper* of the late-1890s.

attributed credit: Credit for an image given to a particular photographer due to the specific characteristics of that image when no concrete evidence is available to verify the photographer. He or she is "assumed" to be the photographer. (See Fig. 1-5.)

balsa gum: A sticky sap collected from balsa wood, used as an adhesive during the nineteenth century. It was used in the Cutting patented ambrotype process to seal a protective cover glass to the image.

bevels: A daguerreotype plate *configuration* consisting of bends along the edge of certain plates, done to make the plate easier to handle during the polishing process.

blindstamp: The photographer's name or logo, embossed into a paper photograph for identification. (See Fig. 6-8).

boudoir print: A variation of the cabinet card, measuring $8\frac{1}{4}'' \times 5''$, popular from the late 1870s.

bromide print: A photograph made on gelatin-coated silver-bromide paper, the first true "printing" paper which required development to bring out the *latent image*.

burnished: Given a high-gloss by running the photographic print between hot rollers. An in-

tegral part of the *cabinet card* process in later years.

cabinet card: A photographic print mounted to a card measuring $4\frac{1}{4}'' \times 6\frac{1}{2}''$, popular from the late 1860s. Most cabinet cards were albumen prints, although other processes were sometimes used. (See Figs. 8-2 through 8-7.)

calotype: The first practical form of photography on paper, introduced in 1841 as an improvement of Fox Talbot's *photogenic drawing* and *talbotype*. (See Figs. 5-2 through 5-4.)

carbon print: The first "permanent" type of photographic print, patented in 1855 and perfected in 1866. The negative was printed onto carbon tissue, then double-transferred to paper. An expensive and elaborate process, it was usually reserved for exhibition prints.

carte de visite: An albumen print on a lightweight cardboard mount measuring $2\frac{1}{2}'' \times 4\frac{1}{4}''$, popular from the mid-1850s in Europe and from 1860 in America. (See Figs. 7-1 through 7-10, 7-15, 7-19, 7-21, and 7-23.)

cased image: Any of a group of photographic images contained in a leather, paper, or plastic case, popular from 1839 to about 1867.

ceramic photograph: A collodion-based image which has been transferred to chinaware or porcelain then covered with a ceramic glaze. This is an unusual and expensive photographic variant. (See Fig. 4-26.)

chloride print: A photographic image produced on gelatin-coated silver-chloride *printing-out paper,* which replaced albumen paper near the turn of the century. (See Fig. 10-2.)

chocolate tin: A photographic image produced on lightweight iron plates coated with brown varnish (a variant of the *tintype* or *ferrotype*).

collodion: A highly flammable, viscous pale yellow liquid solution of nitro cellulous, alcohol, and ether. Originally used as a liquid bandage by the military, collodion was found to be the perfect base for holding sensitizing solutions to glass in a photographic process which came to be known as the *wet process.*

combination print: A photographic image produced by printing several different negatives onto one print to produce the desired effect. This technique was often used by art photographers such as Rejlander and Robinson.

configurations: The various marks left on daguerreotype plates by tools and techniques of the process, including *bevels, plate holders,* and *gilding* tools.

coral glass: A dark, violet-colored glass used as a base for ambrotypes as a way of eliminating the need for a black backing (also known as *ruby glass*).

crayon daguerreotypes: A vignetted daguerreotype image, patented by John Whipple in 1849, produced by the manipulation of screens behind and in front of the sitter. Crayon daguerreotypes are easier to view, due to a substantial decrease in shadow (reflective) areas. (See Fig. 1-14.)

crystallotype: The first albumen prints from glass negatives produced in America by John Whipple, in 1853.

cyanotype: Also known as "blue prints" or the "ferro-prussiate process." A photographic image consisting of blue lines on a white backround (or vice-versa) developed by Sir John Herschel (1842) and improved by Pellet in 1871. A forerunner of the modern blueprint process. (See Fig. 10-7.)

daguerreotype: The world's first practical photographic process, announced by Frenchman Jacques-Louis-Mandé Daguerre in 1839. Daguerretypes were produced on silver-coated copper plates and usually housed in protective leather or plastic cases.

death portrait: See *postmortem.*

documentation: Specific written information about a collectible image, e.g., photographer, process, sitter's name, or plate configurations. Documentation helps to avoid handling of the image by prospective buyers or future owners.

dry plate: A gelatin-based glass plate purchased presensitized from the manufacturer for exposure at the photographer's leisure. Replaced the collodion wet plate at the turn of the century.

elements: The specific items which make up a *cased image,* which include the *plate, mat, preserver,* case, and cover glass. (See Fig. 4-3.)

emulsion: The light-sensitive coating applied to photographic plates, film, or paper. (*Note:* Among most photohistorians and collectors, this term is usually applied only to gelatin-based coatings.)

estimate: An auction term indicating the price a presented item is expected to bring, usually given as a range (e.g., $200–$350).

ethnics: A collector's term indicating images in which the sitter is of an unusual ethnic background for photographs of the period (e.g., blacks, Indians, Orientals, etc.).

ferrotype: A tintype plate produced by Victor Griswold to compete with Peter Neff's *melainotype* plate in the late 1850s. The term is technically more accurate than *tintype* since the plates were made of iron, not tin.

flat plate: A daguerreotype plate which has no bevels or plate holder *configurations,* usually indicating that the plate was produced during the early years of the process. (See Fig. 1-11.)

folio: A group or *series* of mounted photographs presenting the work of one or more photographers, usually containing the artist's imprint or signature.

foxing: Small brown spots which have developed on older paper photographs, particularly albumen prints, probably caused by chemical instabilities in the paper.

furnishings: Items which make up the setting for a studio portrait, such as chairs, pedestals, drapery, etc.

gallery: Popular name for early portrait studios. Many photohistorians and collectors use the word *gallery* only when referring to *daguerreotype* establishments and the word *studio* for all other photographic establishments.

galvanize: To add additional silver to a daguerreotype plate by electrolysis, thereby improving the quality. Plates which have silver on the back have been galvanized.

gaslight paper: A nickname given to certain gelatin-chloride printing papers which could be developed by artificial light.

gelatin: A clear, tasteless substance made by boiling the bones and skins of animals. Used as base for photographic films and plates since the 1880s.

gelatin dry plate: See *dry plate.*

gelatin print: Although gelatin was used as the base for many photographic processes, this term is usually used in reference to *bromide prints* and *chloride prints.* (See Fig. 10-4.)

gem: A tiny *tintype* format, approximately $\frac{3}{4}'' \times 1''$, produced in a multilens camera with a *repeating back.* Gem tintypes were displayed in tiny *albums* or placed in *sleeves.* (See Figs. 2-9, 2-10, 7-11, and 7-12.)

genre photographs: A term often used as a synonym for *allegorical photographs;* also describes any image which has a specific theme.

glass positive: A positive photographic image produced by printing the negative directly onto sensitized glass (for viewing by transmitted light).

gold chloride: A solution introduced by Hippolyte Fizeau in 1840 to intensify and protect

the finished daguerreotype (see *gilding*). Later gold chloride was used to produce warm tones in cold-tone papers such as albumen.

gravure: See *photogravure.*

gilding: The process of intensifying and toning a daguerreotype image through the application of *gold chloride.*

gilt: In early photography, a small amount of gold applied to the image surface to represent jewelry, buttons, etc.; also, gold applied to cases or mounts as decorative trim.

gutta-percha: A name incorrectly applied to the plastic substance used to produce the *union case.* Gutta-percha is a pliable sap collected from an Indian tree (called "Inosandra gutta") and used to produce buttons, jewelry, cane-heads, etc. Its fragility made it unsuitable for use in the production of photographic cases. See also *union case.*

halftone: A printing process which by converting a photographic image into tiny dots allowed the mechanical reproduction of photographs in books and newspapers; used from the 1880s.

hallmark: The logo or symbol embossed near the edge of a daguerreotype plate as the "signature" of the plate manufacturer. See also *plate mark.*

halo: The area of tarnish on extant daguerreotypes which follows the shape of the mat, surrounding the subject. Halo is considered an "adornment" by some, a distraction by others.

heliograph: The name given by Niépce to the first photographic images, taken on pewter plates in 1827.

heliotype: A "cover term" which includes all of the early processes of Fox Talbot: *photogenic drawings, talbotypes, calotypes,* and "sun pictures". (The term is not commonly used today.)

hyalotype: A positive image printed on glass, used for *stereographs* and *lantern slides,* patented by the Langenheims in 1850.

hypo: Hyposulfate of soda, a solution introduced by Sir John Herschel in 1839 which "fixed" the photographic image, making it insusceptible to the further actions of light. Hypo was used in nearly every major process of the nineteenth century.

imperial carte: A carte de visite on which the portrait image filled as much of the available area as possible (a nineteenth-century "head shot").

imperial photograph: A term used by Mathew Brady to describe his large albumen prints (up to 17" × 20").

imperial print: A large card photograph measuring 7" × 10", popular from the 1880s.

itinerant: A traveling photographer who temporarily set up shop in small towns and communities; during the American Civil War, itinerants visited encampments and battlefields.

Japan varnish: A deep black varnish used to coat *tintype* plates and as a finish for cases (often inlaid with mother-of-pearl).

lantern slide: A transparent glass slide containing a positive photographic image which is projected onto a wall or screen by the light of a *magic lantern.*

latent image: The invisible image which exists on exposed photographic plates or sensitized paper and which can only be brought out by chemical development.

Linked Ring: An organization of photographers who in 1893 broke away from the Royal Photographic Society due to the lack of attention given to "art" photography. Included Henry Peach Robinson as co-founder.

magic background: A vignetting process introduced by Charles Anthony in 1851 employing a series of paper cutouts which, when placed

in front of the plate during the exposure, created a halo of light from behind the subject.

magic lantern: A device for the projection of glass slides, incorporating an enlarging lens and the magnified light of a burning flame.

mammoth plates and prints: Images (18″ × 22″) produced by the giant wet-plate cameras often carried by photographers who documented expansion to the American west.

mascher viewer: A daguerreotype case designed to hold stereographic plates, incorporating a pop-up viewer inside the cover.

mat: A sheet of paper, cardboard, or metal with the center cut out in a particular shape; used to surround, beautify, and protect the image in a cased photograph. (See Figs. 4-8 through 4-21.)

measles: Small spots on a daguerreotype plate, probably caused by residual polishing chemicals. These spots often appear on *renewed* plates, as a reaction to the cleaning solution.

melainotype: The original name for the *tintype* process as patented by Peter Neff in 1854; it was replaced by the term *ferrotype* in the 1860s. (See Fig. 4-5.)

metol: Metol-hydrochinon solution; used as a developer for bromide and chloride prints near the turn of the century.

mezzotint: A mechanically produced print made from engraved copper plates.

mourning mat: A black paper mat used on daguerreotype images to indicate that the subject had died or was in mourning for someone who had died (see next entry).

mourning portrait: A portrait of a person who is in mourning for a recently deceased friend or relative, sometimes sent to the immediate family of the dead person when the sitter could not be there in person. (See Fig. 4-7.)

nonpariel: A French term meaning "unparal-leled" or "without equal." The term was a freely used catch-word in Victorian times but was used in photography to designate a specific shape of mat that incorporated a French curve in its design. (See Fig. 4-15.)

opaltype: A positive image on white milk glass, coated with a gelatin-bromide emulsion; a cheaper, easier-to-make version of *ceramic photographs.*

Oreo case: See *sweetheart case.*

original print: A photographic print made from the original negative by the original photographer or his authorized agent.

orotone: A positive image on glass, backed with gold foil.

oxidation: A film which appears on metal-based images as a result of chemical reactions with the air or moisture.

panel print: One of the odd-sized card photographs produced during the late nineteenth century, this one 4″ × 8¼″.

passe-partout: A framing style consisting of a painted, pressed cardboard mat sealed to a cover-glass (sometimes also painted); preferred by Europeans for daguerreotypes and ambrotypes. (See Figs. 2-2 and 3-8.)

Photo-Secession group: A society formed by Alfred Stieglitz during the early twentieth century for the promotion of "pictorial" photography. Gertrude Käsebier and Edward Steichen were also co-founders.

photogenic drawing: The earliest images produced by Fox Talbot, in which leaves or lace were placed in contact with salted paper and exposed in the sun, resulting in a contact negative.

photograph: In the early years of the art, a term applied only to those images produced on paper; later, a more general designation for any image produced by the action of light.

photogravure: A high-quality photomechanical reproduction printed from engraved copper plates. (See Fig. 8-4.)

pinhole photography: Discovered by John Mascher in 1855; refers to a process in which a sensitized plate is placed in an enclosed box with a small hole opposite it, an image of the object or scene in front of the hole is produced on the plate.

pirated photograph: An image (usually a portrait of a celebrity) that was taken by one photographer and copied and sold by another without permission. For obvious reasons, pirated photographs are seldom imprinted with a logo.

plate mark: The name or *hallmark* of a plate-maker which is embossed near the edge of a daguerreotype plate. (See Figs. A-1 through A-20.)

platinum print: A photographic image on paper, formed entirely by precipitated platinum. One of the most permanent types of photographs. (See Fig. 10-6.)

plumbeotype: An engraved mechanical print produced from a daguerreotype original. The process was popularized by John Plumbe in the late 1840s. It is not a photographic process.

porcelain print: A positive photographic image produced by printing the negative directly onto sensitized porcelain.

portfolio: See *folio.*

postmortem: A portrait of a deceased person, taken to give the appearance that the person is sleeping. Common during the period of the *cased image;* less common in later years. (See Fig. 2-13.)

preserver: A thin frame of malleable brass which encompasses the *plate mat* and the cover-glass of a *cased image,* holding them securely in place. (See Figs. 4-22 through 4-24.)

printing-out paper: Photographic paper which produces an image during exposure and does not require chemical development (*albumen* paper, *aristotype* paper, etc.).

promenade print: One of a variety of card photographs produced during the late nineteenth century; this one measures $3\frac{3}{4}'' \times 7\frac{1}{2}''$.

provenance: The history of a photograph, including (when possible) its place of origin and all of its previous owners.

quickstuff: A chemical mixture (often a secret formula of the operator) that was applied to a daguerreotype plate via a "fuming box" to increase sensitivity.

renewed plate: A daguerreotype plate which has been cleaned with a chemical dip to remove tarnish. Renewal of daguerreotype plates is not recommended.

repeating back: An attachment to a wet-plate camera which allowed the separate exposure of each half of the plate. Used in combination with a multilens setup, the repeating back allowed for the production of dozens of images on one plate.

reserve: An auction term signifying the lowest amount the seller will take for a particular item.

rub: A blemish in a daguerreotype image caused by contact with the surface of the plate.

ruby glass: See *coral glass.*

salt print: A print made on *calotype* paper from a glass negative. (See Fig. 5-6.)

salting: Small green spots on daguerreotype plates and brass mats caused by a chemical reaction to air and moisture.

self-cut plate: A plate cut by the operator from a larger plate to save money. Plates without *plate marks* have usually been self-cut.

series: A group of photographs pertaining to the same subject, usually distributed as a set.

shield: A light-tight holder into which a pho-

tographic plate is inserted for transportation to the camera. After it is placed into the camera, a slide is removed, allowing the plate to be exposed.

shorted plate: A *self-cut plate* made slightly smaller than standard size. By this method a "thrifty" operator could get more plates for his money.

silver bromide, silver chloride, silver nitrate: The three major sensitizing solutions used in the nineteenth century.

silver print: A generic name given to all paper prints produced after the introduction of gelatin-coated paper, on which the image is formed by silver.

silvering: The silver "dusting" which occurs near the edges of aging gelatin prints.

sleeve: A carte de visite–sized paper frame into which a *tintype* or *gem* tintype was inserted for protection and adornment. (See Figs. 2-9 and 7-11.)

solarization: A brilliant white area on a daguerreotype, containing little or no detail, caused by overexposure of light-colored objects. This was a common problem during the early years of the process and prompted operators to insist that the sitter wear clothing of a neutral shade.

speculum camera: A type of camera invented by Wolcott and Johnson (1839 to 1840). Rather than a lens, the camera used a concave metal reflector which projected the image onto a sensitized daguerreotype plate. The shorter exposure times required by this camera made portraiture possible and inspired the first commercial studio.

stereograph: A pair of pictures of the same object, taken at slightly different angles, presented side by side for viewing in a *stereoscope*. (See Figs. 9-1 through 9-15, 11-12, and 11-13.)

stereoscope: A binocular device for viewing stereoscopic pictures. The spacing and angle provided by special lenses produces a three-dimensional effect. (See Fig. 9-4.)

sweetheart case: A type of *union case* consisting of two discs which are attached together by screw-threads or friction, with one or both discs holding the round image. Because of their resemblance to a popular modern cookie, these cases have obtained the nickname *Oreo case*. (See Figs. 3-11 and 3-12.)

talbotype: A photographic image produced on salted paper by continued exposure in a camera. This process was the predecessor to the *calotype* process, in which the *latent image* was brought out through chemical development.

third foot: Nickname for the infamous head rest used to hold the sitter's head steady during lengthy exposures. In standing portraits, the base of the support is often seen next to the subject's feet, inspiring the nickname "third foot." (See Fig. 7-9.)

tintype: Popular misnomer for the *melainotye* and *ferrotype* process; tintype images were actually produced on thin sheets of *iron* painted with *Japan varnish*. While the period of the tintype's popularity was short-lived (1858 to 1865), the tintype has the distinction of having been produced in quantity longer than any other nineteenth-century process (1858 to 1930). (See Figs. 2-3, 2-4, 2-8, 2-9, 2-12, 3-11, 3-12, and 4-6.)

tipped-in: Mounted to a book page or leaf of an album. Books illustrated with original photographs usually have the images tipped-in.

toning: The overall tinting of an image, usually through a bath in *gold chloride*. Toning brings a warmer color to the image and has protective qualities as well.

union case: A type of molded plastic image

case, introduced in the early 1850s. The plastic was made by combining wood fibers or coal dust with shellac and color. Incorrectly called the *gutta-percha* case. (See Figs. 3-4, 3-9 through 3-12, 3-16, and 3-17.)

Velox: Brand name for a popular *gaslight paper* of the late 1890s.

vignette: A style of portrait in which the image seems to float on a background of light or clouds, produced by various mechanical, optical, or chemical means. (See Fig. 1-14.)

waxed negative: An improvement to the *calotype* process in which the paper negative was coated in wax, thereby making it more transparent.

wet process: Name given to the process in which a negative image was produced on a *collodion-*coated glass plate. In order to assure maximum sensitivity, the plate had to be exposed while still wet.

wiped plate: A daguerreotype plate which has had the image destroyed by attempted cleaning with a cloth or with abrasives. (See Fig. 4-1.)

woodburytype: A elaborate photomechanical printing process popular for illustrated books and *folios*. The image was formed by pigmented gelatin, pressed onto paper by a lead mold. (See Fig. 10-8.)

Bibliography

This book has provided much of the basic information collectors need to enjoy collecting as a hobby and/or to make wise investment decisions. However, the scope of nineteenth-century photography is far greater than any one volume can even touch on. The serious collector would be well advised to expand his or her education through continued reading. What follows is a list of the best-known books dealing with the various aspects of this subject, each accompanied by a simple review.

Albumen and Salted Paper Book, by James M. Reilly (Light Impressions, Rochester, NY, 1980).
 A comprehensive guide to the history and technique of albumen printing, with emphasis on the process itself.

The American Daguerreotype, by Floyd and Marion Rinhart (University of Georgia Press, Athens, Georgia, 1981).
 A "must have" for daguerreotype collectors, this large volume is the most comprehensive study available to date. Extensive appendix and biographical sections.

American Miniature Case Art, by Floyd and Marion Rinhart (A.S. Barnes and Co., Cranbury, New Jersey, 1969).
 While the recent Krainik book *Union Cases* (presented later), covers that specific type of case thoroughly, the Rinharts' book is still the only comprehensive volume covering all aspects of image case history and production.

Care and Identification of 19th Century Photographic Prints, by James M. Reilly (Eastman Kodak Co., 1986).
 One of the most thorough books on the subject, this volume contains color plates, closeup illustrations, and a wall chart.

Cartes de Visite in 19th Century Photography, by William Darrah (self-published, Gettysburg, Pennsylvania, 1981).
 A very extensive technical history of the carte; includes thorough subject guide and large photographer index.

Collecting Photographica, by George Gilbert (Hawthorne Books, New York, New York, 1976).
 Somewhat outdated but still interesting reading.

Daguerreotype: A Sesquicentennial Celebration, edited by John Wood (University of Iowa Press, Iowa City, Iowa, 1989).
 An impressive volume containing many pre-

viously unpublished images and informative essays by noted authorities.

The Daguerreotype in America, by Beaumont Newhall (Dover Publications, New York, New York, 1976).
Authoritative information from a leading photohistorian. Not as complete as the Rinhart book, but a good inexpensive substitute with some excellent plates.

Daguerreotypes of Southworth and Hawes, by Robert Sobieszek and Odette Appel (Dover Publications, New York, New York, 1980).
Over 100 plates by two of the most artistic and prolific American daguerreotypists; each plate has accompanying text.

Golden Age of British Photography (1839–1900), by Mark Haworth-Booth (Apeture, New York, New York, 1984).
A superb portfolio of images from the top museums in Great Britain, with informative text.

History of Photography, by Helmut and Alison Gernsheim (London, Thames, and Hudson, 1969).
An early, but still authoritative history.

History of Photography, by Beaumont Newhall (Museum of Modern Art, New York, New York, 1982).
A "must have" for image collectors; covers the processes and "trends" from the beginning of the art into the twentieth century. An excellent reference work.

How to Buy Photographs, by Stuart Bennett (Phaidon Press, Oxford, England, 1987).
Concentrates primarily on "high-end" art photography from the turn of the century; touches lightly on early works and has a section on modern prints. European flavor.

International Guide to 19th Century Photographers, by Gary Edwards (G. K. Hall, 1988).
Lists over 4,000 names with pertinent information, including auction catalog listings.

Keepers of Light, by William Crawford (Morgan and Morgan, Dobbs Ferry, New York, 1979).
An extensive guidebook to early photographic processes, with emphasis on chemicals, materials, and techniques.

L.J.M. Daguerre, by Helmut and Alison Gernsheim (Dover Publications, New York, New York, 1968).
First published in 1956, this work is still the authoritative source for information on the inventor of the world's first practical photographic process. Numerous related plates.

Military Uniforms in America: Long Endure: The Civil War Period, edited by John Elting and Michael McAfee (Presidio Press, Novato, California, 1982).
Complete reference of "standard" military uniforms for the period 1852 to 1867. Important to collectors of military images.

Mr. Lincoln's Camera Man, Mathew Brady, by Roy Meredith (Dover Publications, New York, New York, 1974).
Complete study of the life and work of America's most famous nineteenth-century photographer. Contains examples of his early works, as well as Civil War and postwar images.

Origins of Photography, by Helmut Gernsheim (Thames-Hudson, London, England, 1983).
An extensive history of photography's earliest years, superbly illustrated using special printing processes.

Paper & Light, by Richard Brettell (David

R. Godine Publisher, Boston, Massachusetts, 1984).

A major survey of the calotype process in France and Great Britain, superbly illustrated.

Photographic History of the Civil War, in five double volumes (Blue and Grey Press, Secaucus, New Jersey, 1987).

The most extensive collection of Civil War photographs ever accumulated; originally published in 1911.

Photographs: A Collector's Guide, by Richard Blodgett (Ballantine Books, New York, New York, 1979).

Concentrates primarily on "high-end" and art photographs usually sold at auction. Prices given reflect trends of the previous decade.

Photography and the American Scene, by Robert Taft (Dover Publications, New York, New York, 1964).

Originally published in 1938, this work was the earliest extensive photographic history published and is still a required reference for collectors and photohistorians.

Photography: The Early Years, by George Gilbert (Harper and Row, New York, New York, 1980).

A compendium of nineteenth-century photographic history spotlighting famous individual photographers.

Photography: Essays and Images, edited by Beaumont Newhall (Museum of Modern Art, New York, New York, 1980).

Works by and about those individuals who shaped the photographic art. Excellent plates.

Union Cases, by Clifford and Michele Krainik (Centennial Photo Service; Grantsburg, Wisconsin, 1988).

The newest and most authoritative cataloging of plastic image cases, with superb illustrations and including a separate list of collectible values.

Victorian and Edwardian Fashion, by Alison Gernsheim (Dover Publications, New York, New York, 1981).

History of fashion taken from original photographs, of which numerous plates are included. An important reference for dating early images.

World of Stereographs, by William Darrah (self-published, Gettysburg, Pennsylvania, 1977).

A complete history of the stereograph, including extensive subject guide and list of stereographers.

Index